the art of
EDENA™

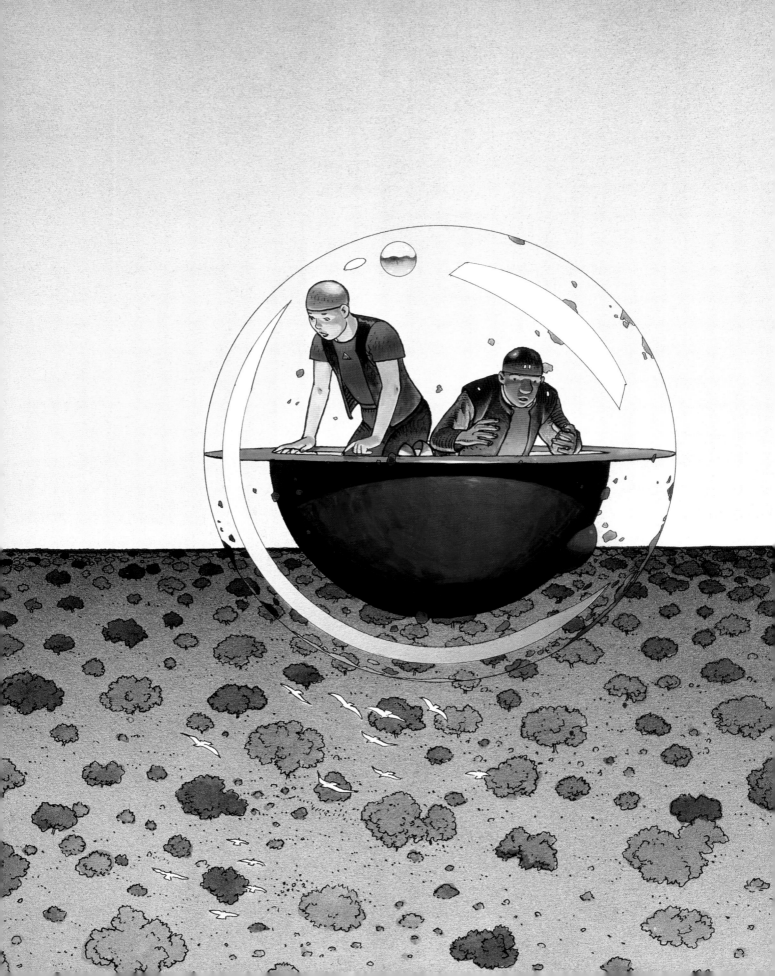

MOEBIUS LIBRARY

the art of
EDENA™

Written and illustrated by
JEAN "MOEBIUS" GIRAUD

Commentary by
ISABELLE GIRAUD & MOEBIUS PRODUCTION

Translated by
DIANA SCHUTZ

Lettering by
ADAM PRUETT

DARK HORSE BOOKS

Publisher
MIKE RICHARDSON

Editor
PHILIP R. SIMON

Assistant Editor
MEGAN WALKER

Designer
RICK DeLUCCO with **JUSTIN COUCH**,
in collaboration with **CLAIRE CHAMPEVAL**

Digital Art Technician
ADAM PRUETT

MOEBIUS LIBRARY: THE ART OF EDENA
The Art of Edena © 2018 Moebius Production / Isabelle Giraud. All rights reserved. The images seen on pages 110 to 117 are © Angel Fine / Moebius Production. Dark Horse Books® and the Dark Horse logo are registered trademarks of Dark Horse Comics, Inc. All rights reserved. No portion of this publication may be reproduced or transmitted, in any form or by any means, without the express written permission of Dark Horse Comics, Inc. Names, characters, places, and incidents featured in this publication either are the product of the author's imagination or are used fictitiously. Any resemblance to actual persons (living or dead), events, institutions, or locales, without satiric intent, is coincidental.

Published by
Dark Horse Books
A division of Dark Horse Comics, Inc.
10956 SE Main Street
Milwaukie, OR 97222

DarkHorse.com | Moebius.fr

To find a comics shop in your area, visit comicshoplocator.com

First edition: April 2018
ISBN 978-1-50670-321-3

10 9 8 7 6 5 4 3 2 1

Printed in China

Library of Congress
Cataloging-in-Publication
data is on file.

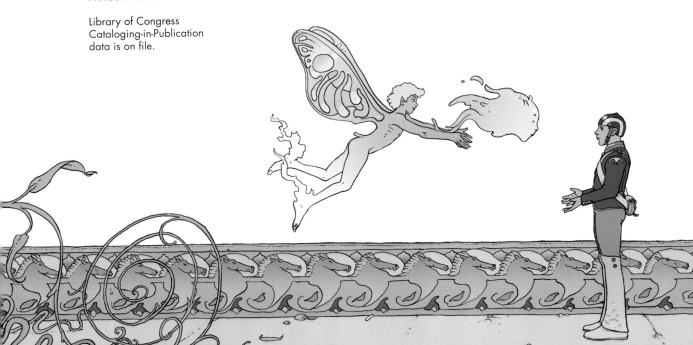

CONTENTS

FOREWORD

Jean Giraud produced his Edena Cycle between 1984 and 2001. He drew from both his personal life and the very heart of his artistry to offer us the gift of his own conception of paradise on earth.

On Planet Edena, two forces clash—two visions of the world are at war. Despite the two extremes, they each share the same goal: the quest for perfection. Tension springs from the fight for survival on Edena—a secret planet at the center of the universe, also called the "Perfect World."

Both factions deploy their forces on every possible plane: reality, dream, and waking dream. These planes intertwine and intersect, so that both desires and nightmares are fair game. One side supports a societal pyramid, regulated and closed off to random events—every instant must be preprogrammed, every failure eliminated. The other side's members favor truth, thereby condemning themselves to heightened self-consciousness. Guided by love, they set off in search of their doubles, confronting their fears with courage and evolving in the course of this personal journey. The oneiric plane is the principal arena of their actions.

At the center is Lazlo, the child, hidden away in the Lower Depths. He's a medium and a failed clone, birthed via the diseased mind of a monster—the Paternum—whose subjects are grown from his own genetic stock. Lazlo turns a (literally) blind eye to his world's absurdities and instead devotes himself to his visions, fully aware that inner actions can impact the outer world. The spirit of Moebius may very well be expressed through Lazlo: gentle, intelligent, and attentive to beauty, the child is also a practitioner of meditation, much like the artist who enters a trance state, allowing his sensations to overtake him completely in order to translate them onto the blank page. The author, of course, may also be found in the character of Stel, the pure-hearted adolescent who is transformed by the discovery of love.

Four chapters give voice to themes that are highly regarded by Moebius and illustrated through short stories and representative drawings. First up, the notion of *repairs*; second, *deviation*; the third encompassing *rebirth and transformation*; and last but far from least, the *journey*.

—Isabelle Giraud, August 2017

ABOUT *THE WORLD OF EDENA*

The World of Edena began with a 1983 advertising campaign for Citroën cars—a short story commissioned for the company's internal use. This initial prompt led Jean "Moebius" Giraud to further develop the story he'd started, giving it a richer flavor by adding characteristically Moebius-esque embellishments. As he once remarked, such a long story was never in the plan, and yet the story grew into a long one. A graphic novel was never in the plan, and yet the long story became a graphic novel. Nor was an entire *cycle* of stories in the plan, and yet this entire cycle of stories simply could not be denied!

In 1985, two years after that first story, Moebius embarked on instincto-therapy, a form of nutrition based on the consumption of original, raw foods. This practice, for him, paralleled the idea of an original paradise, a theme that he would develop in *The World of Edena*. Later that same year, in Japan working on the animated adaptation of *Little Nemo*, the legendary comic strip by Winsor McCay, Moebius took advantage of a break in the filming to spend a month in his Tokyo hotel room drawing the first twenty-five pages of "The Gardens of Edena," a follow-up to the Citroën story.

Initially, *Edena*'s two main characters are divorced from the kind of spontaneity and animal nature that typify all living creatures. By extrapolating on mankind's contemporary therapeutic practices and pushing them to the extreme, Moebius would introduce a theme derived from modern medicine: that the body is an imperfect machine whose parts can and must be replaced. Stel and Atan, the story's protagonists, sincerely believe that good health consists of good transplants. This is a view of humanity as severed from its roots, especially its sexuality. Moebius soon realized that from a simple advertisement for Citroën, he'd unconsciously, and quite surprisingly, orchestrated a fantastic cosmic drama based on his heroes' rediscovery of their true human essence.

Originally, Moebius had unwittingly drawn Stel as masculine and Atan with a more feminine, albeit still undefined, form. In fact, the story first develops in a somewhat male or even neutral world, certainly an asexual one, as these characters mirror the author's deeply grounded blurring of the lines between his masculine and feminine sides.

The story begun in the first chapter was now starting to take shape. Through the metaphor of food, Moebius portrayed his protagonists' return to a completely natural state from their overly artificial one, including all the resistance, fear, and inhibition that would accompany such a transformation and reinvention of self . . . Stel and Atan, as products of the future, removed from both their normal environment and their early conditioning, experience things in contact with Planet Edena that they had only ever known in the abstract: apples and water, for instance—not to mention sex!

When asked about the personal dimension of this work, Moebius always replied that his inspiration was directly linked to his own personal inquiries and experiences. This particular narrative felt clearer to him than his previous stories, as it was tied not only to his discovery of instincto-therapy but, more importantly, to areas of his own unconscious. In an ongoing attempt to understand his own essence and his own beliefs, his creation of *The World of Edena* would shed light on these major concerns and provide the author with answers in the course of the story itself.

One of these concerns would play an unprecedented role here: sentiment. In this story, the two protagonists truly love each other. Moebius was greatly intrigued by the realization that he'd never actually portrayed sentimental feeling before, unless from a sardonic perspective. With *Edena*, not only do his characters have emotions, but emotion becomes the driving force of the story.

In other words, more than thirty years ago, Moebius was already addressing issues that are now more pressing than ever—issues of gender and of ecology. In service to these ideas, he would adopt a pure drawing style for the Edena Cycle, the placid yet utterly pristine line work that defines *ligne claire*, or the "clear line" style pioneered by Hergé.

The World of Edena is also pure Moebius: "From the moment I enter into a Moebius storyline, I am automatically projected into an entirely different head space. There are Moebius comics that whisper, others that sing. There's solemn Moebius, and deadly serious Moebius; there are even moments of fun, however rare . . . I continue to evolve in my life, so my emotions and various states of mind continue to evolve as well."

This is the way Jean "Moebius" Giraud saw himself as an artist.

(Excerpted and adapted from interviews with Jean "Moebius" Giraud. This text was provided by Moebius Production and translated by Diana Schutz.)

JE N'ARRIVAIS PLUS À LA
CONTRÔLER... ELLE CHERCHAIT
À TUER LE HORS-NID ALORS
QUE MON BUT ÉTAIT DE LE
CAPTURER...

C'EST UN HORS-NID SPÉCIAL,
CHEF... IL A RÉUSSI
À RÉPARER LE FLY-BUS.

JE SAIS... C'EST POUR ÇA
QUE J'AI ATTENDU AVANT
DE ME MANIFESTER.
JE VAIS AVOIR BESOIN
DE LUI...

MAIS, CHEF... SI LA
CITÉ-NID N'EXISTE PLUS...
C'EST AFFREUX...!
- OUI, C'EST AFFREUX!
NOUS N'AVONS PLUS NULLE
PART OÙ ALLER...

- IL Y A UN ENDROIT...
- ???...

- JE VAIS VOUS Y
CONDUIRE... TOUS AU
FLY-BUS

LA PATRONNE
A ÉTÉ ASSASSINÉE
PAR DES REBELLES
TRAÎTRES.

QUOI ?.. MAIS ALORS,
LA CITÉ-NID !!!

PRISE... TOMBÉE...
C'EST POUR ÇA QUE CE
CRÉTIN DE CHEF A
TUÉ LE RADIO ET
DÉTRUIT LE POSTE... IL
A PANIQUÉ...

MAIS C'EST VOUS LE
CHEF... NON...

OUAIS, C'EST MOI... TOUT
EN DESSOUS... MAIS
AU DESSUS... C'EST
MOI, LA PATRONNE...

ATTENDEZ, JE NE
COMPRENDS PAS...
COMMENT AVEZ-VOUS
FAIT POUR...

J'ÉTAIS DANS LE...
NON, J'ÉTAIS LE
MONSTRE... C'EST
TOUT CE QUE J'AVAIS
RÉUSSI À CRÉER
APRÈS MON
ASSASSINAT.

JE M'EXCUSE
D'AVOIR TIRÉ.

NON, AU CONTRAIRE
TU M'AS LIBÉRÉ DE
CETTE FORME STUPIDE

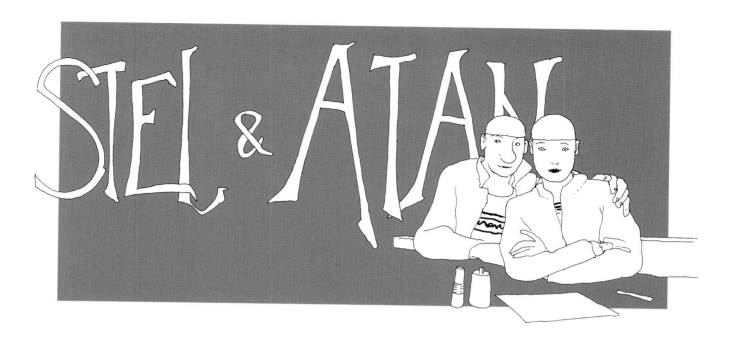

DES RÊVES DES VISIONS... J'AI CRU QUE JE DEVENAIS FOU... HEUREUSEMENT, LES ÉQUIPES DE CLONES MÉDICS ONT RÉUSSI À ME PROTÉGER EN ME PLONGEANT DANS UNE STASE CHIMIQUE DE SYNTHÈSE... D'OÙ JE POUVAIS CONTINUER À DIRIGER LE NID ET CES CHERS PIF-PAF !...

2

ET QUE - TU L'AS TUÉ ?

- MÊME PAS... À MON AVIS, IL A DÛ CREVER DANS UN COIN DE FORÊT, BOUFFÉ PAR LES FOURMIS.

- ET AS-TU ENTENDU PARLER DE BURG ? MAÎTRE BURG !

- HEU... BURG... AU DÉBUT, OUI IL A FAIT PARTIE DES HALLUS DONT LES MÉDICS M'ONT GUÉRI... ÇA A DE L'IMPORTANCE ?

- HEU... NON... DIS MOI CE QUE TU VEUX DE MOI... POURQUOI TOUT CE CIRQUE... CETTE TÊTE BIDON..?

- BAH... FAUT BIEN S'AMUSER, NON?. ÇA NE TE PLAÎT PAS, TOUTES CES BELLES FILLES, PROGRAMMÉES POUR TON PLAISIR.

- ET ORAN ?

- OH, ORAN !!!... IL A MALHEUREUSEMENT EU MOINS DE CHANCE... SES RÊVES L'ONT RENDU RÉELLEMENT DINGUE... UN AUTRE BOURBON? NON?... TU AS TORT, C'EST DE LA PARFAITE SYNTHÈSE... PAS DE LA BIBINE POUR LONGÈVE...

4

- ARRÊTE TA CHIALOPEN... OÙ EST ATANA ?...

- ...

- ALORS... RÉPONDS !...

- TON ATANA S'EST PRISE POUR UNE SORTE DE DÉESSE... ELLE A FOUTU LA MERDE DANS MA CITÉ-NID... ELLE A DÉTRUIT MON ENVELOPPE MILLÉNAIRE ET PAS SA FAUTE... ET SI JE N'AVAIS PAS EU L'IDÉE GÉNIALE DE PRÉVOIR CETTE CITÉ-FILLE... J'EN SERAIS RÉDUIT À ERRER DANS LE DÉSERT DANS LA PEAU D'UNE BESTIOLE STUPIDE.

- QU'AS-TU FAIT D'ELLE ?

- ÉCOUTE STEL... JE VOUDRAIS DISSIPER TOUT MALENTENDU...

OUI, ORAN... D'ABORD IL S'EST MIS IL EST ENTRÉ EN CONFLIT DANS LA ... IL PRÉTENDAIT TÊTE QUE NOUS DEVIONS CRÉE LE NID, SIMPLEMENT PAR NOTRE DÉSIR INCONSCIENT, EN UTILISANT LE CHAMP PSYCHOMORPHE DU PLASMA PLANÉTAIRE D'EDENA... QUE C'ÉTAIT UNE MONSTRUOSITÉ UN CANCER DONT IL FALLAIT DÉBARASSER LA PLANÈTE AU PLUS TÔT.

3

JE NE SUIS PAS TON ENNEMI... NI L'ENNEMI D'ATANA... MON SOUHAIT EST QUE TOUT CE MONDE PUISSE VIVRE EN PAIX... EDENA EST VASTE... IL Y A DE LA PLACE POUR TOUT LE MONDE...

- MAIS OÙ EST-ELLE ?...

- EH BIEN, C'EST COMPLIQUÉ... SON CORPS EST TOUJOURS BIEN QUE PART DANS LA CITÉ-NID, MAIS SON ESPRIT EST PARTI...

- PARTI ?... MAIS OÙ ÇA?...

- SI JE LE SAVAIS MON PAUVRE STEL... LES MONDES ONIRIQUES SONT UN VRAI LABYRINTHE

- C'EST AFFREUX... ATANA... O ATANA !...

- ÉCOUTE, JE PEUX FAIRE QUELQUE CHOSE POUR VOUS DEUX

... ET ALORS... QU'EST-CE QUE TU AS FAIT...

- QUE VOULAIS-TU QUE JE FASSE AVEC UN TEL FOU..? J'AI ESSAYÉ DE LE FAIRE SOIGNER... MAIS L'INGRAT S'EST ÉCHAPPÉ DEVENANT AINSI LE PREMIER HORS NID... MAIS AUPARAVANT IL AVAIT LE TEMPS D'ÉCRIRE UN PAMPHLET SÉDITIEUX, LE LIVRE DE LA PYRAMIDE... UNE MERDE MYSTICO-PRÉTENTIEUSE COMPLÈTEMENT ILLISIBLE

5

- AH OUI...?

- JE T'ENVOIE À SA RECHERCHE... MOI JE NE PEUX PLUS... J'AI DÉJÀ ASSEZ DE MAL À MAINTENIR MA FORME, DANS CE PLAN... (MATÉRIEL)

- MH... C'EST TENTANT... COMMENT FERAS-TU ?

- J'AI MES TECHNOS... MES CLONES MÉDICS...

- POURQUOI FAIS-TU ÇA...

- JE NE SUIS PAS UN MONSTRE, STEL... ET ON A TOUJOURS ÉTÉ DE BONS COPAINS TOUS CES DEUX... TOUS LES TROIS MÊME...

- LAISSE-MOI RÉFLÉCHIR !

the world of EDENA™

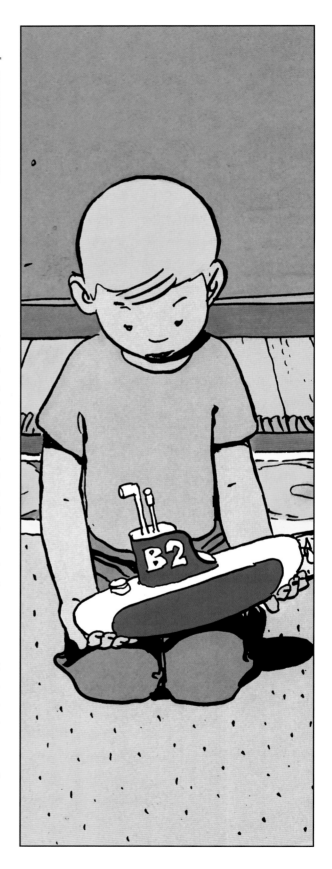

THE EDENA CYCLE

Jean "Moebius" Giraud refers to the chapters and illustrations associated with his mystical paradise planet, Edena, as parts of a "cycle"—his Edena Cycle. That's how his graphic novel *The World of Edena*, at the heart of this cycle, should be experienced—as a cyclical, continuous event. Moebius's *Edena* graphic novel, like his namesake, is a twisting-yet-continuous tale that ends by beginning anew. Through his adventures, the character Stel shows a growth in his understanding of the universe, his reality, and his dreams. When *The World of Edena* ends, with the last page of chapter 5, the reader is encouraged to return again to chapter 1, as Stel's cyclical story returns to his space adventures with Atan, and his cycle of growth and rebirth repeats over again.

CHAPTER 1, PART 1—REPAIRS

In the first chapter of *The World of Edena*, we meet Stel and Atan, repairmen in a huge universe filled with strange biomechanical beings and machines. Straightforward and earnest, Stel is a pilot and "mekanik" filled with a sense of adventure. Atan is a bit more thoughtful, using psychic powers more than mechanical acumen to solve problems. This short chapter shines a light on Stel's personal sensitivity and pureness of heart, which are assets to him as he attempts to fix a Waymaster's unstable power core.

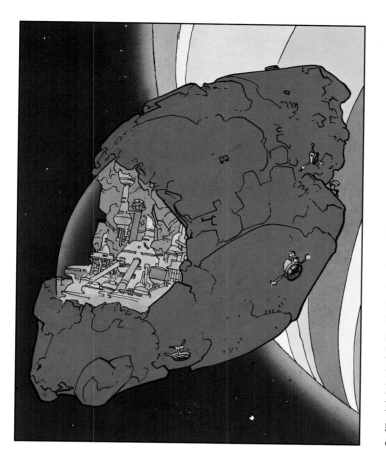

CHAPTER 1, PART 2—
UPON A STAR

With countless adventures behind them, colleagues and good friends Stel and Atan investigate an abandoned refinery in deep space, hoping to uncover the secret behind its missing crew. As the refinery orbits a huge planet, the pair explore it for clues and are startled to find themselves falling and crashing to the nearby planet's surface. Dubbed "Pool Ball" by Atan, the desolate planet seems to lead them with a nightly lightshow to a city of spaceships—a gathering of pilgrims. A large group of beings from all corners of the universe have been called or led to "Pool Ball" in order to gather around a massive pyramid, which is actually a living space ship that will take them to the legendary paradise planet known as Edena. Stel is revealed to be the ship's long-awaited pilot, and he and the large gathering of beings board the living star craft, which flies them out into space.

CHAPTER 2—
THE GARDENS OF EDENA

Waking from a deep sleep, Stel and Atan are ejected from the living ship and find themselves now stranded on a lush planet filled with forests, gardens, fairies, and the strange Master Burg. When they are forced to consider consuming natural food and water and when the futuristic implants in their bodies stop working, Stel and Atan undergo short bouts of physical discomfort and find that they have previously suppressed sexual characteristics that are now returning quickly. With Atan transforming into a beautiful woman, Stel's newly-revived hormones arrive and hit him with a mad passion. Stel scares Atan/Atana away with his insistence on lovemaking, and Atana has to knock him out to escape his unbridled lust. Stel meets and is seemingly toyed with by the powerful Master Burg, who urges Stel to try to assume control over his dreams and to learn from his nighttime visions.

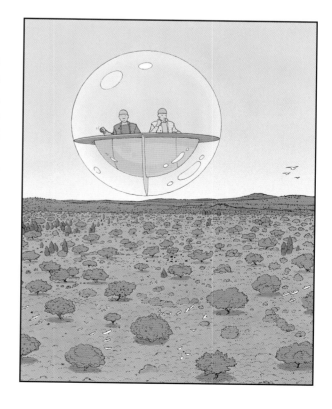

CHAPTER 3—THE GODDESS

On her own, Atana (formerly Atan) is captured by the Snufflers and forced into one of their nests, where the Paternum is intent on killing her. She regrets leaving Stel, but she's soon thrust into a game of cat and mouse with both physical and spiritual manifestations of the Paternum. Burg doesn't appear to her—but the Paternum does. In a trance-like state and bearing new powers after being revived from death, Atana emerges as a force for revolution, and she inspires several dubious Snufflers to break free from the hold the Paternum has over them.

CHAPTER 4—STEL

Searching the seemingly endless forests and gardens of Edena for his lost Atana, a guilt-ridden Stel survives in the wild, scavenging and fighting off strange beasts, including monstrosities that the Paternum sends to kill him. Encountering a band of arguing Snufflers facing mechanical problems, Stel fixes their machine and is brought to a nest—but not the one Atana helped free. Stel's old friend Trollopen (one of the lost crewmen that Stel and Atan were searching for at the beginning of the book) is now an agent of the Paternum. Trollopen is completely taken over by the Paternum, and Stel is captured, tortured, and placed in a suboneiric snare which is designed to capture the goddess-like Atana.

CHAPTER 5—SRA

In this surreal chapter, Stel finds himself existing in several realities at the same time. He's on Edena as a victim of the Paternum's pawn Trollopen, in the suboneiric snare he's a wanderer on Planet Strange hoping to find his goddess Atana, and he's a space pilot who's just been rescued and is recovering from E.D.N.A. Syndrome.

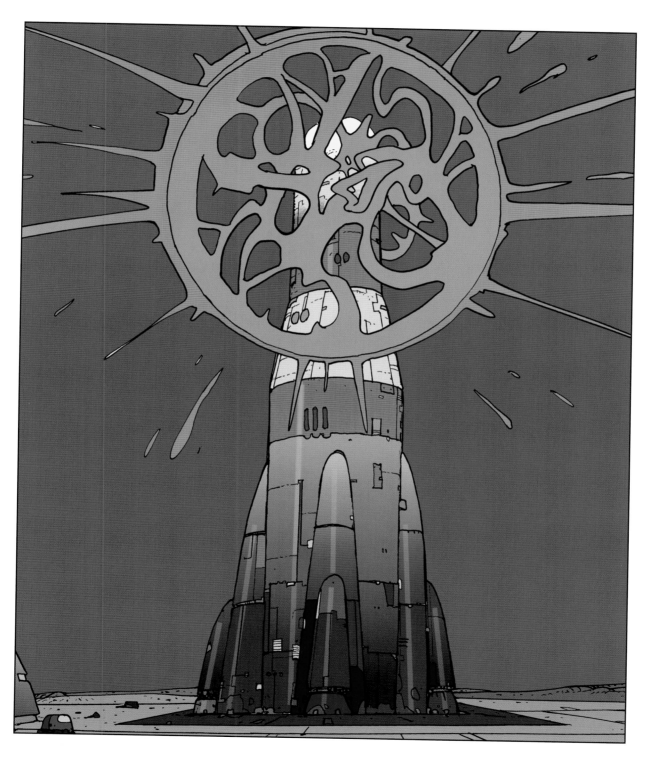

THE CHARACTERS OF EDENA

The characters of Edena all have one aspect in common: they live on several planes at the same time, in numerous forms. Stel and Atan go from asexual beings, genderless and serene, to very human creatures, overwhelmed by their new emotional depths. Setting out on a kind of space opera, they live their true lives, and their forms adapt accordingly. Even the spelling of their names changes from one page to the next: an *A* latches onto the root term *Atan*, while [in the original French edition] *Stel* sometimes morphs into *Stell,* with two *Ls*—or *ailes* [meaning *wings*]. Readers mustn't think of these as errors; rather, they're deliberate variations that make a certain sense.

The creator of these characters has given them all a language of their own, full of double- or even triple-entendres: a distinctly Moebius-esque dialect brimming with contractions and hybrid terms—sometimes difficult to translate but always playfully funny.

From a technical point of view, what's remarkable about the work is its stylistic cohesion. Despite the fact that the series was created over a fifteen-year period, the scenes link up organically, through a seamless graphic continuity that applies to both the drawing and the color, as well as to the details of the story itself. And so, inasmuch as different people were involved in producing the color art, all their work began and progressed under the creator's benevolent control, and ultimately reflects the final, distinctive touch of Moebius himself. Each panel reveals a perfectly feasible reality, although one that's projected ahead some 7,000 years . . .

In 2010, Moebius chose to present his extensive exhibit at the Fondation Cartier in Paris under the name "Moebius-Transe-Forme." In French, this inventive, hybrid term combines the words *trance* and *form* into *transforms*, a bit of characteristic wordplay shedding light on the artist's never-ending pursuit: to see the world differently by virtue of a light trance state, allowing for a better appreciation of the incredible, multifaceted beauty of the worlds and beings around us, including our own selves.

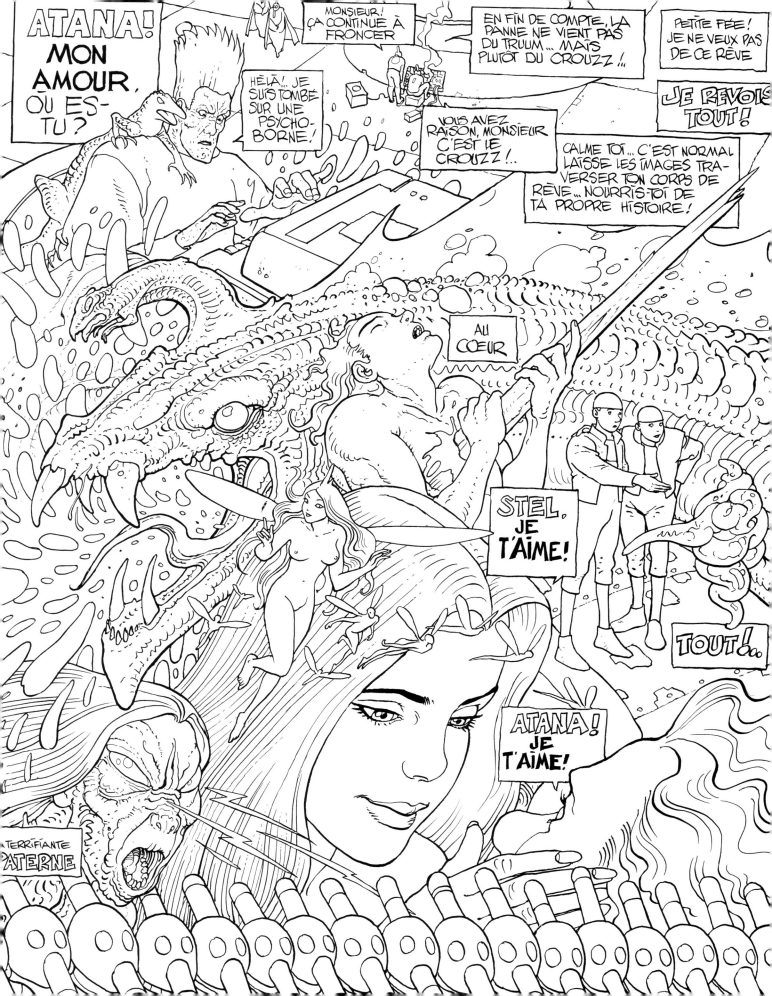

STEL

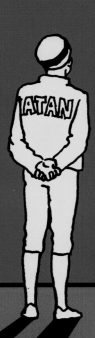

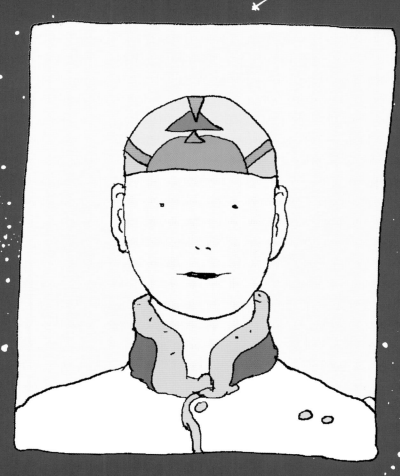

ATAN

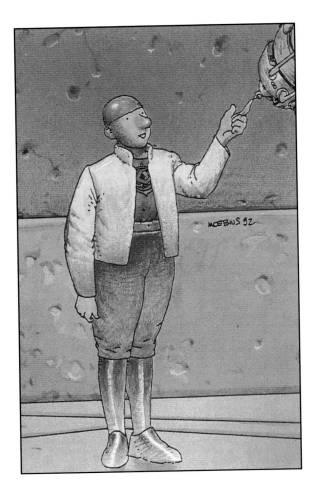

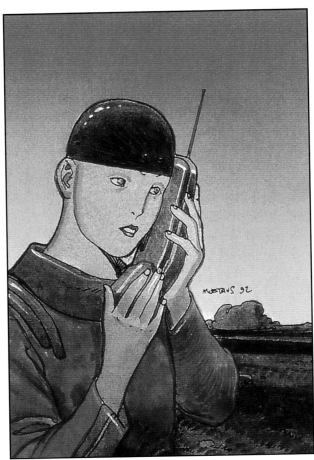

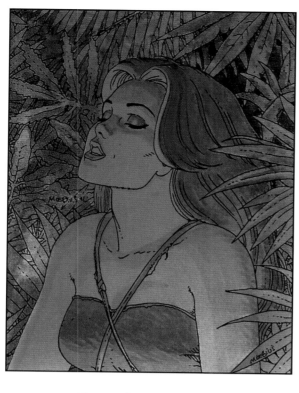

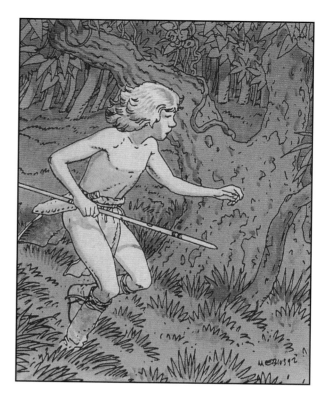

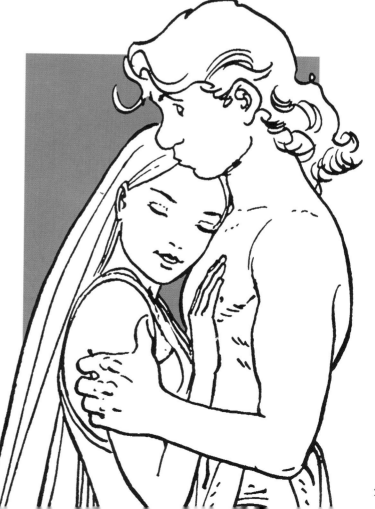

STEL AND ATAN

One wields a genius for repairs; the other, the secret of perception.

Stel:
"If we want to survive, we'll have to rid ourselves of all of our old, paranoid fears!"
"Atana! Where are you, my love?"

Stel is a mutated pilot born several thousand years ago, with an innate gift for physical and psychic repairs. In the course of this story he learns to live on many levels at once, split between the real world and the world of dreams, his consciousness sharpened by his visions. Stranded on the planet Edena with his faithful companion Atan, Stel must face his own history and that of Atan, who turns out to be more than a simple crewmate—but Stel confronts his fears with courage, always electing to move toward the truth. He's the one who takes the initiative to change, convinced that the transformation operating within him will help him find the one he loves: Atana.

Trollopen, ruminating on Atana:
"This woman is fascinating . . . her oneiric quotient is significantly strong! Her dreams can link up to three levels of pseudo-reality!!!"

With a nod to the Botticelli painting *The Birth of Venus*, the nude Atana does indeed resemble a goddess. She is, in fact, a telepath. Realizing her love for Stel once the two are separated, she decides to find him again, just as he decides to find her, despite the obstacles that stand in their way: the Paternum, his Nest, and his Snufflers' incessant attempts to kidnap or kill her. In the process, Atana develops her telepathic powers, and—thanks to Lazlo—she is revealed as the long-awaited goddess prophesied in the Nest's mythic texts. In light of this information, the Snufflers alternate between reverence and fear, ultimately opting for her power to liberate them in their struggle against the tyrannical Paternum.

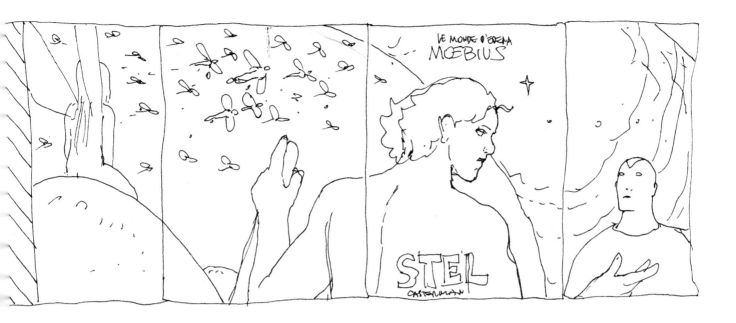

25

BURG

Master Burg to Stel:
"Hello, Stel! Let me tell you, finding you wasn't easy, due to how your shadow field closes space around you. However, you're way more gifted than most. Your luminous cocoon has three left sides, which is quite exceptional."

Master Burg is the creator of the world of Edena. Notably present for Stel and Atana, he is the true conductor of Stel's Dream and the intimate enemy of Trollopen—the Paternum, that is. Burg comes and goes as if by magic, changing his form from moment to moment. His word is written in the Papessa's Book. At the little fairy's warning that Stel is in danger, Burg doesn't hesitate to intervene in his protégé's dream, changing the face of history in the real world—even though passing out of the plane of appearance and entering a mortal's dream might prove fatal, if Burg is cast into the abyss of the Void.

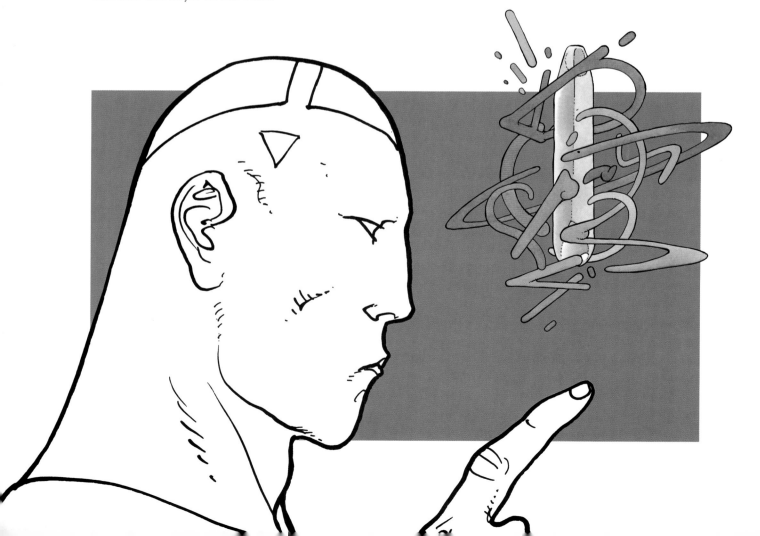

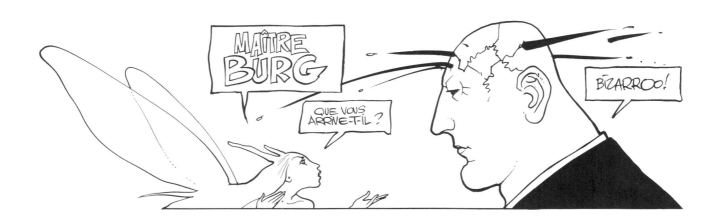

SNUFFLERS
AND THE PATERNUM

The Snufflers:
"Our hearts are exploding with joy to have you here!"

The Paternum:
"I will kill the first one who tries to resist!"

The long-nosed inhabitants of the Nest come from the same human genetic strain as both Stel and Atan—but unlike these two, Snufflers haven't had the chance to really see the paradise on earth in which they live.

Dominated by an authoritarian dictator, Snufflers live in fear of their bodies and their emotions, forced to wear uniform outfits depriving them of their senses of smell and taste. Nature is but a myth to them. The highly structured, geometric character of their environment was designed by Jean Giraud to reflect their hidebound spirit as prisoners of the Paternum.

A former human alienated from his own body and from nature in general, Trollopen was once Stel and Atan's friend. As the egotistical Paternum, ruler of the Snufflers, he's become stark raving mad: ready to backstab, beguile, and even butcher anyone who gets in the way of his vision for a perfect society.

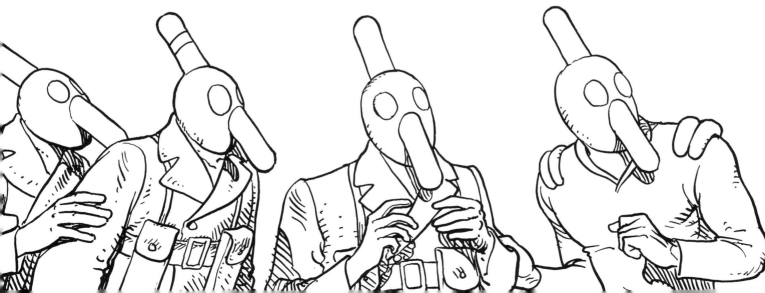

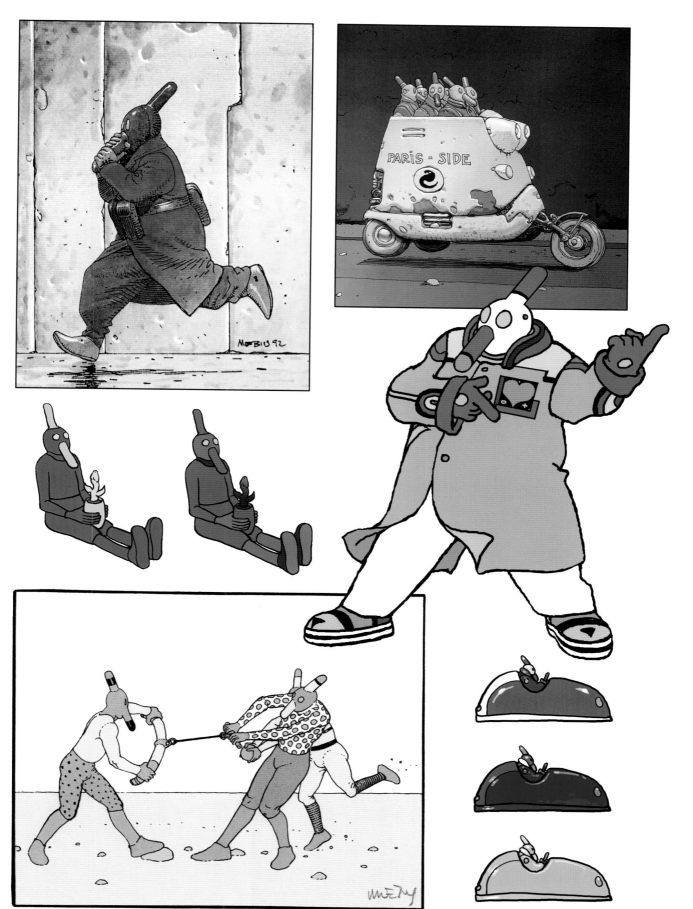

PARIS - SIDE

MŒBIUS 92

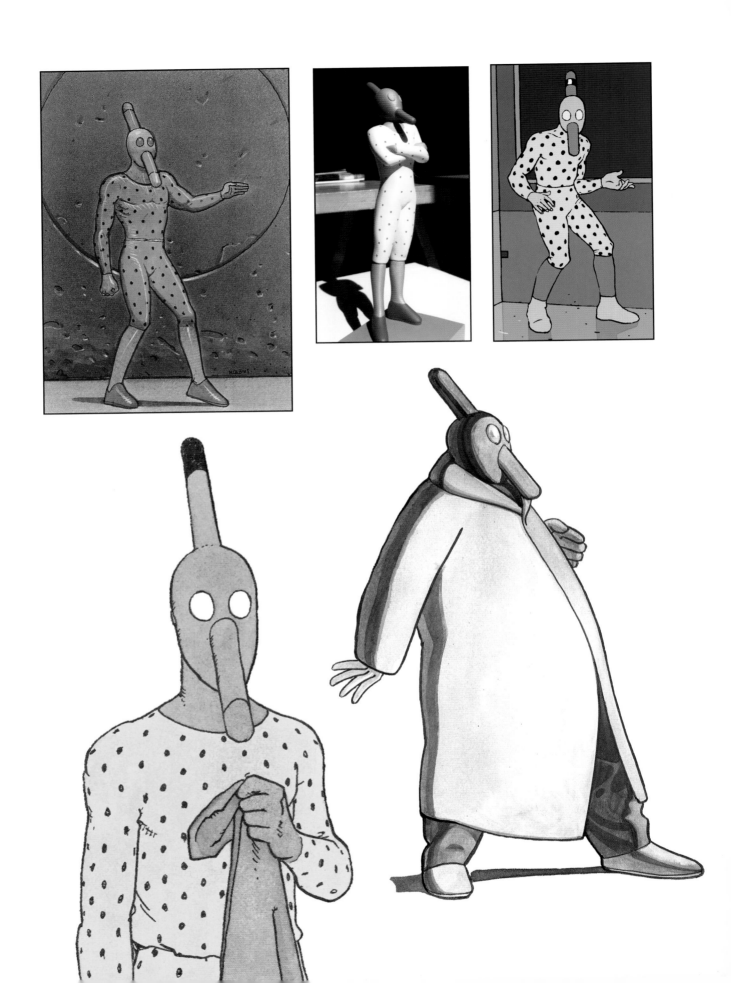

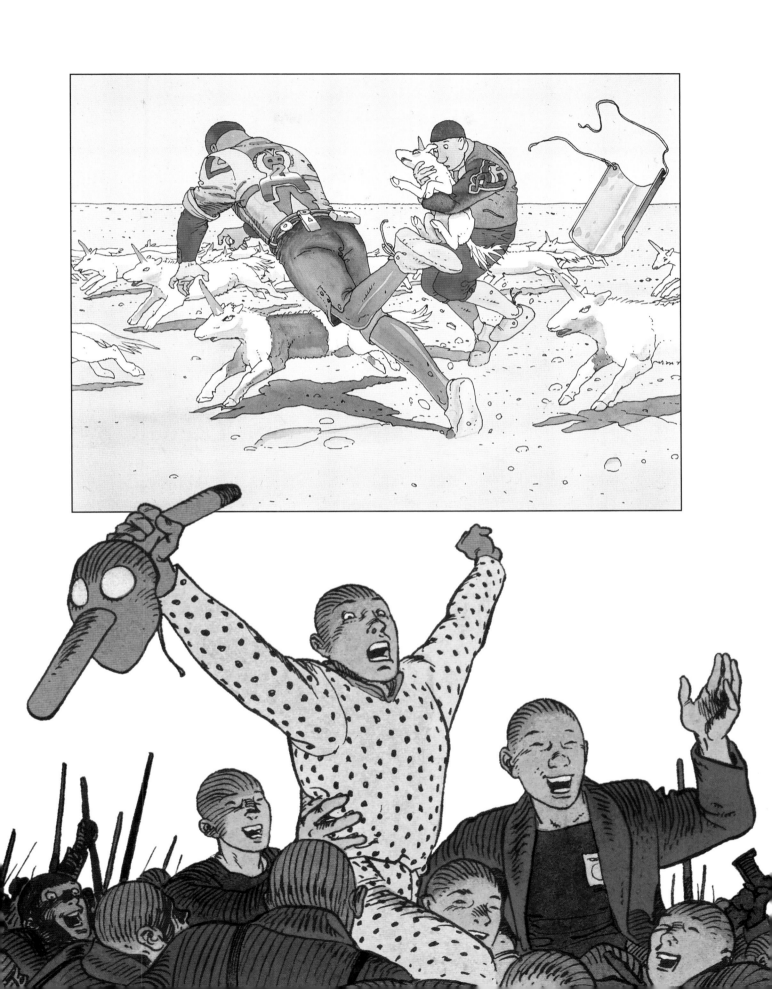

THE FAIRIES OF EDENA

Master Burg:
"A simple Elemental . . . an Edelf! These small crea-
tures come and go as they please on Edena. They live
in the Interplane . . ."

Like Stel, Edena's Elementals come from the stars.
These countless Edelves teach dreamers the "true
vision." They belong to the nonmaterial world,
and at night they populate our dreams.

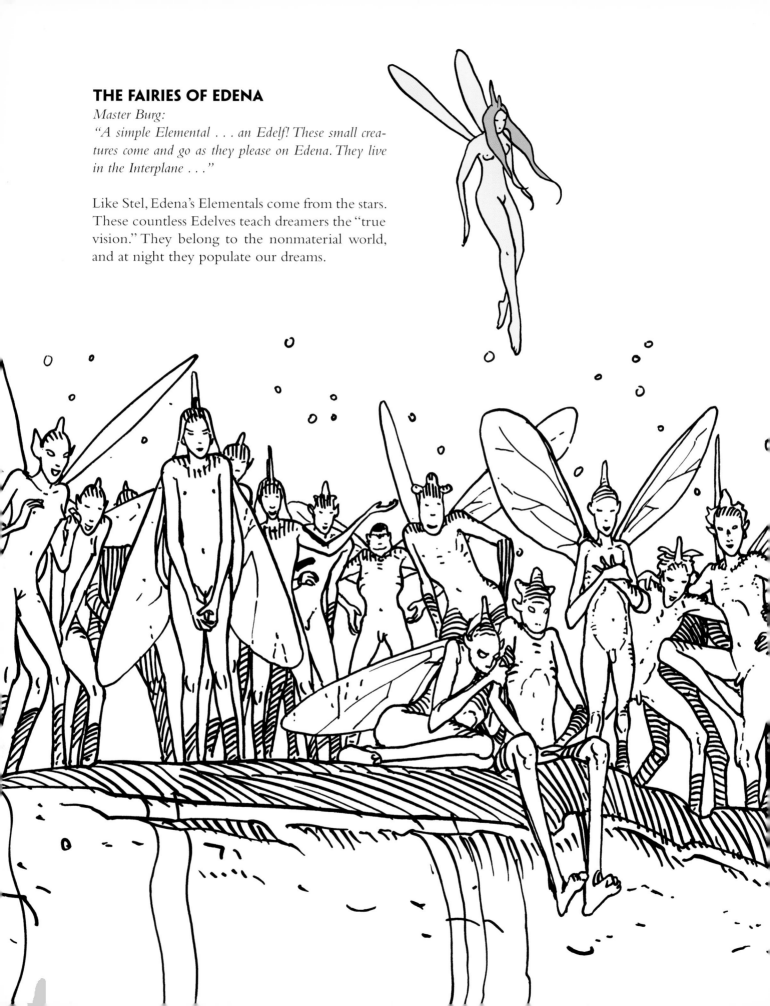

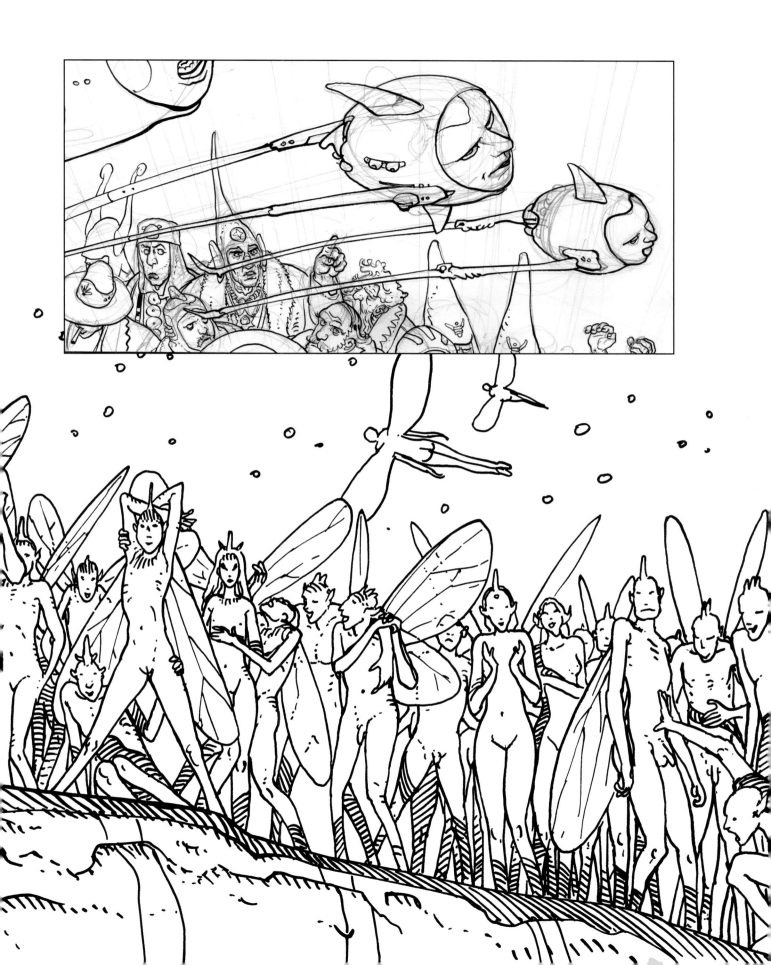

CHAPTER 1
REPAIRS

Jean Giraud (1986):
"I wanted to do a story connecting me with the world of robots and the world of mechanics, guys who are themselves in touch with engines . . . I think that cars are a particular type of robot: they're like envelopes that contain us. And people who are responsible for the care of our personal envelopes are in a very special position in relation to us: this gives them a great deal of power."

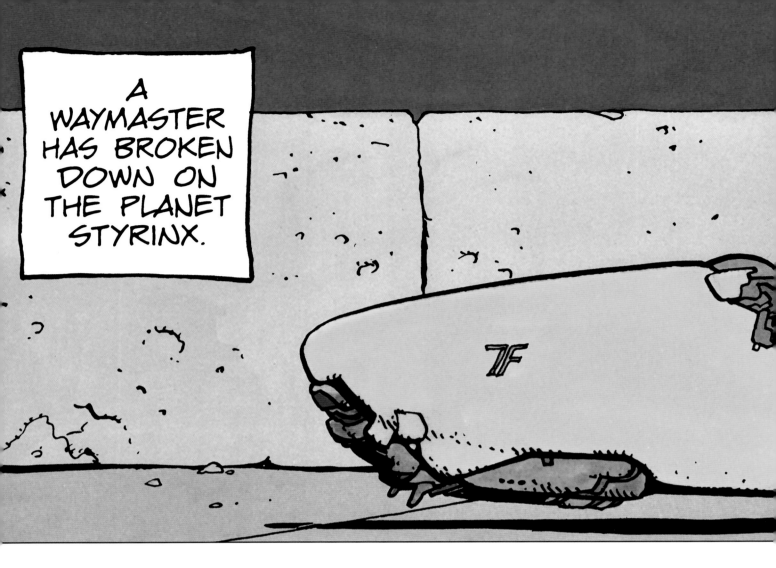

A WAYMASTER HAS BROKEN DOWN ON THE PLANET STYRINX.

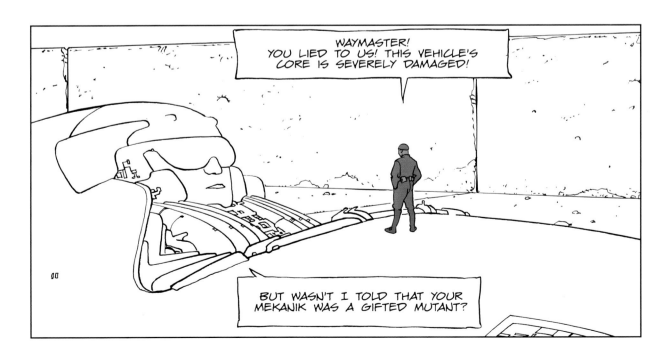

WAYMASTER!
YOU LIED TO US! THIS VEHICLE'S CORE IS SEVERELY DAMAGED!

BUT WASN'T I TOLD THAT YOUR MEKANIK WAS A GIFTED MUTANT?

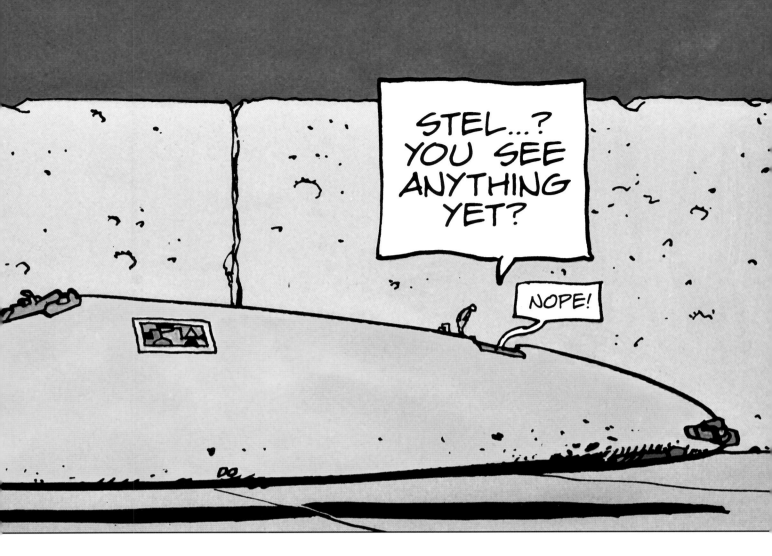

A Waymaster breaks down on the planet Styrinx: R4⁶⁷SE.09. His black core isn't radiating the way it should, and it requires the kind of psykik repair that only a pure heart can offer. Accompanied by his faithful crewmate Atan, the brilliant Stel easily diagnoses the problem; as a mutated mekanik, he is gifted with an innate intuition for repairs. Returning to the past, he heals a long-ago memory of a broken toy, a precious submarine that once belonged to the young Stel.

His knowledge of repairs extending even to the pain of buried memories, Stel brings the object of his childhood play and desires back to the surface, thus allowing the Waymaster to resume his journey: endlessly driving across the incredible network of roads covering the planet.

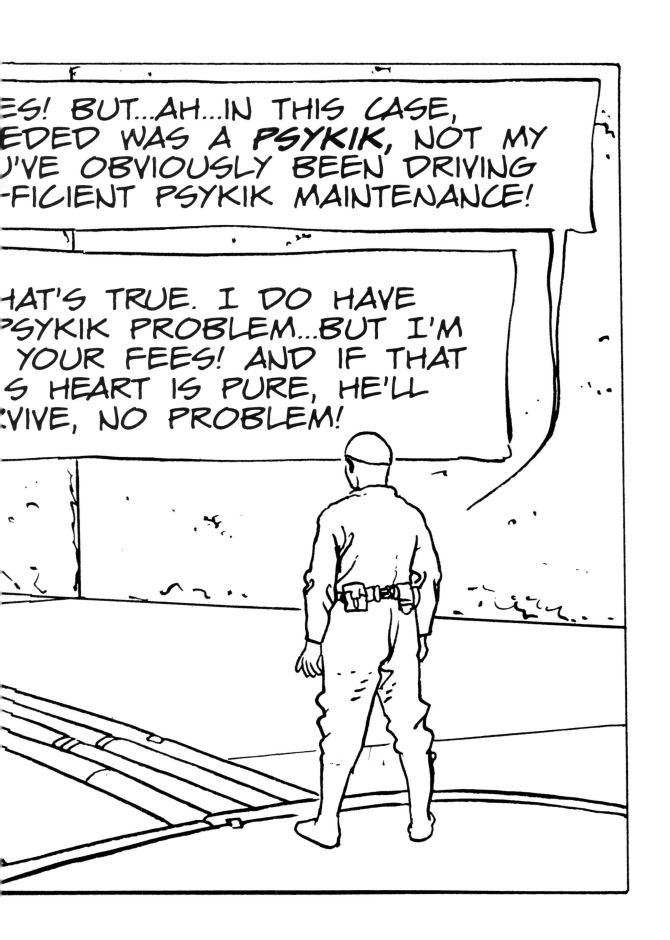

ES! BUT...AH...IN THIS CASE,
EDED WAS A **PSYKIK,** NOT MY
J'VE OBVIOUSLY BEEN DRIVING
-FICIENT PSYKIK MAINTENANCE!

HAT'S TRUE. I DO HAVE
PSYKIK PROBLEM...BUT I'M
YOUR FEES! AND IF THAT
S HEART IS PURE, HE'LL
VIVE, NO PROBLEM!

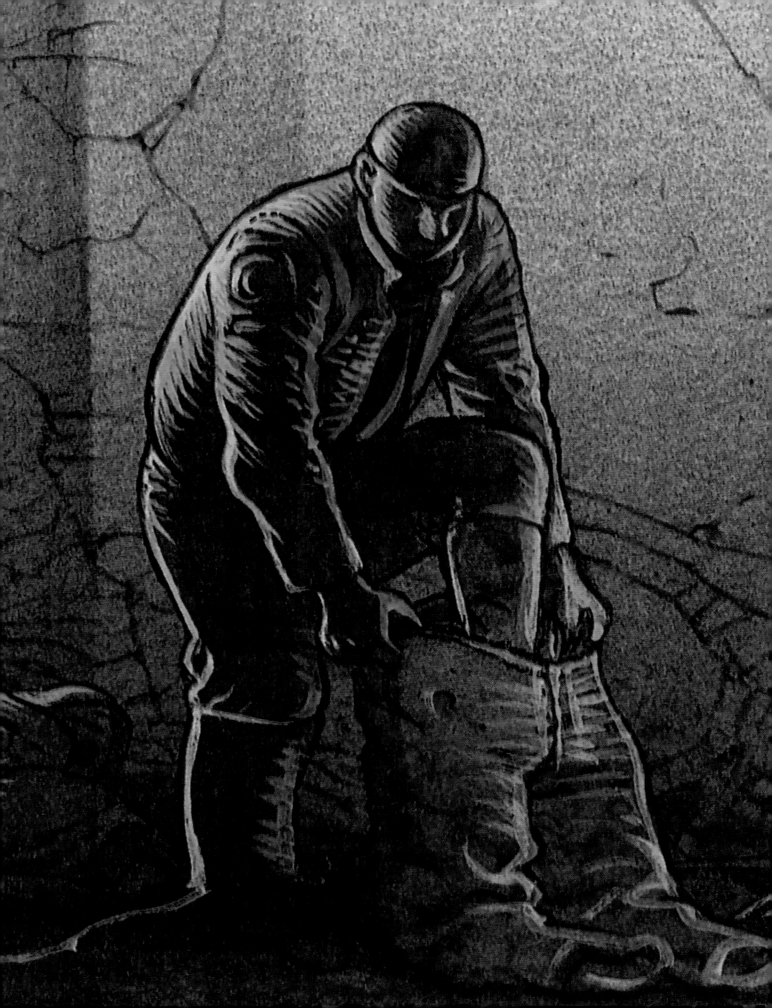

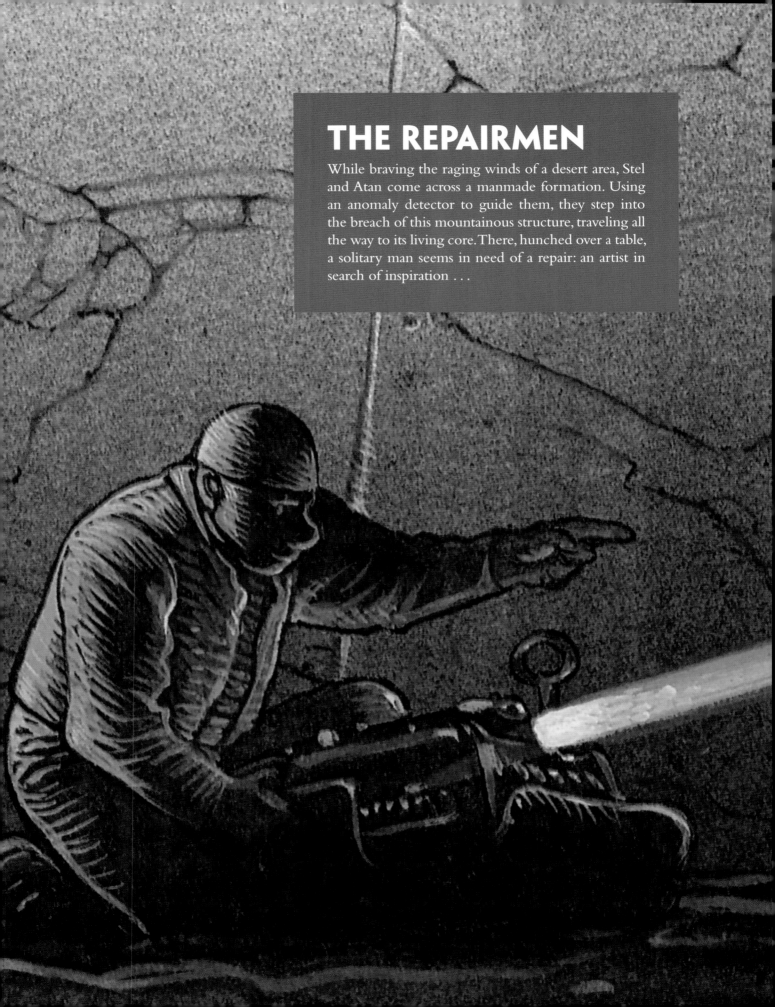

THE REPAIRMEN

While braving the raging winds of a desert area, Stel and Atan come across a manmade formation. Using an anomaly detector to guide them, they step into the breach of this mountainous structure, traveling all the way to its living core. There, hunched over a table, a solitary man seems in need of a repair: an artist in search of inspiration . . .

THE REPAIRMEN

Colors by
MOEBIUS

THE REPAIRMEN

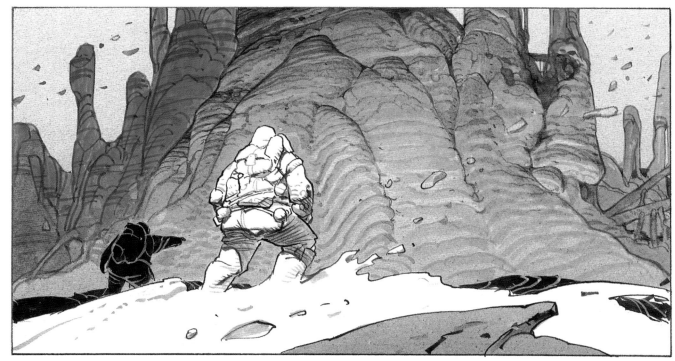

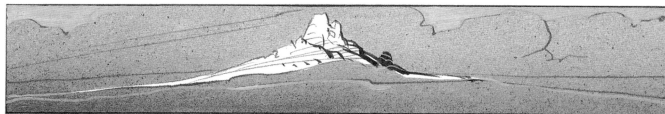

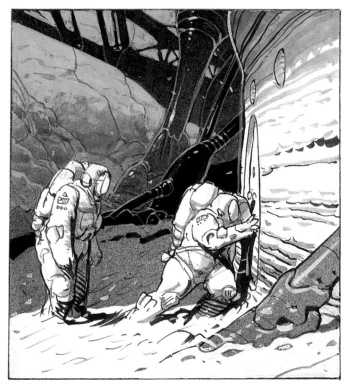

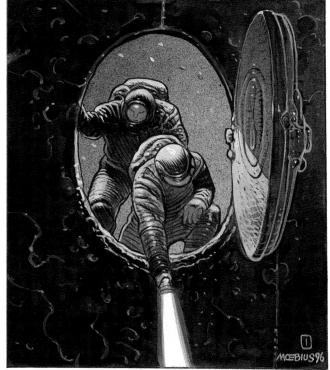

44

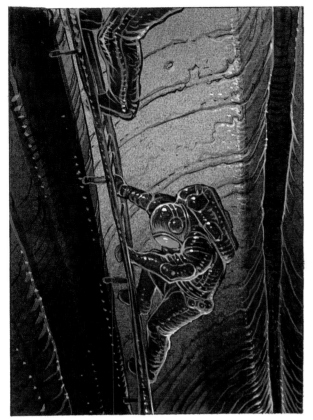

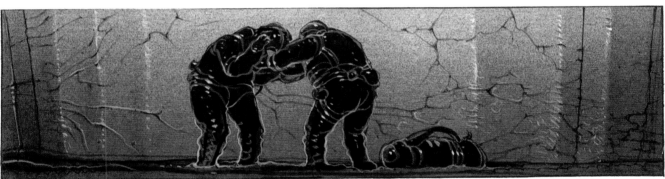
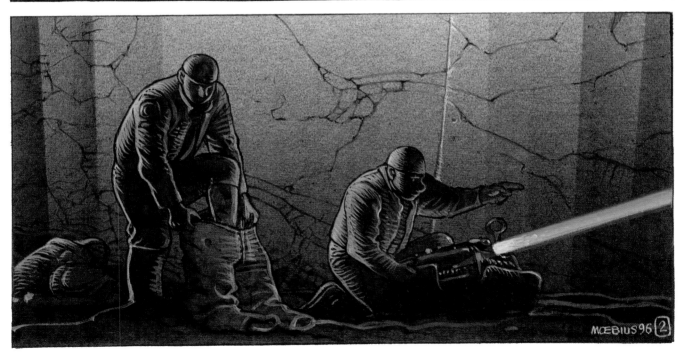

MŒBIUS 96 2

45

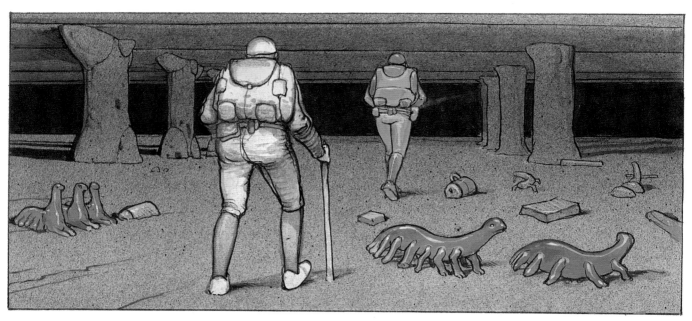

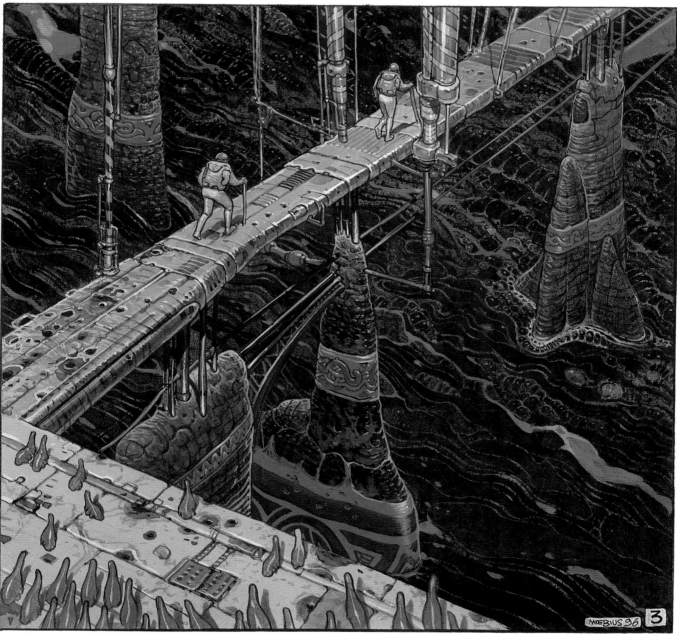

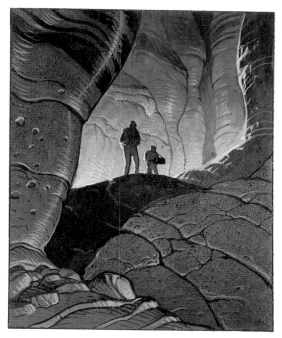
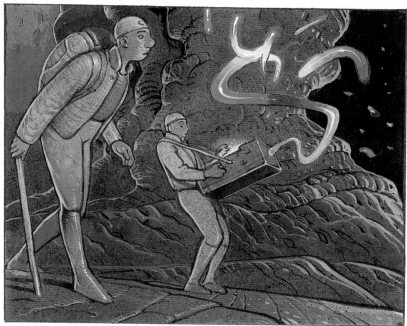
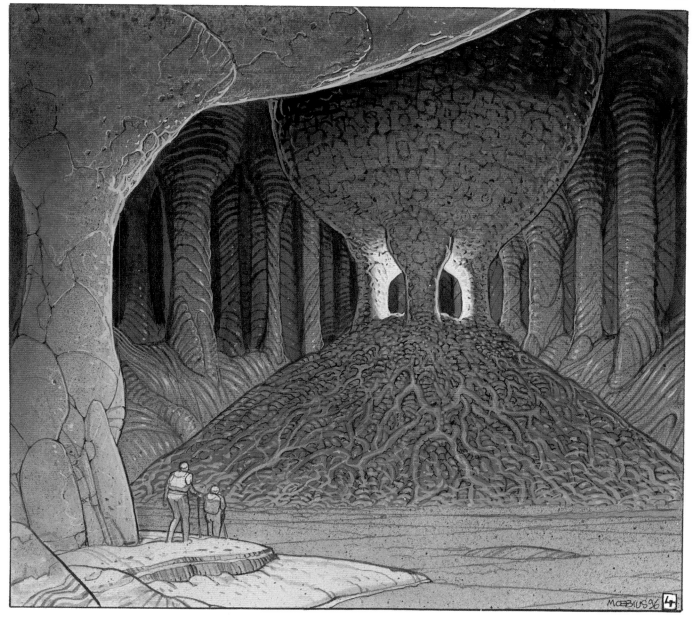

MOEBIUS 96

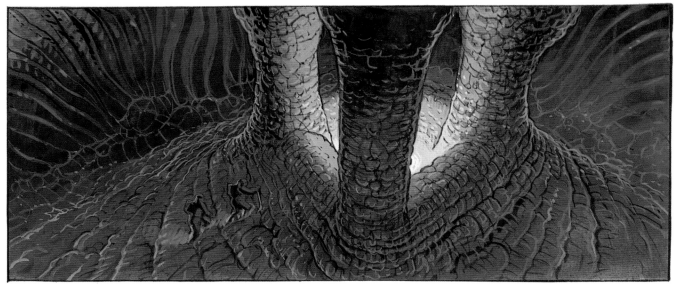

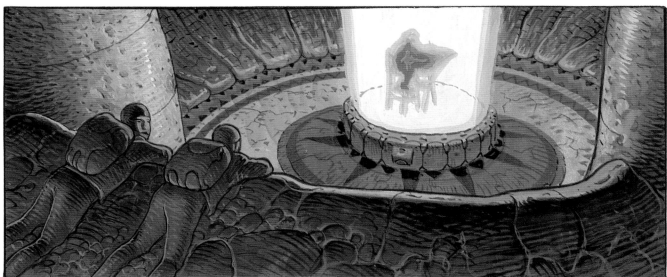

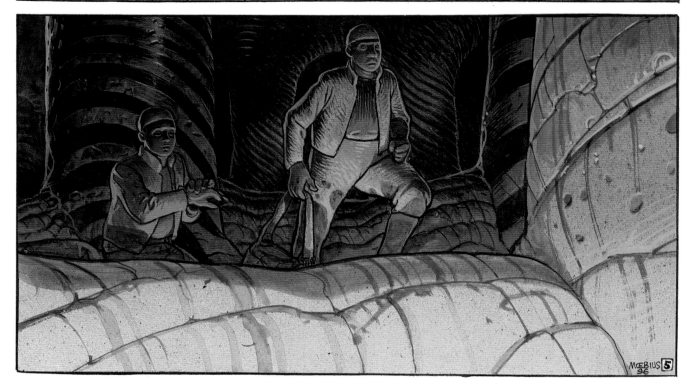

48

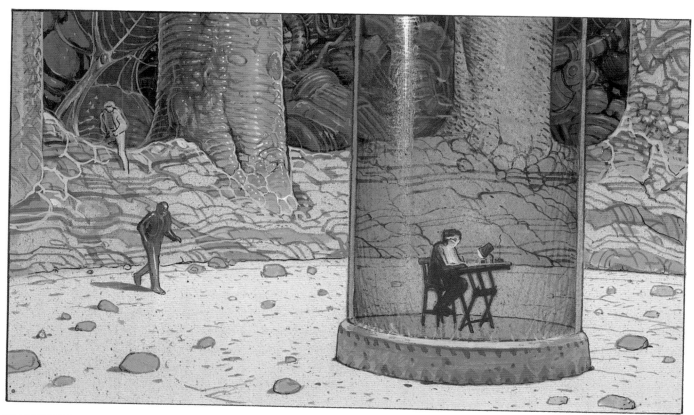

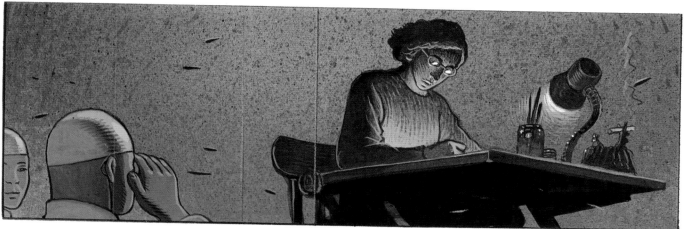

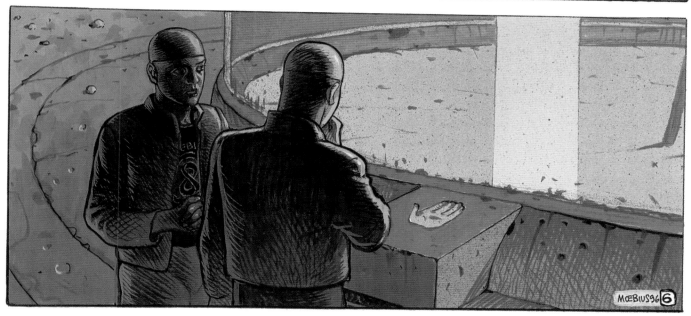

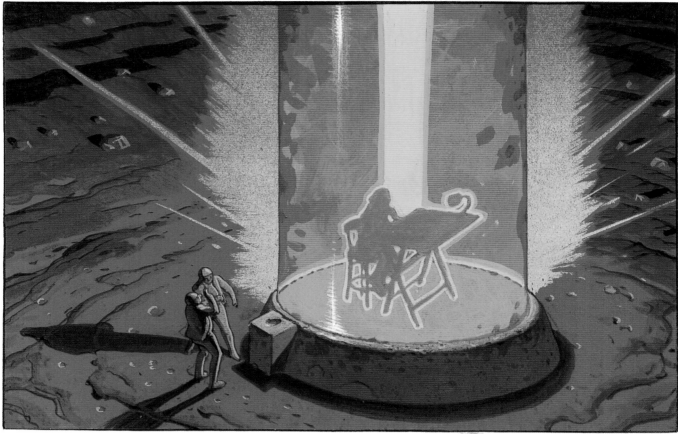

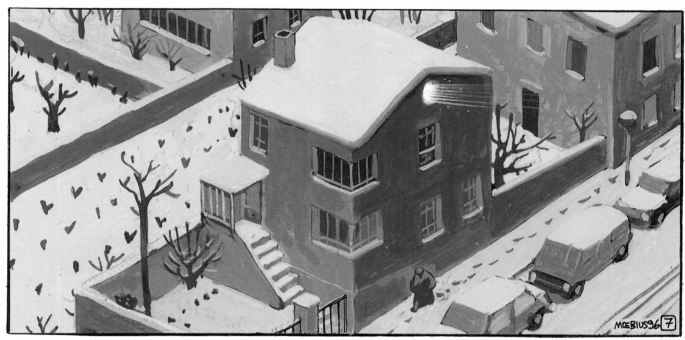

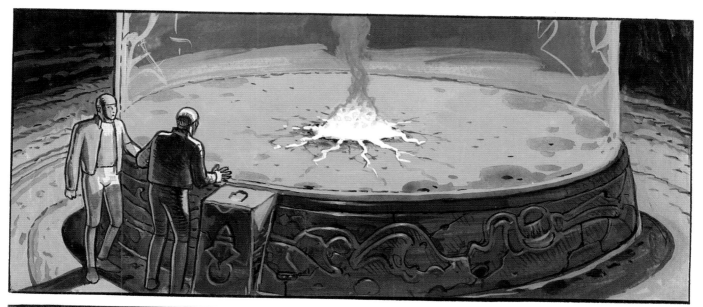

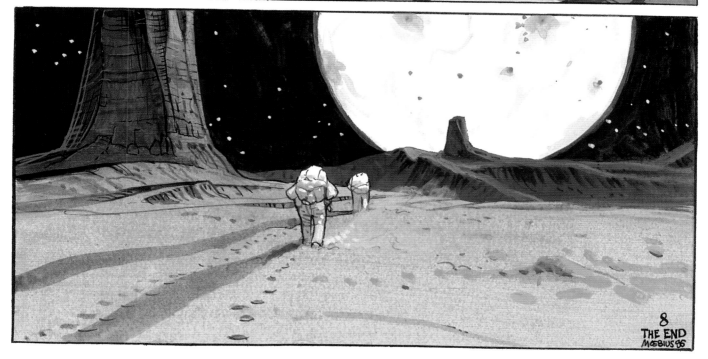

8
THE END
MŒBIUS 86

CHAPTER 2
DEVIATION

Jean Giraud (2010):
"My primary jumping-off point was 1960s science fiction and its prevailing theories on time: all revolving around the idea that time can be subdivided into different possible streams, that each moment in time creates a proliferation of possibilities. These timestreams may run dry or they may continue, though they all take place simultaneously . . . But I always saw this in a very literary, dreamlike light: as if, by dreaming, we might be able to enter tangential zones between those different times and different spaces."

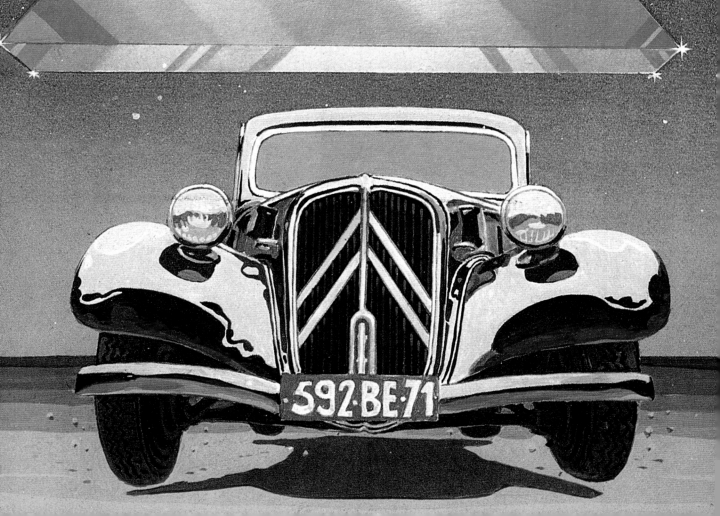

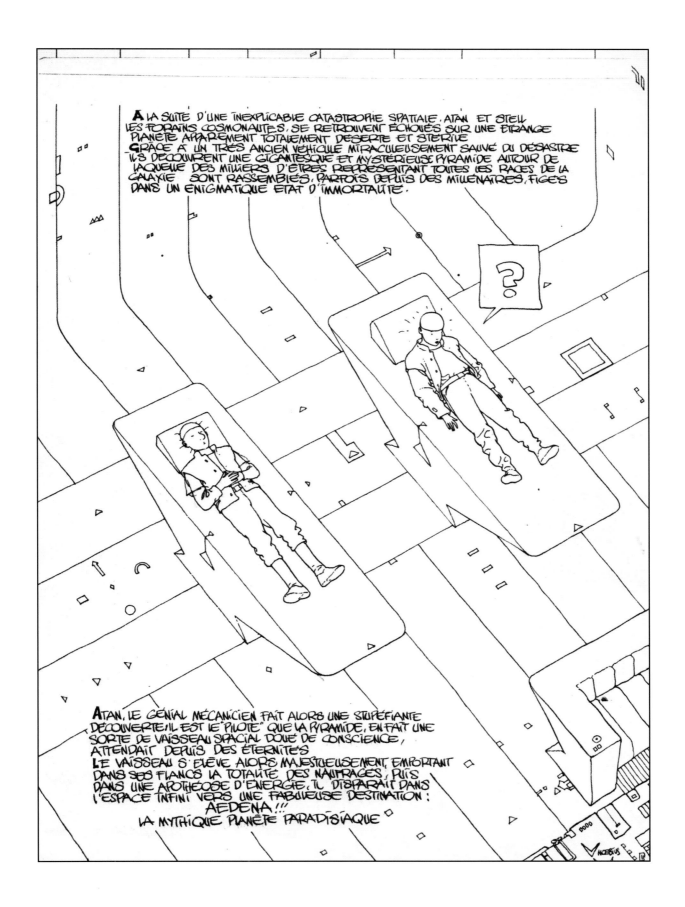

TOP!

ET ÇA ROULE?

SI ÇA ROULE !?... CECI EST UNE VOITURE À ESSENCE CITROËN TRACTION-AVANT, 15CV, SIX CYLINDRES FABRIQUÉE PAR UN PAYS DE LA TERRE EN 1938 DE L'ANCIENNE ÈRE... C'EST UN BIJOU QUI NOUS EMMÈNERA AU BOUT DU MONDE !...

DIS DONC... IL Y A DES RATIONS POUR UN MOIS ...BON ON A LES ARMES... LES DUVETS...

J'EMMÈNE AUSSI UN PEU DE LECTURE

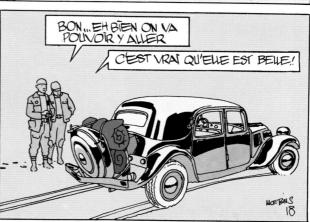

BON... EH BIEN ON VA POUVOIR Y ALLER

C'EST VRAI QU'ELLE EST BELLE!

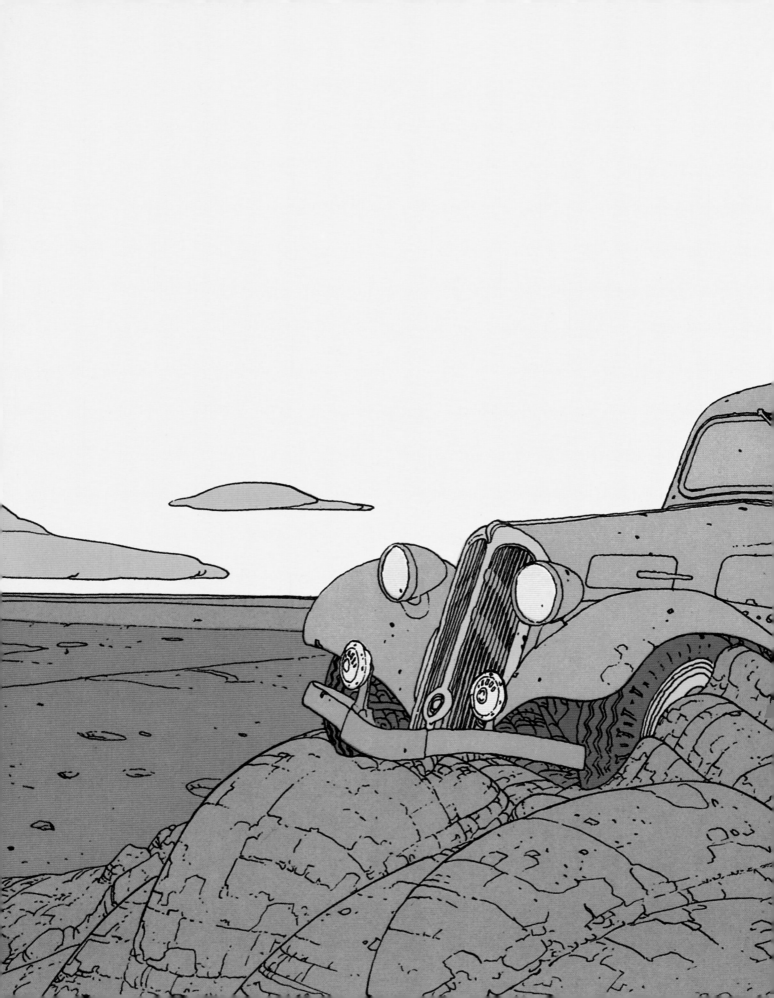

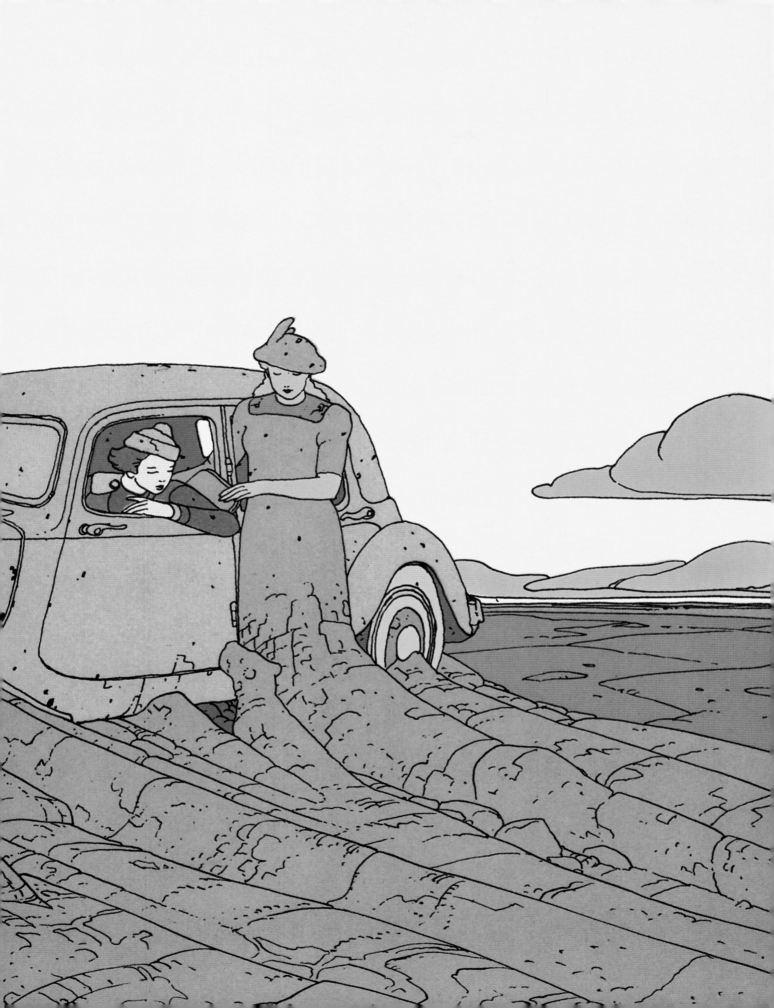

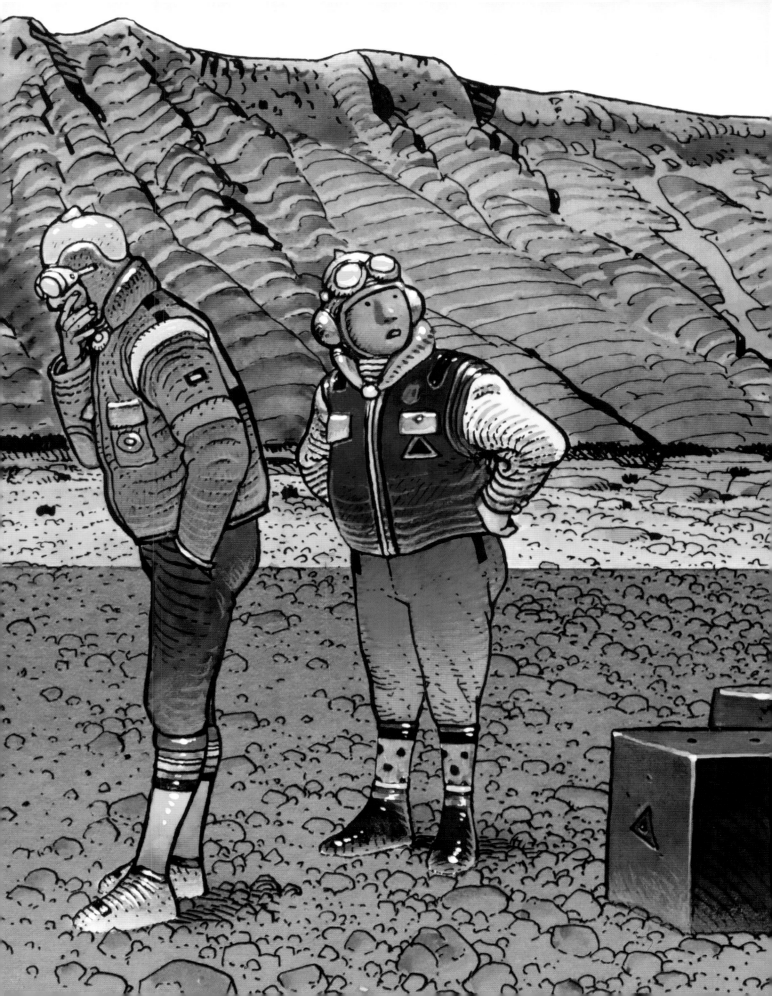

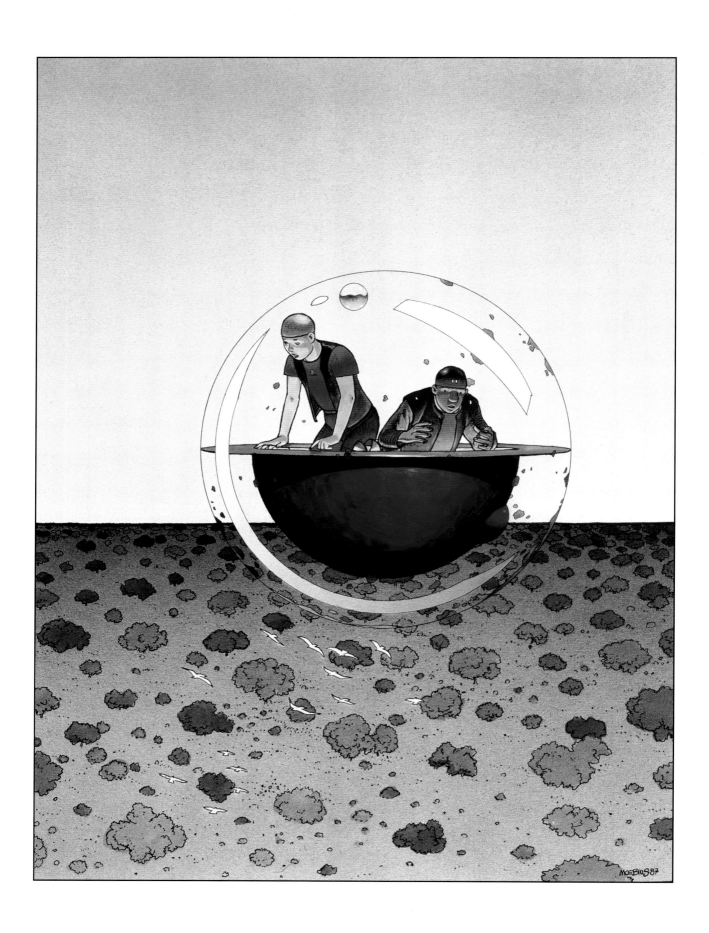

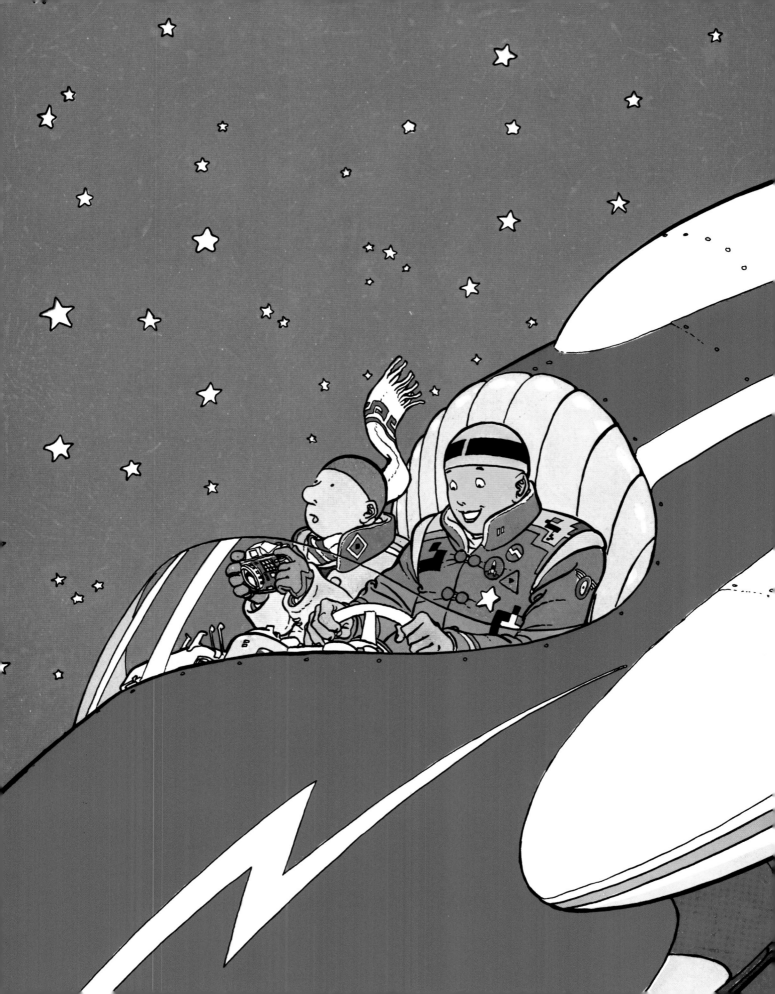

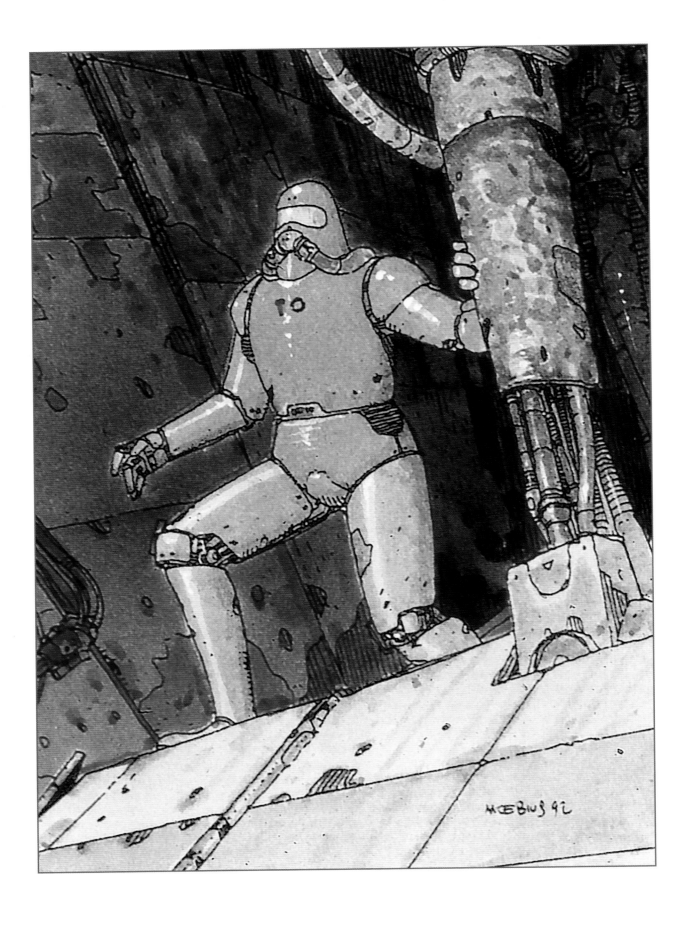

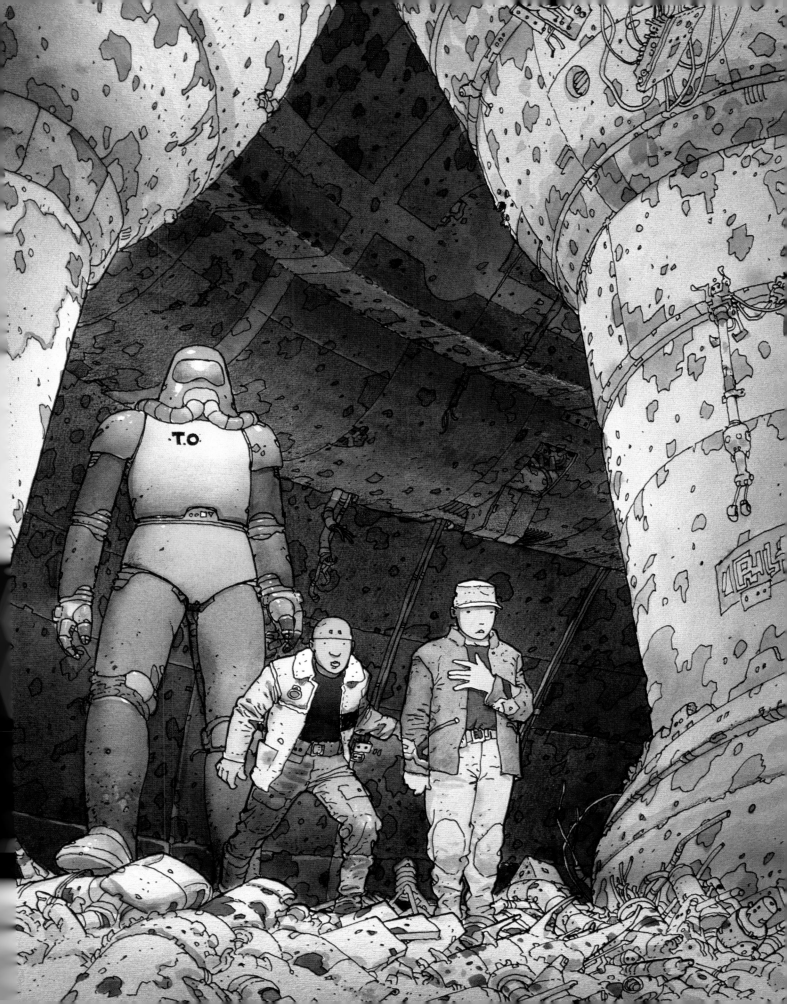

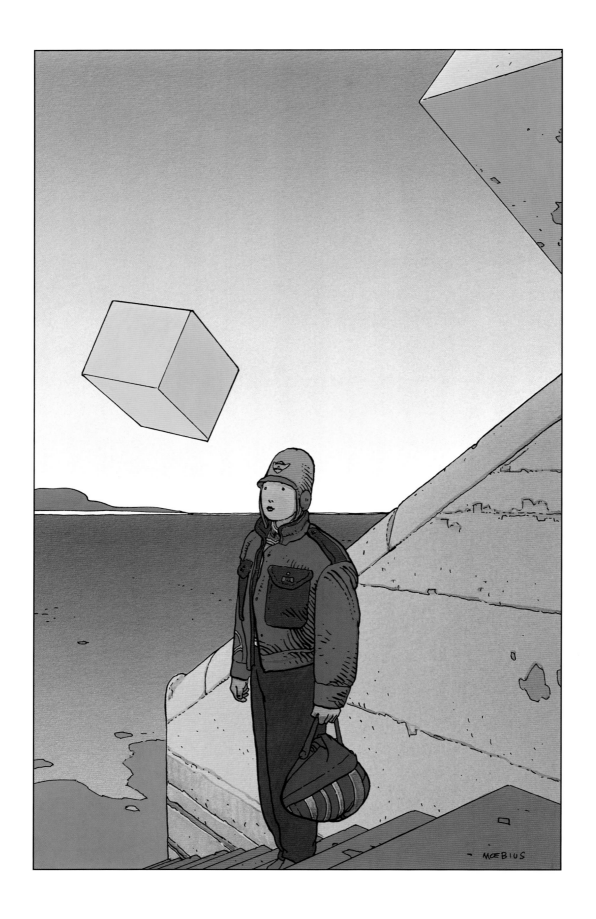

FINDING ONE'S WAY

Jean Giraud (1989):

"I'd often stare at things and draw out their meaning. For example, if I were staring at a tree, at some point it stopped being a tree and became only the meaning of a tree."

Master Burg:

"Deserted does not mean empty . . . You must move forward and advance. Feel your way . . . it is like exploring a new machine."

The world of Edena teems with a thousand signs of the Invisible. Vegetation, rocks, and crystals are *not* as we see them. They are inhabited, delivering messages to us like so many signposts on the road to knowledge . . .

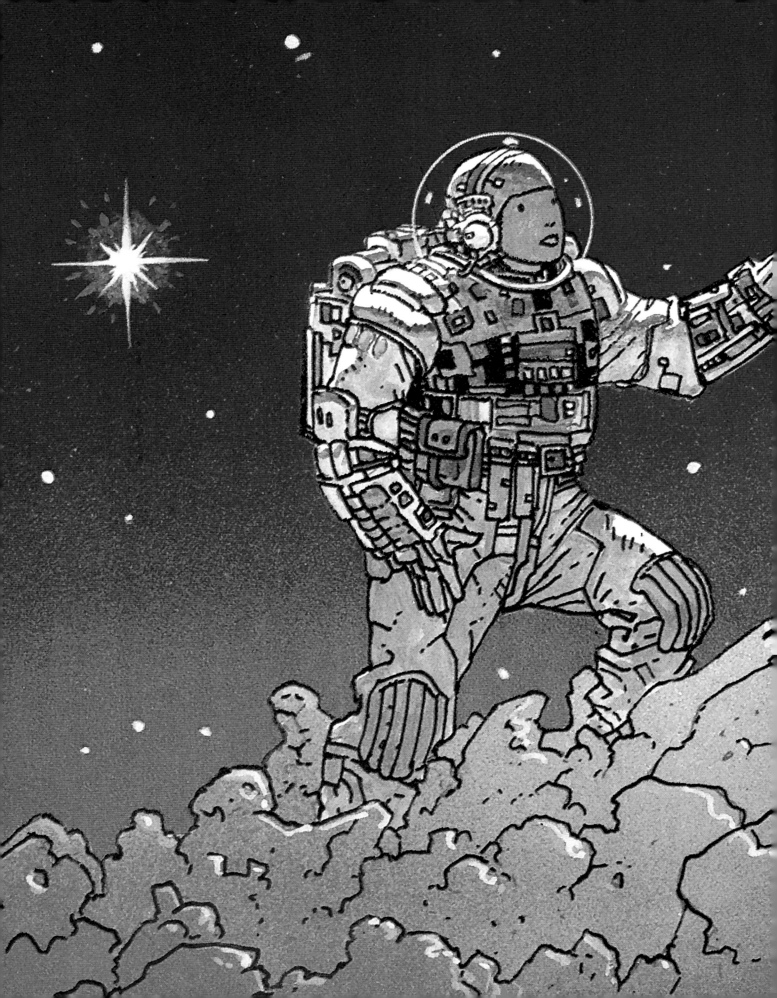

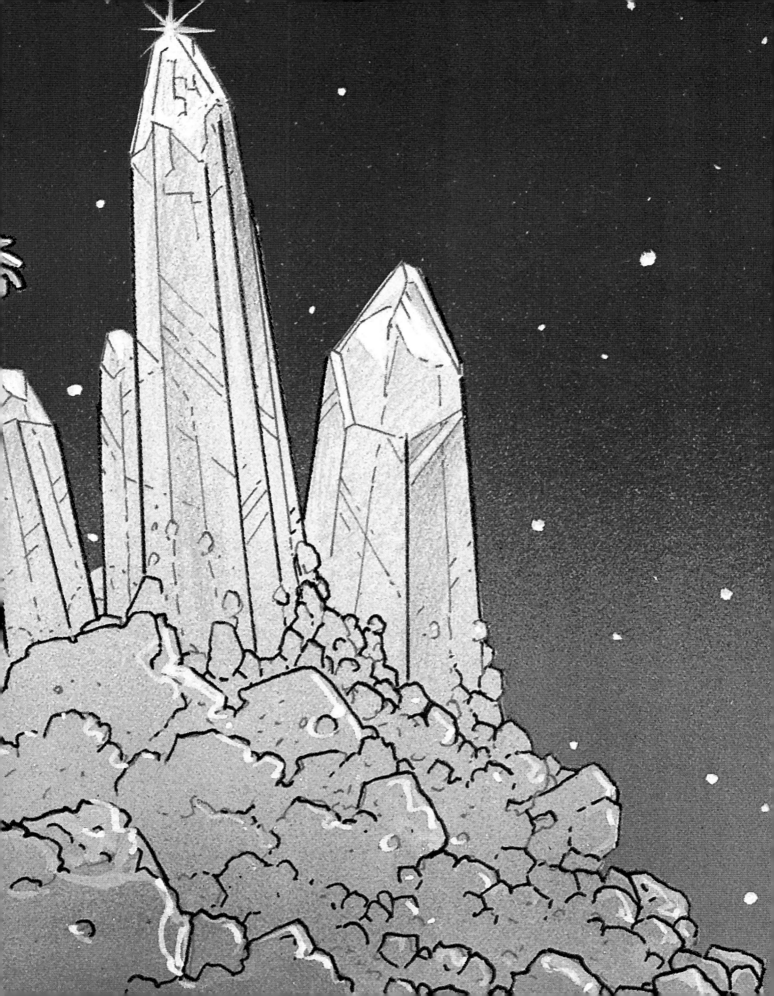

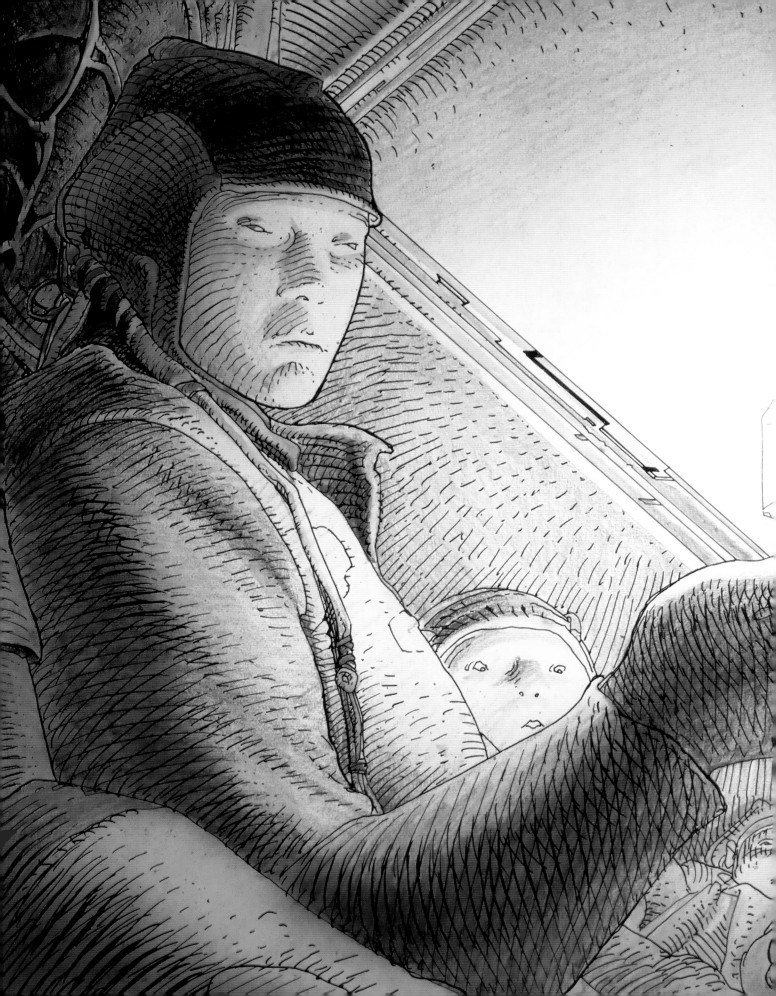

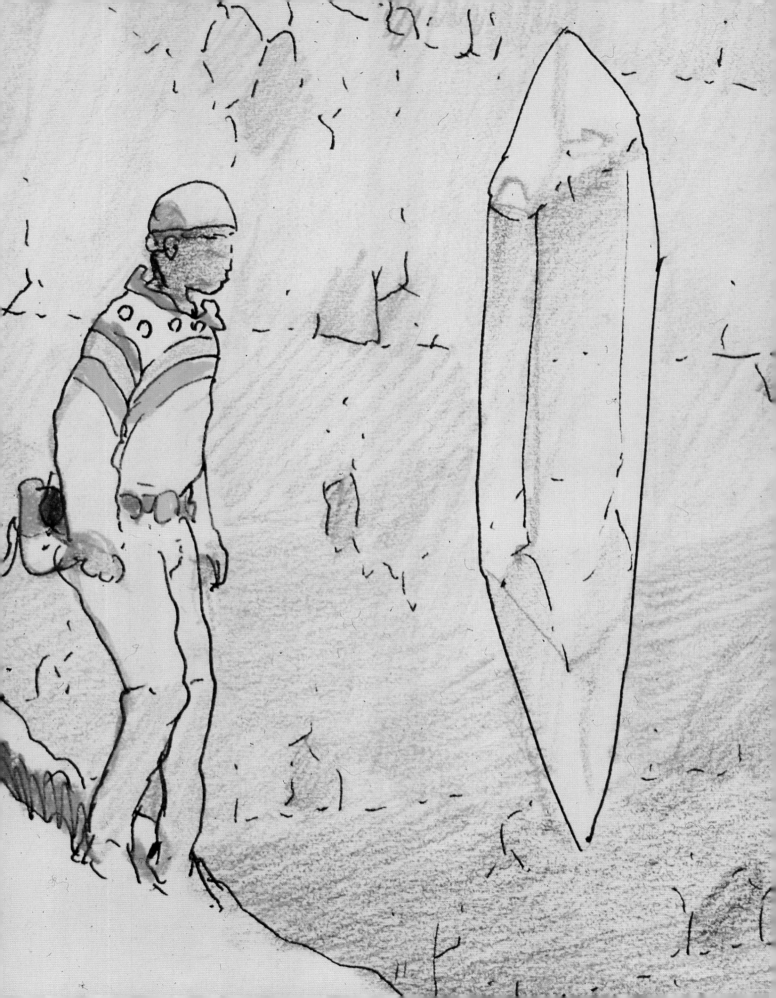

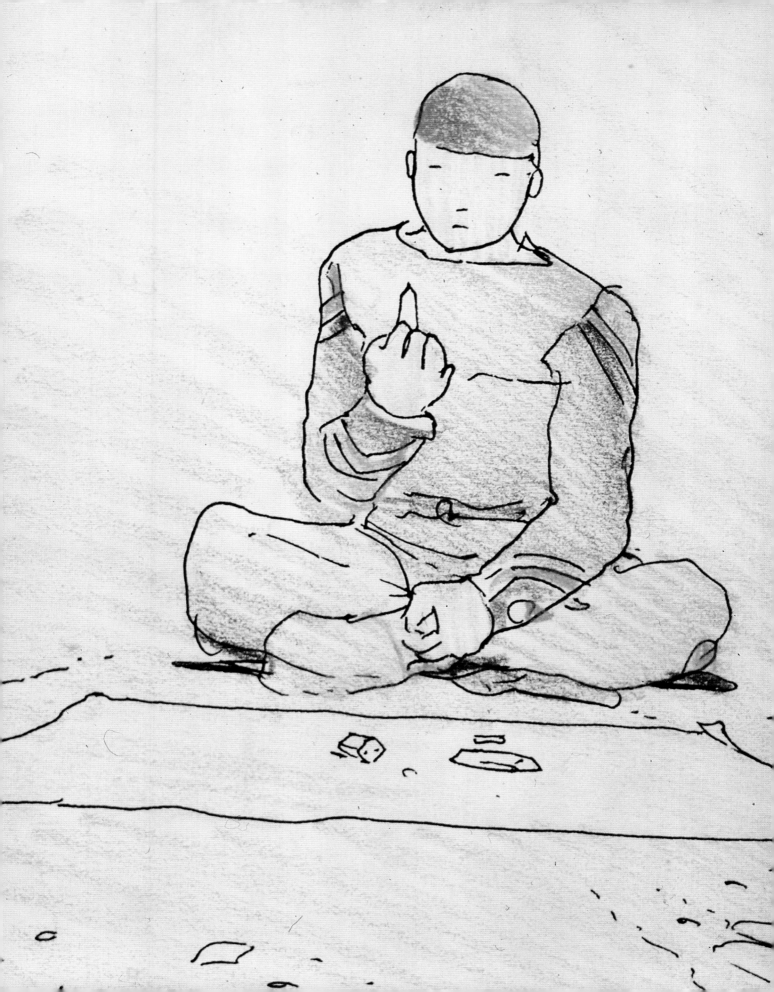

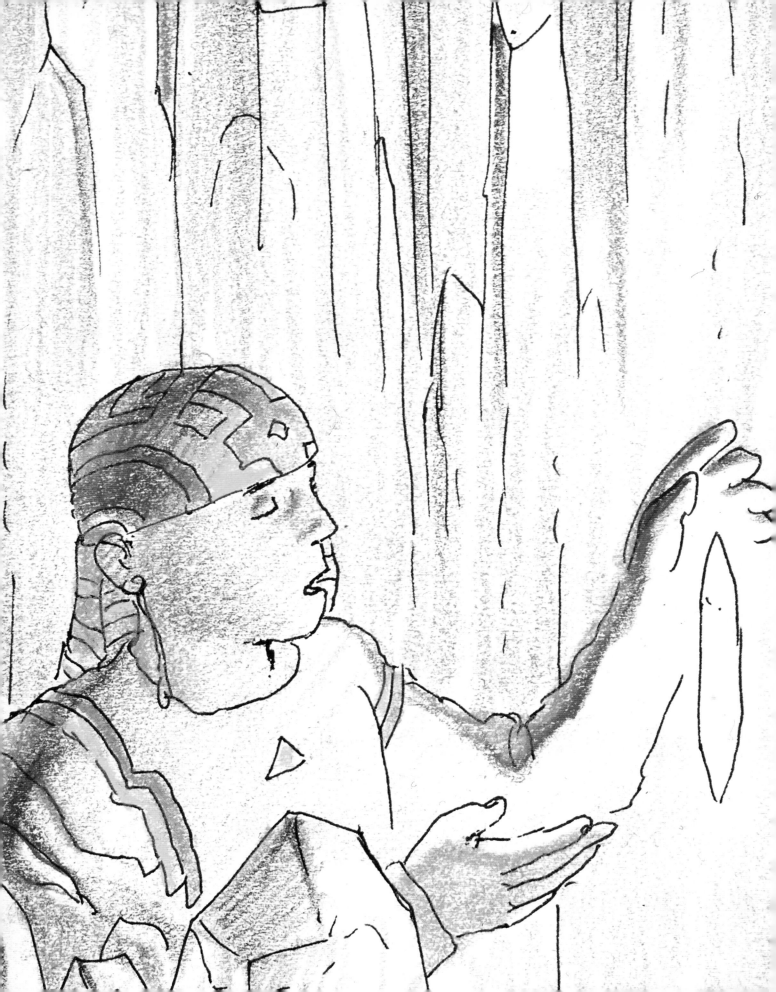

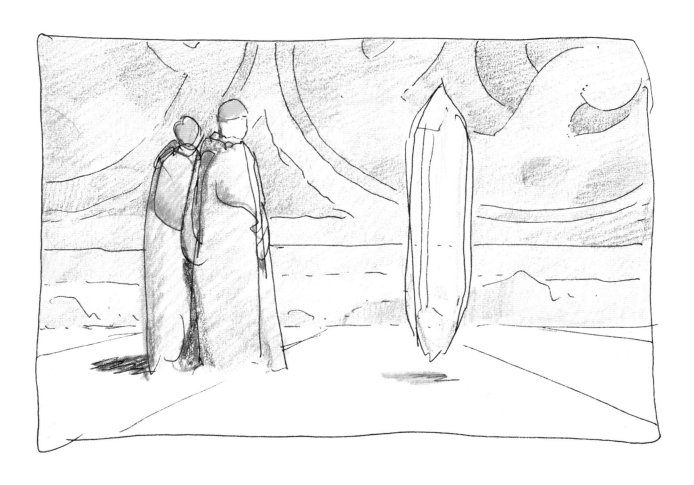

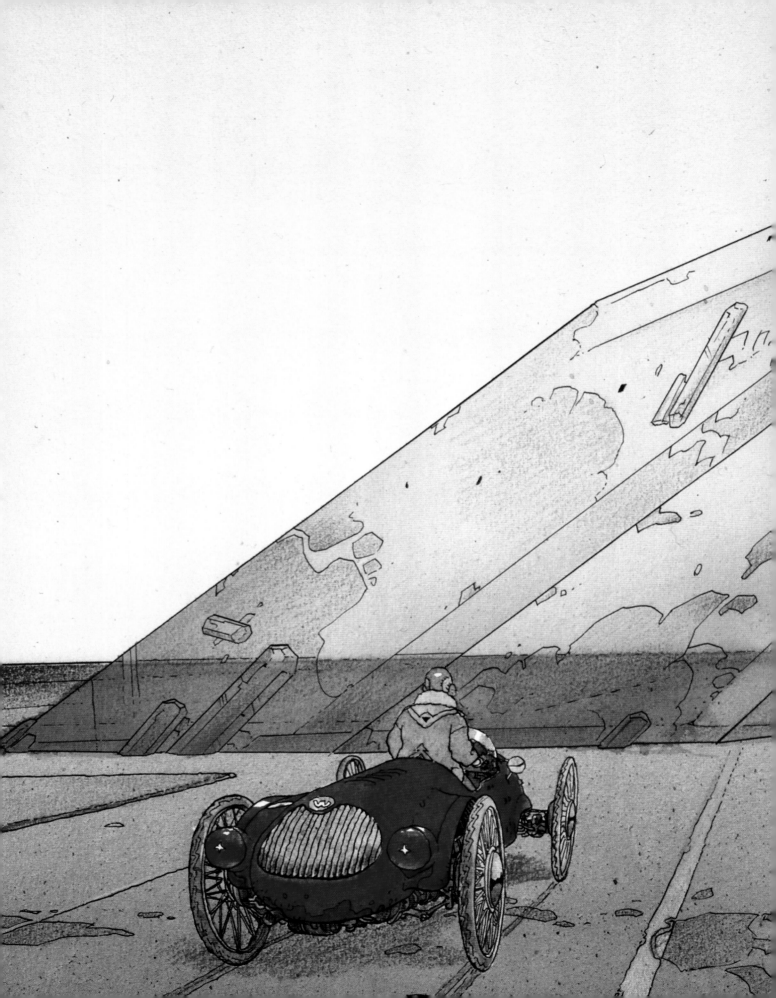

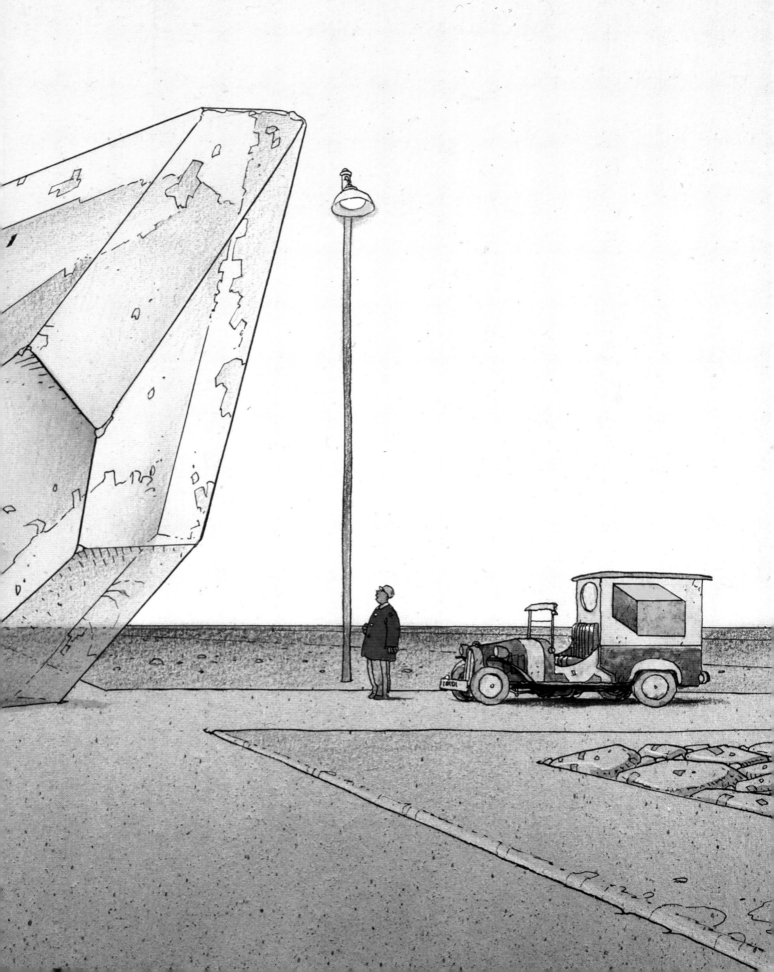

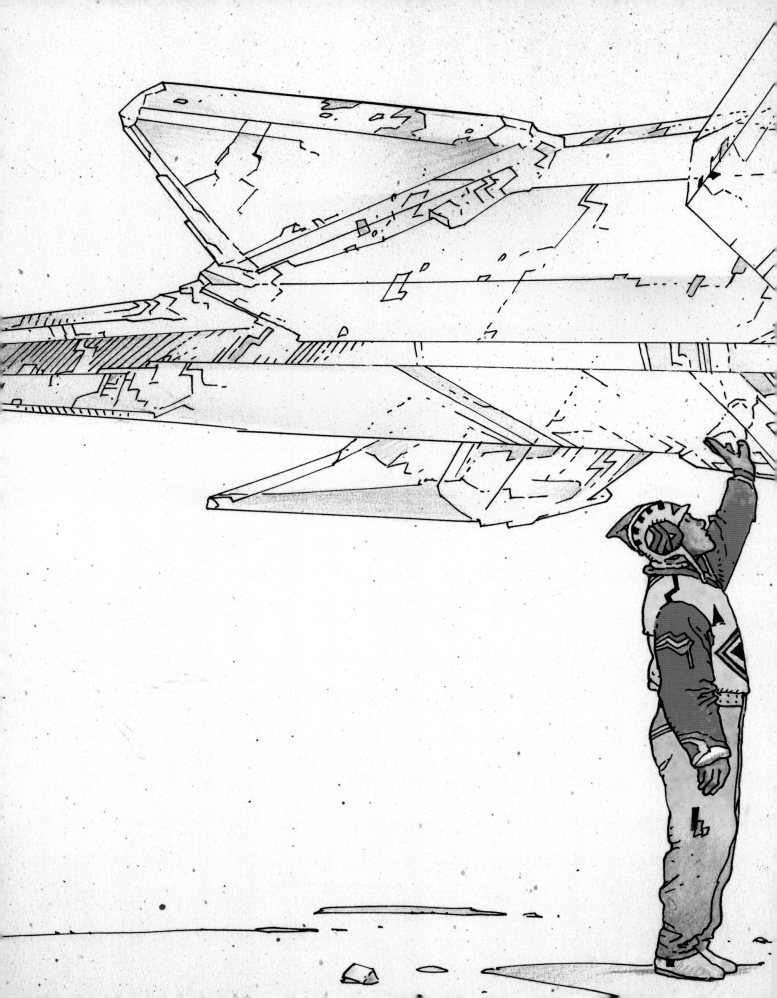

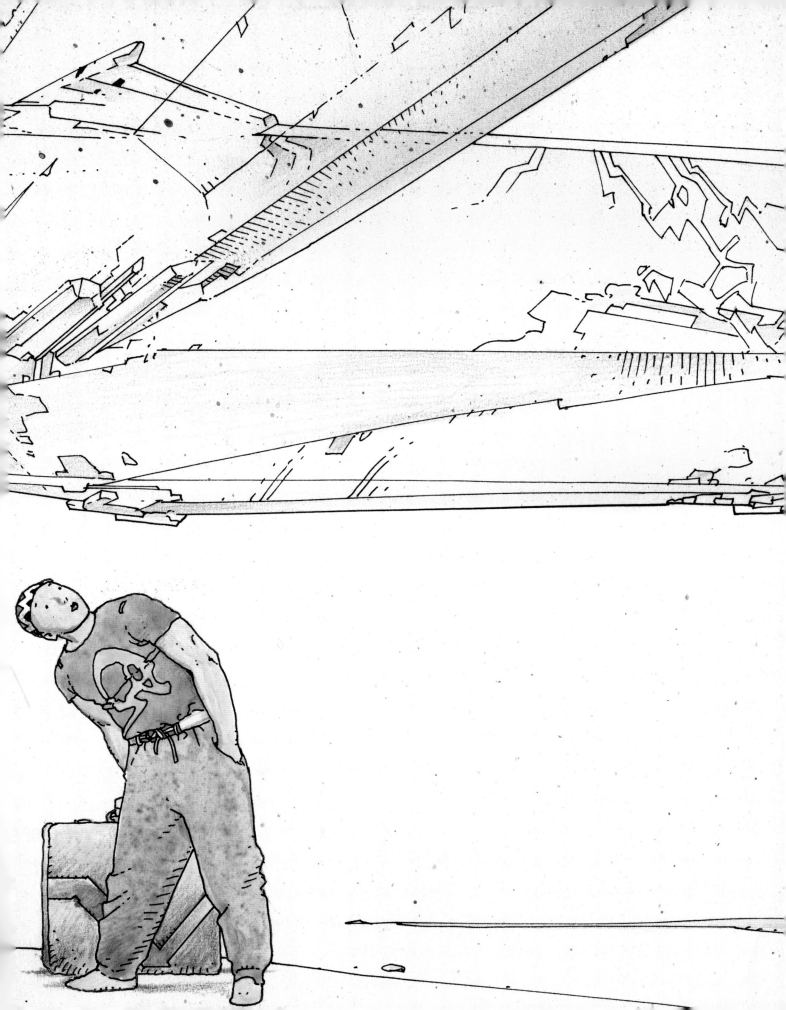

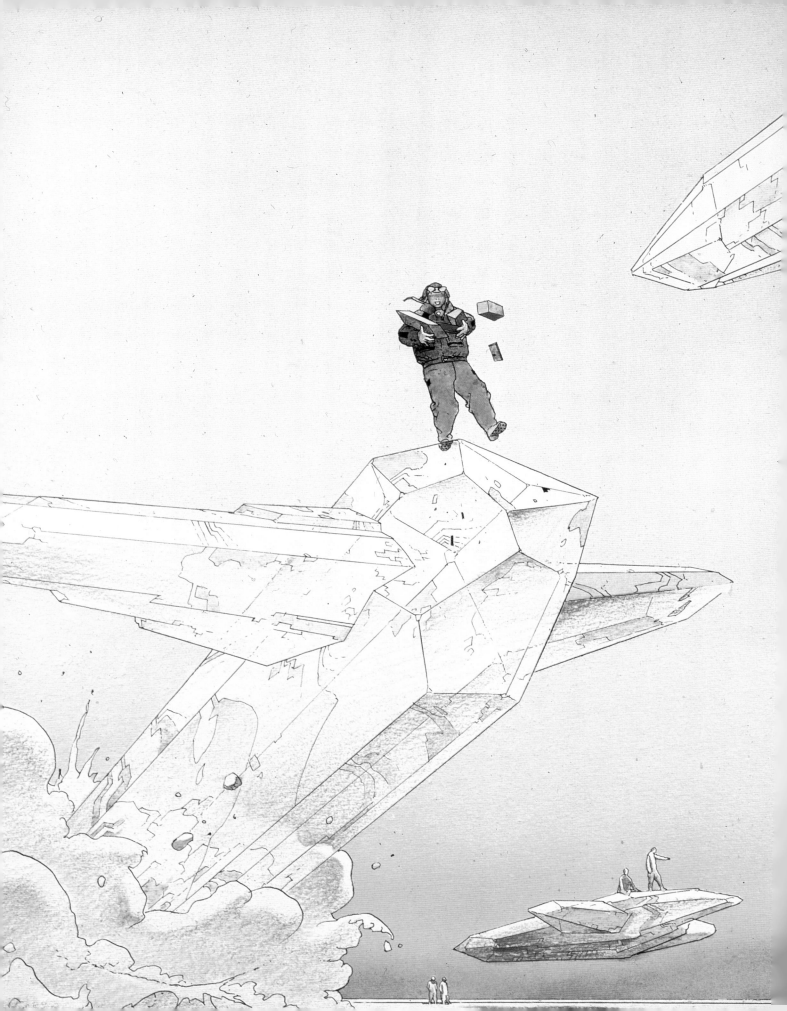

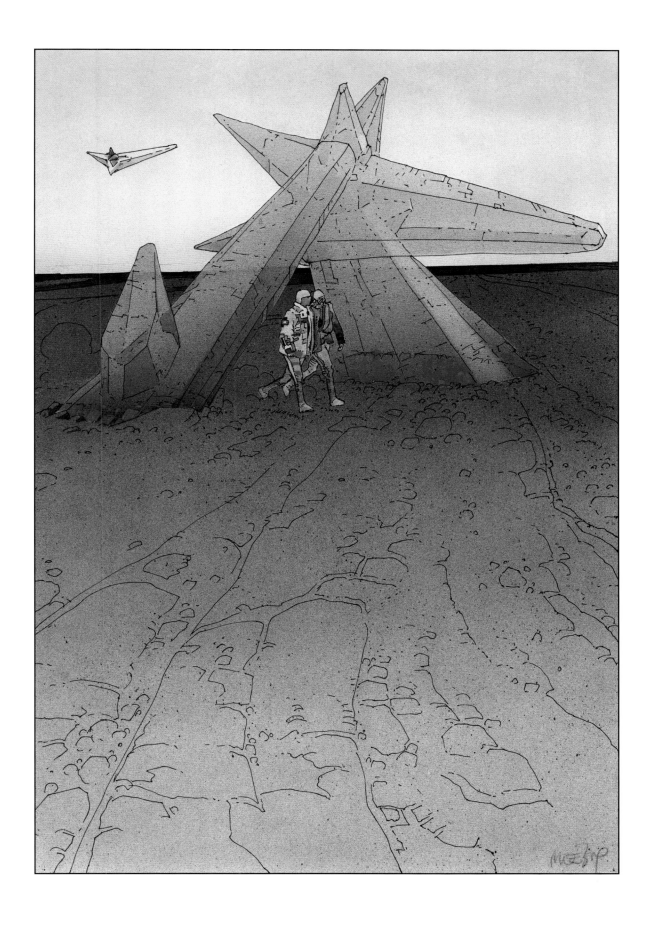

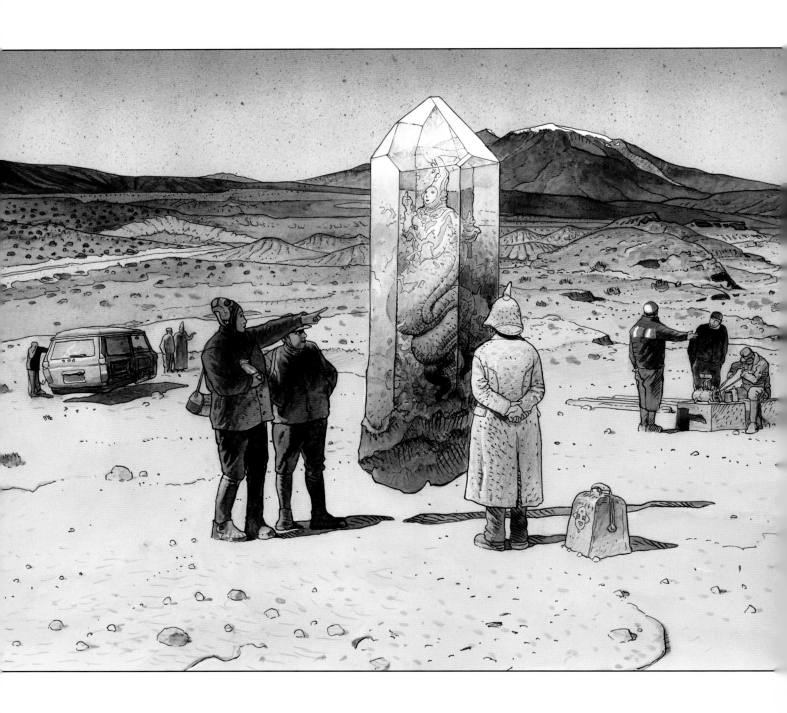

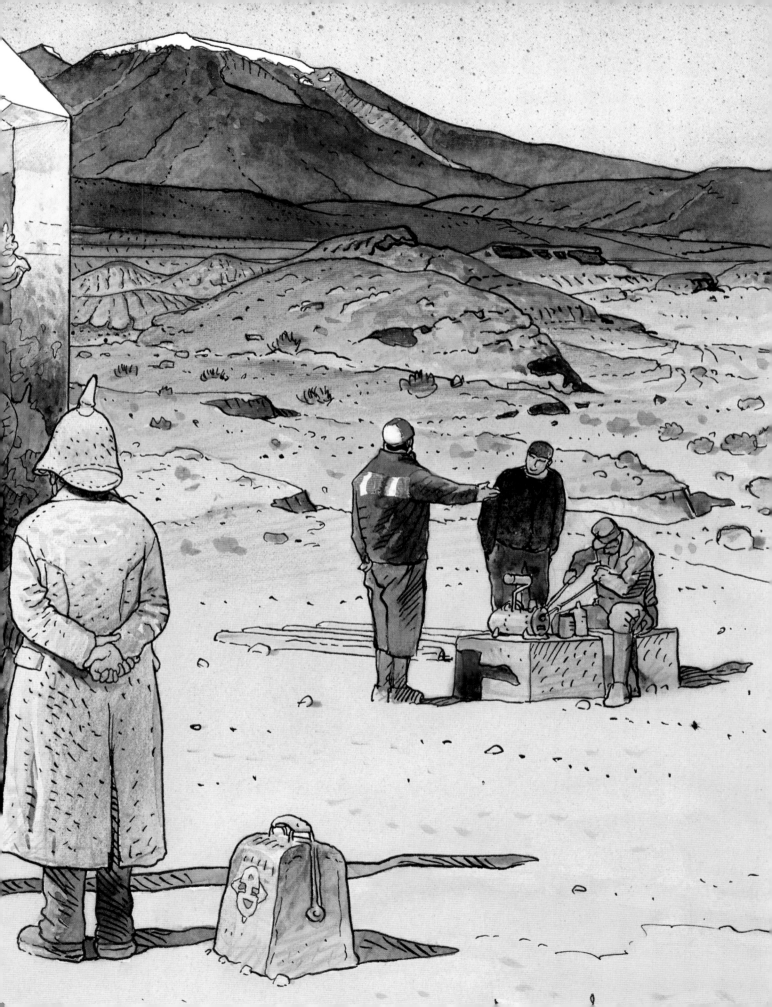

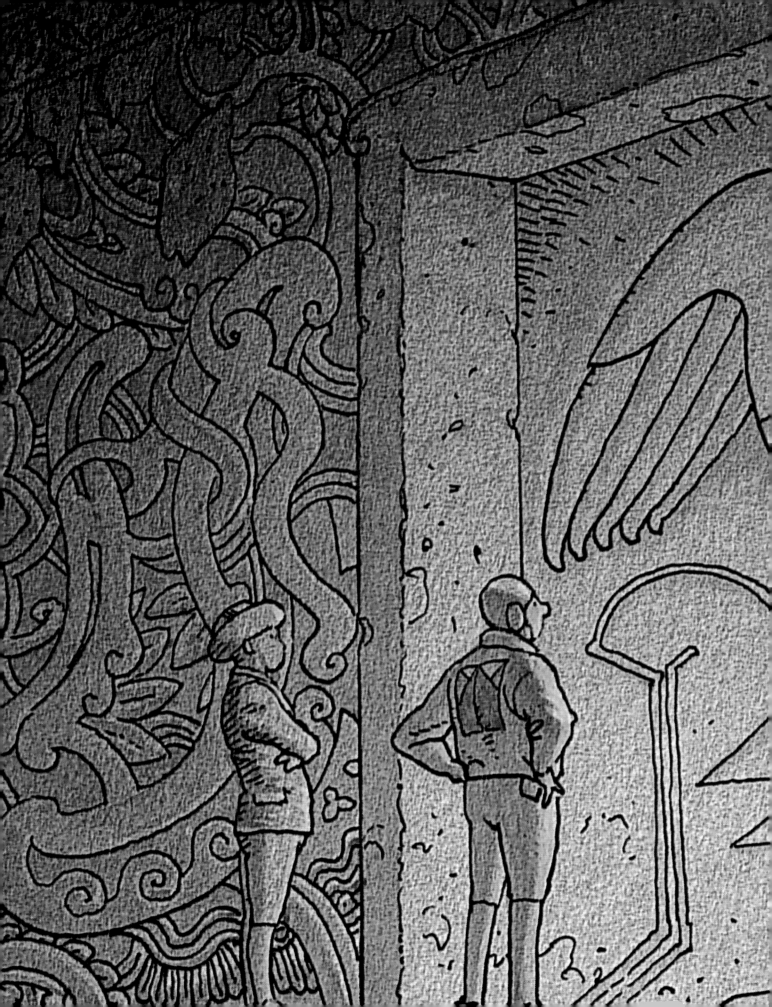

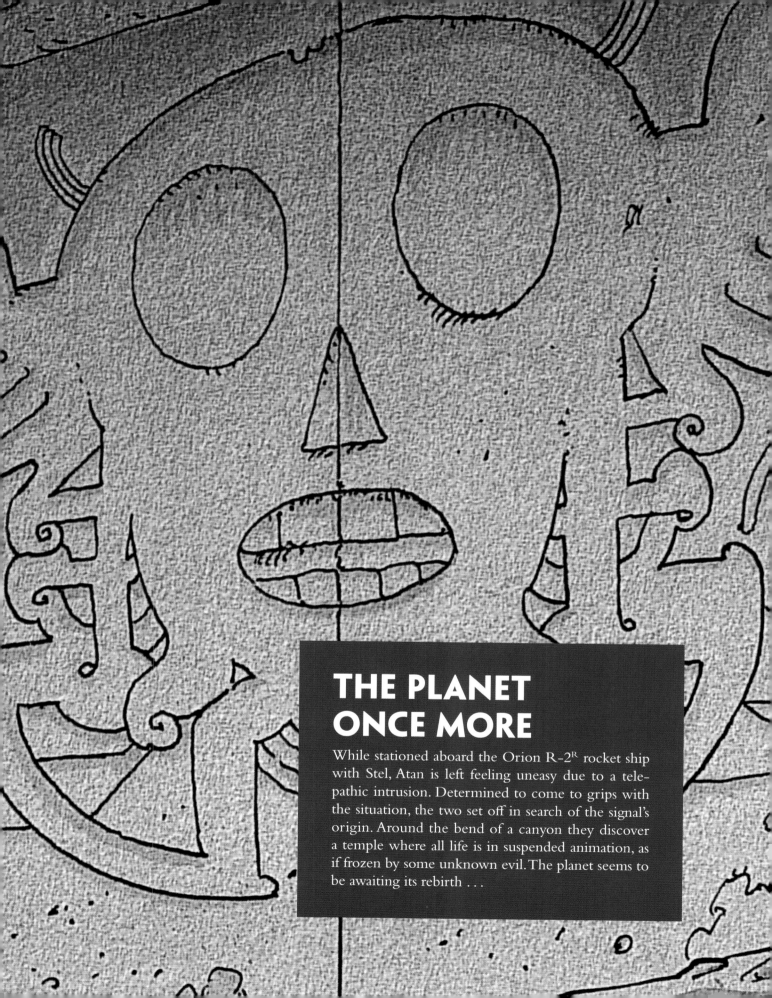

THE PLANET ONCE MORE

While stationed aboard the Orion R-2ᴿ rocket ship with Stel, Atan is left feeling uneasy due to a telepathic intrusion. Determined to come to grips with the situation, the two set off in search of the signal's origin. Around the bend of a canyon they discover a temple where all life is in suspended animation, as if frozen by some unknown evil. The planet seems to be awaiting its rebirth . . .

THE PLANET ONCE MORE... MŒBIUS 90

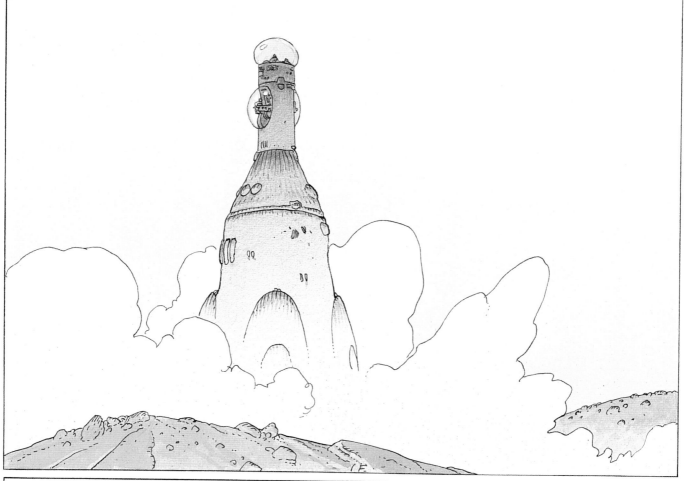

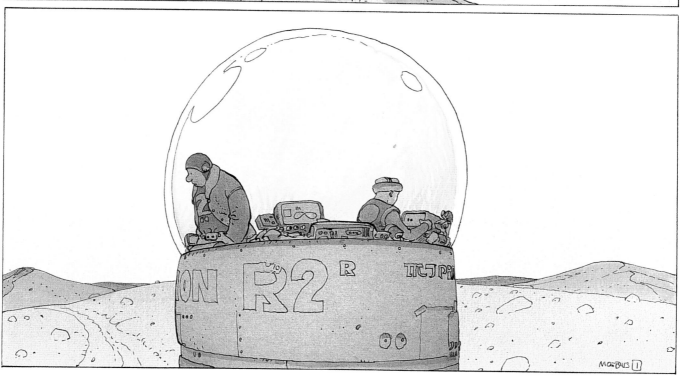

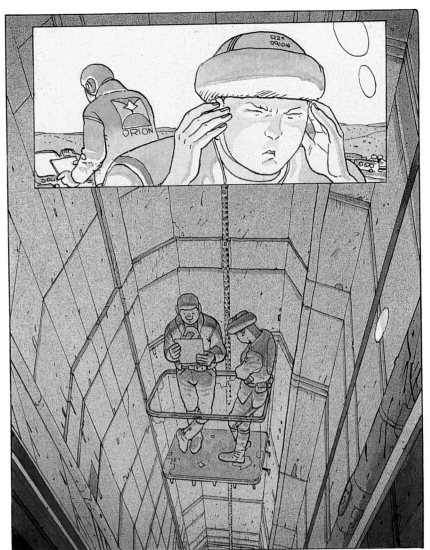
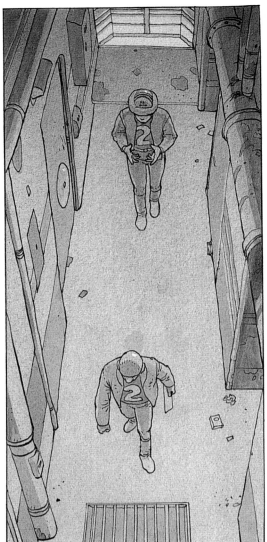
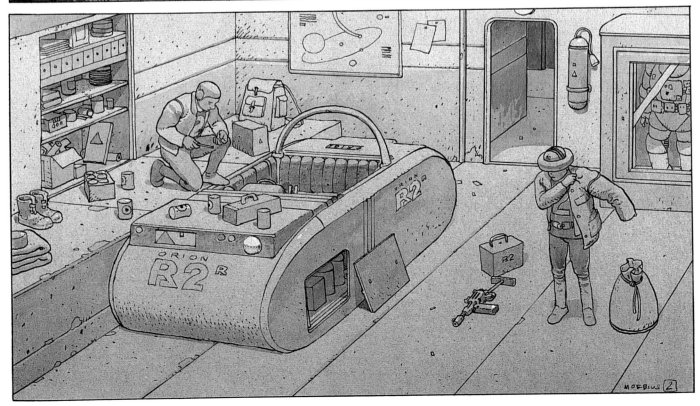

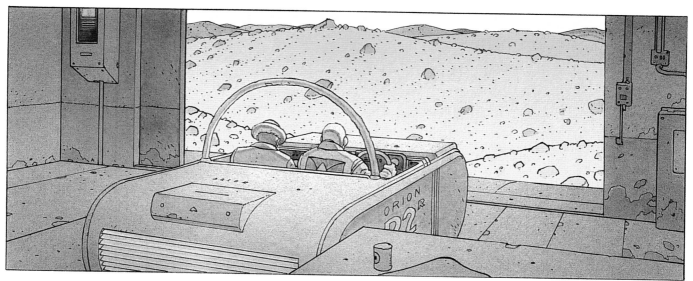

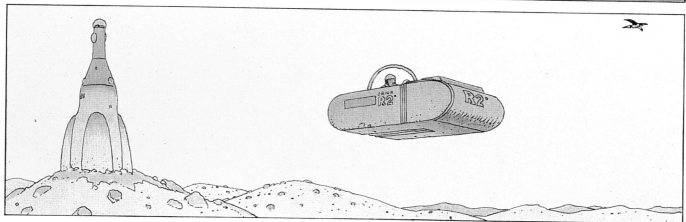

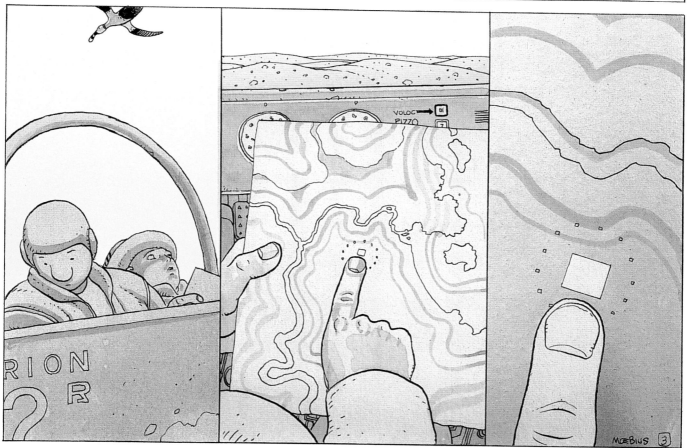

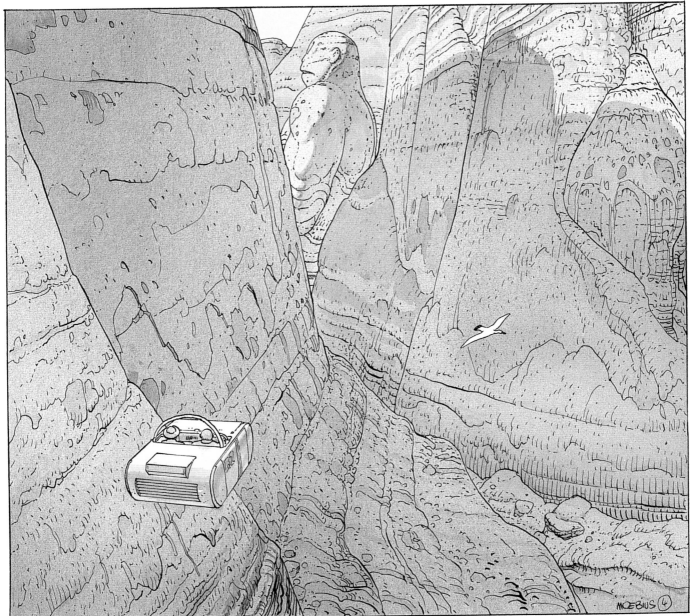

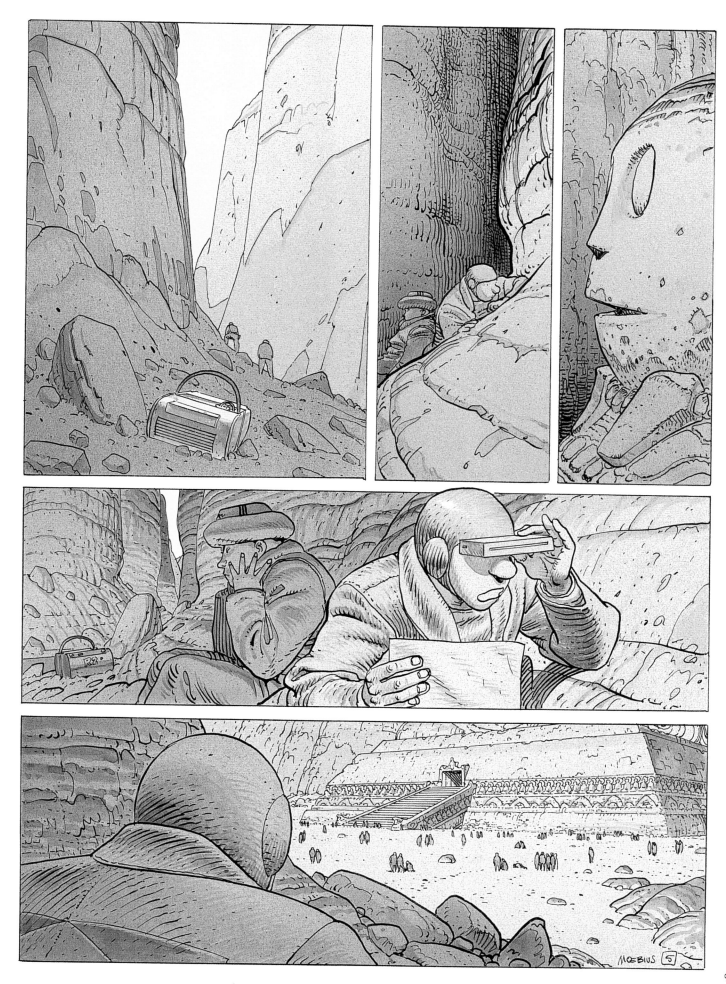

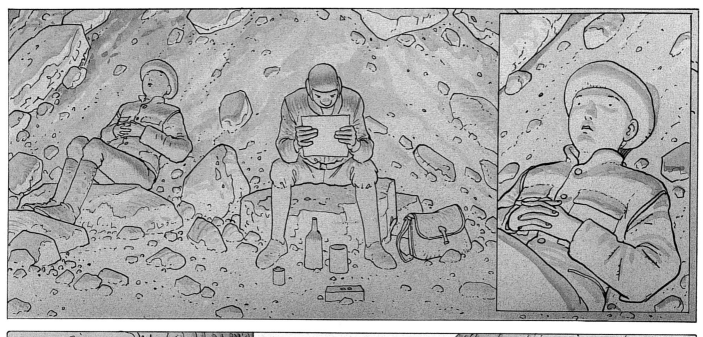

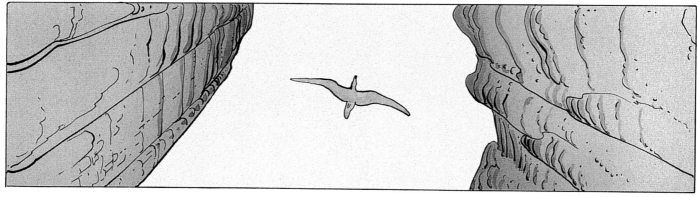

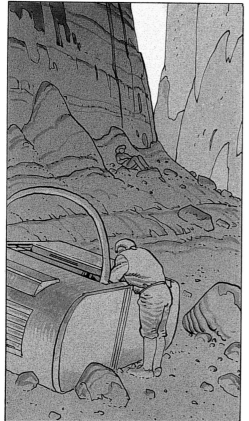

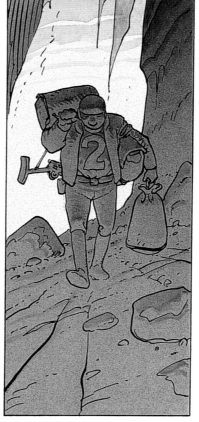

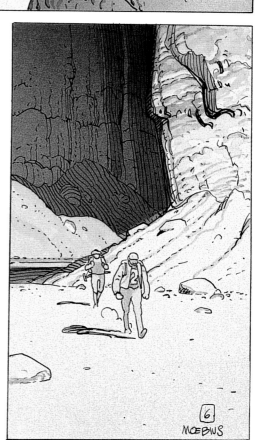

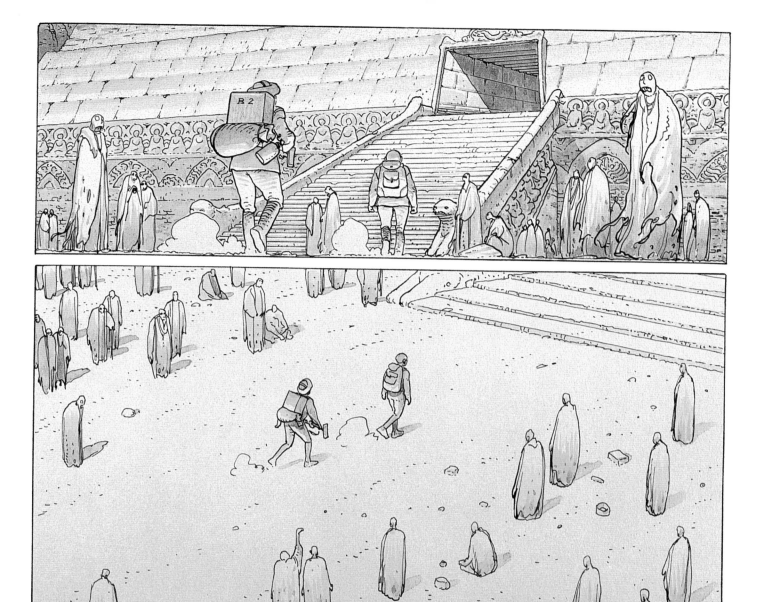

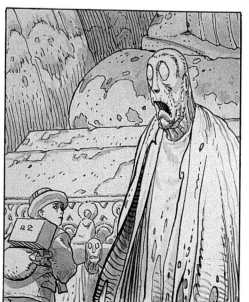

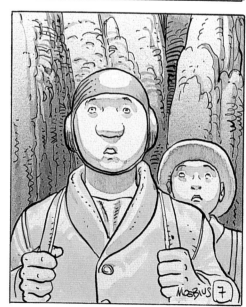

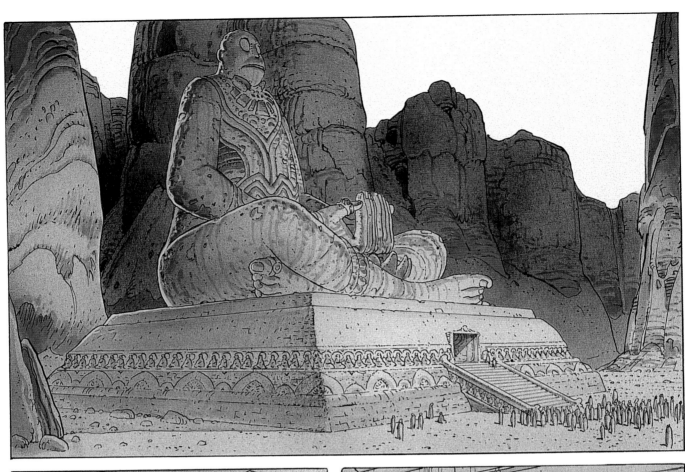

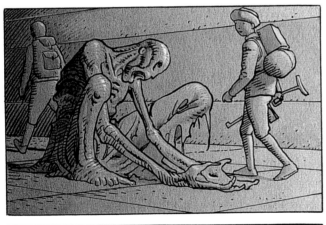

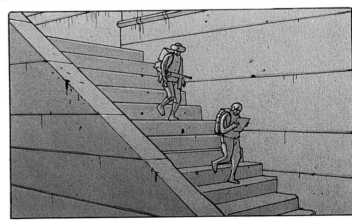

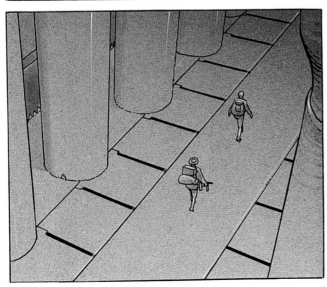

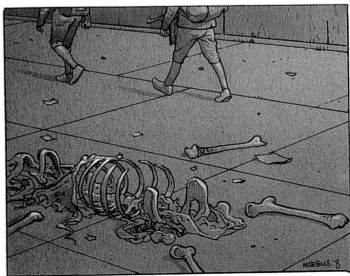

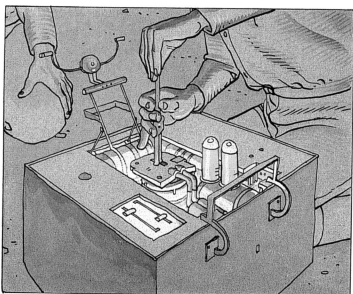
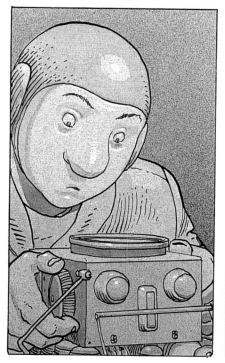

95

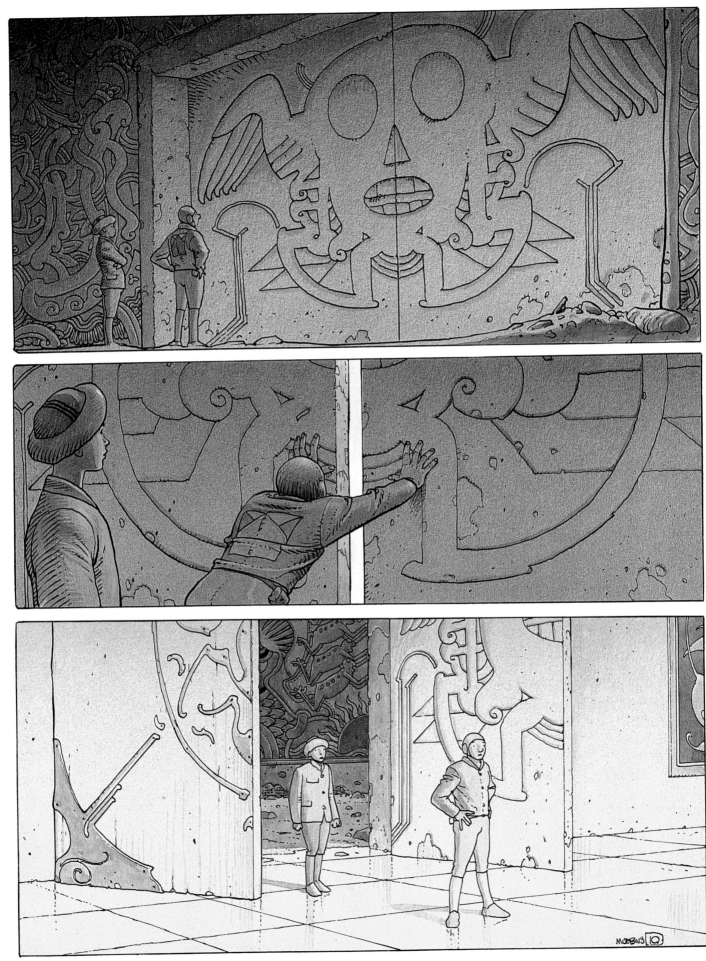

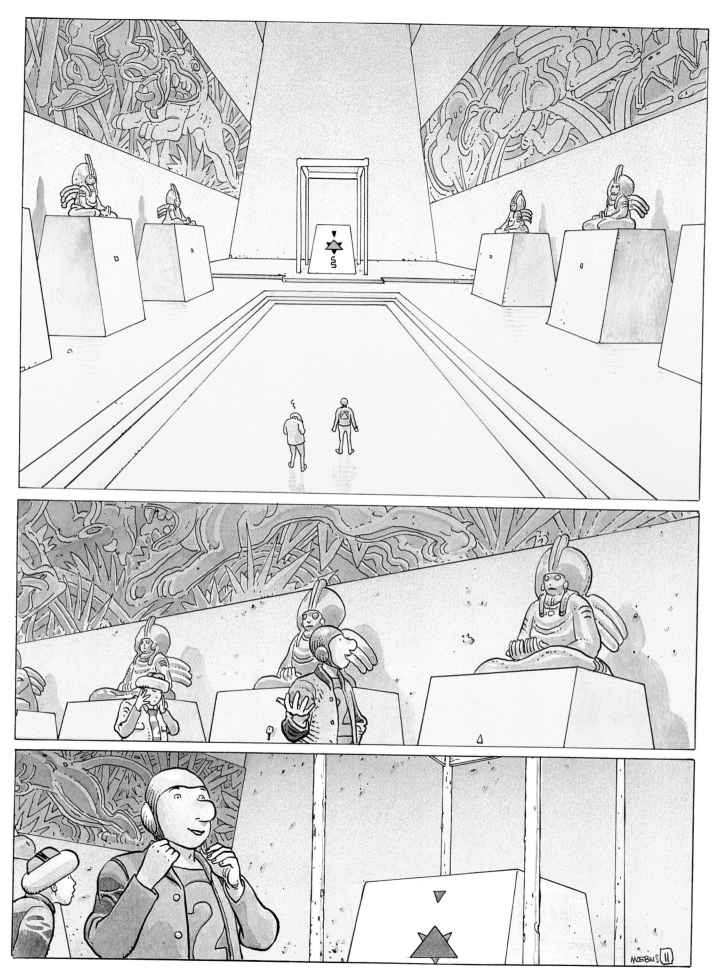

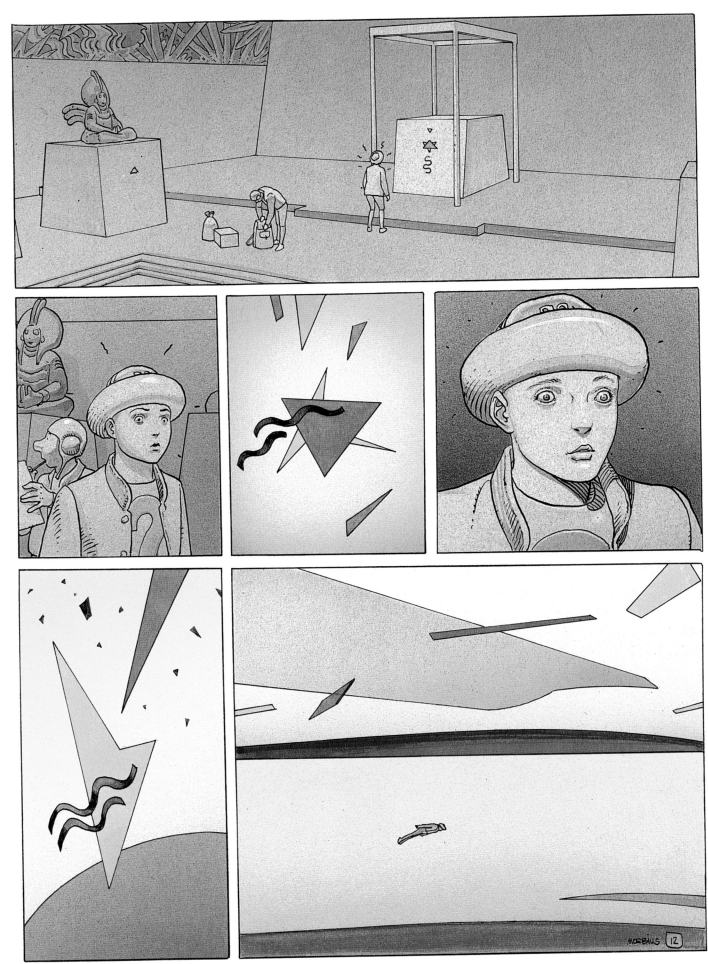

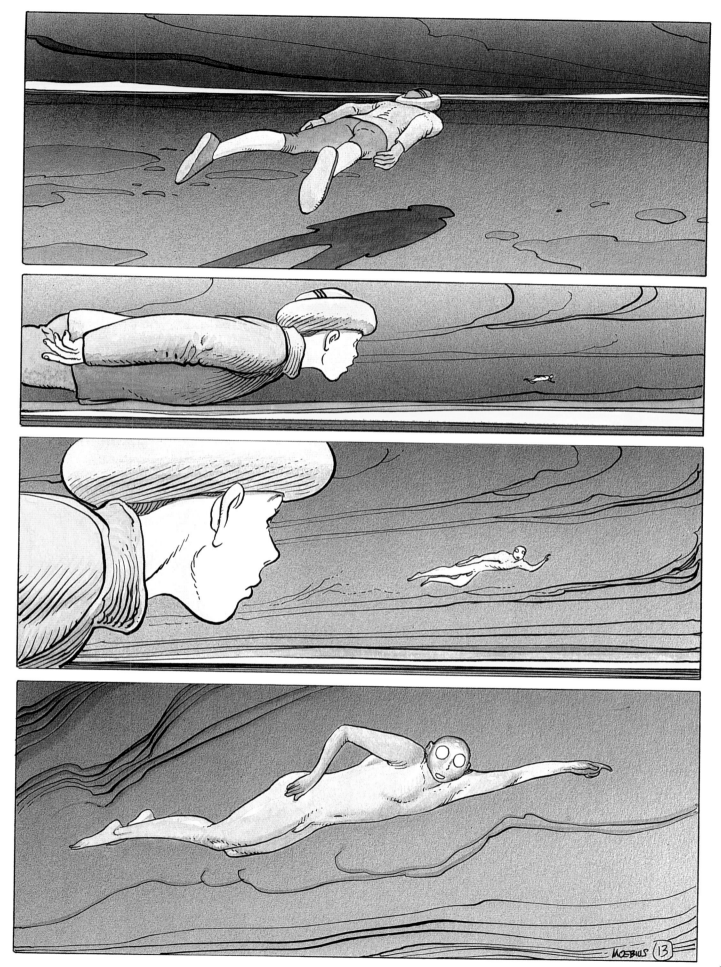

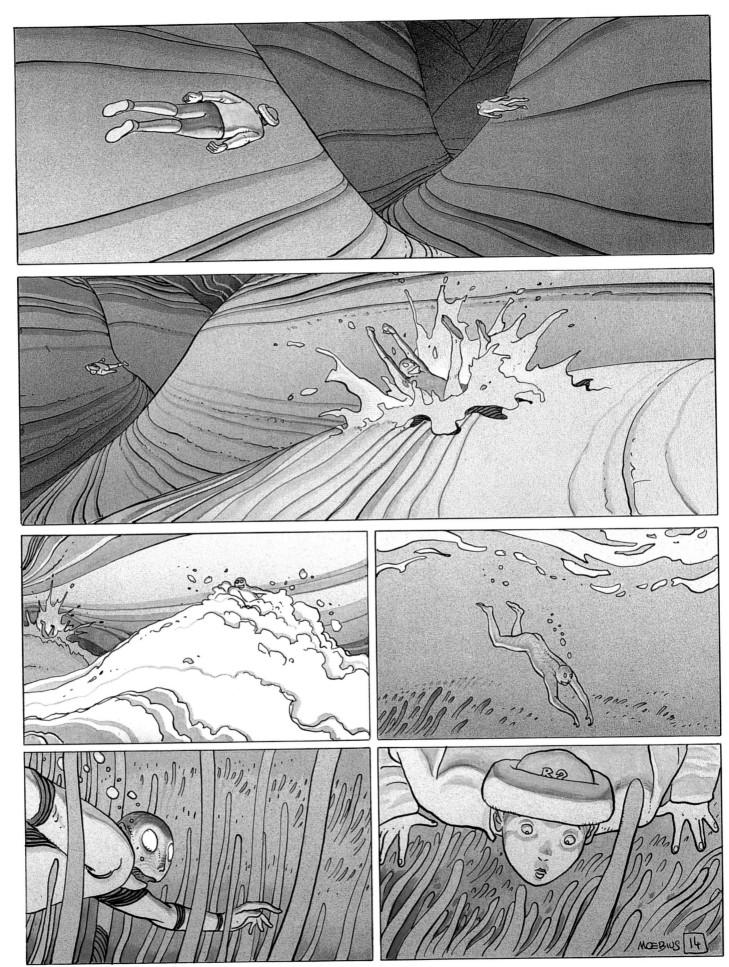

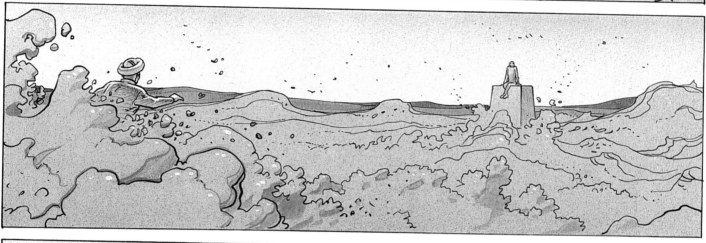
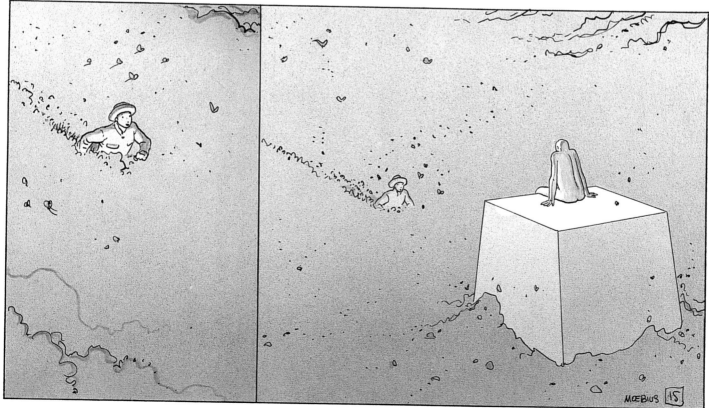

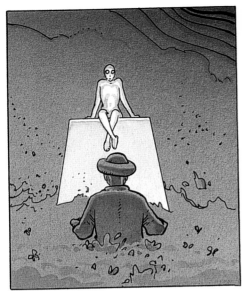
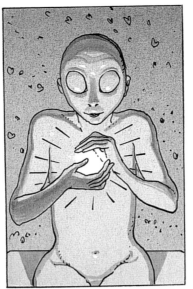
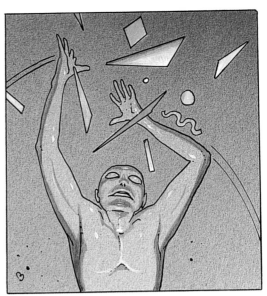
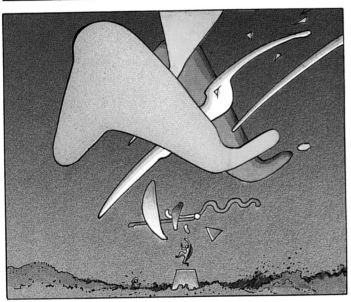
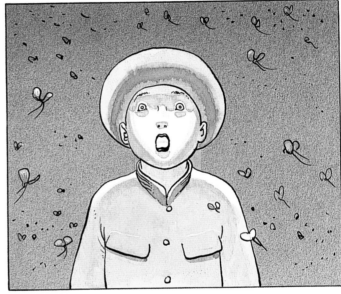
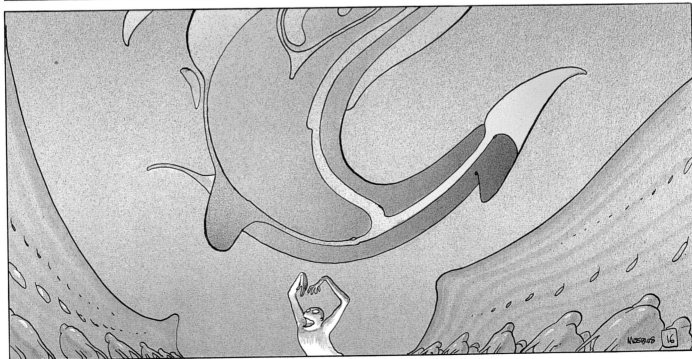

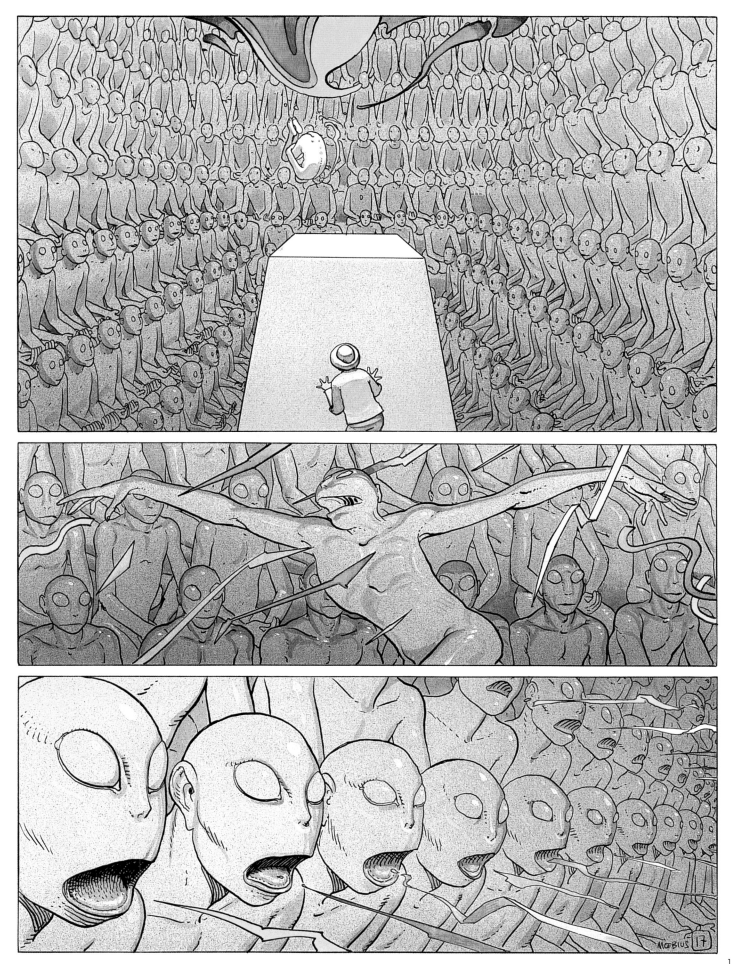

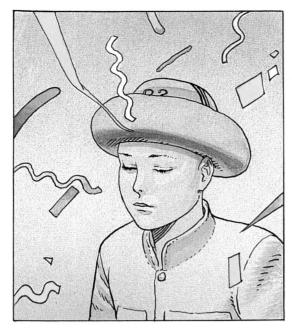
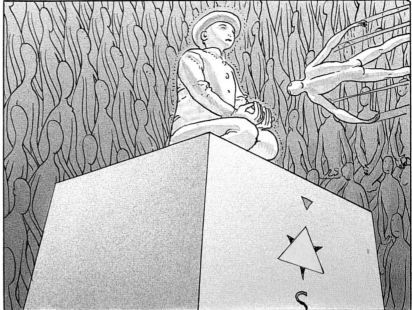
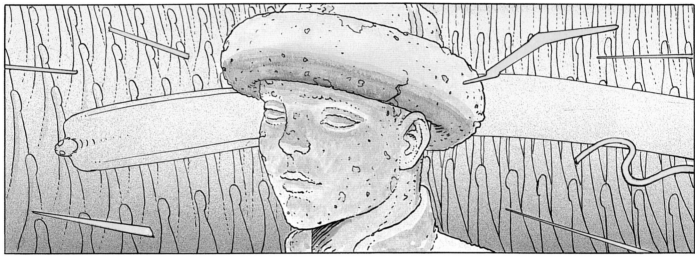
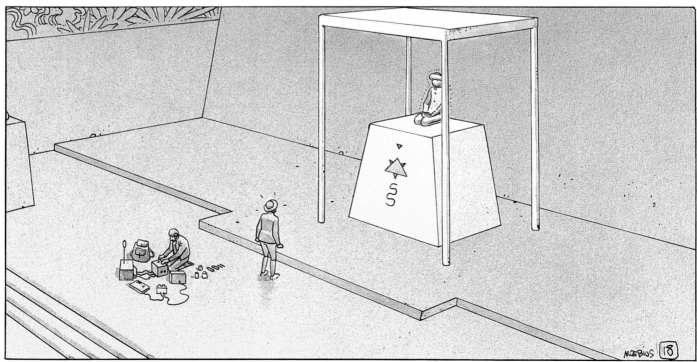

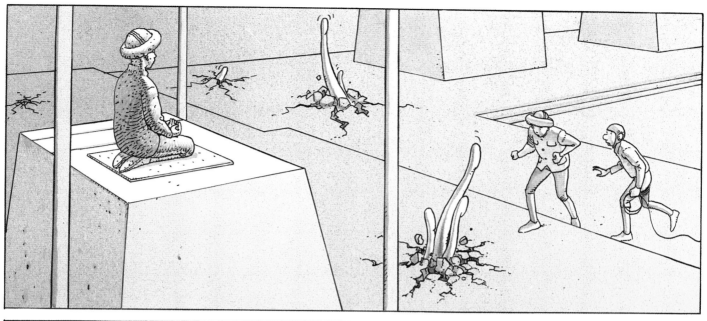

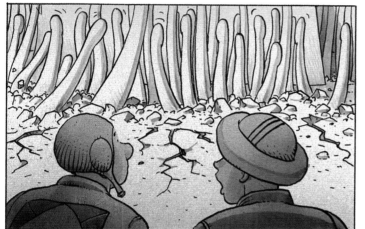

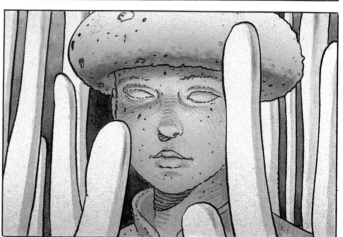

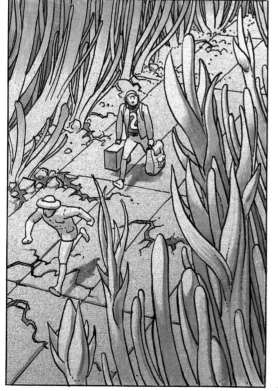

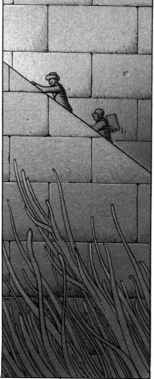

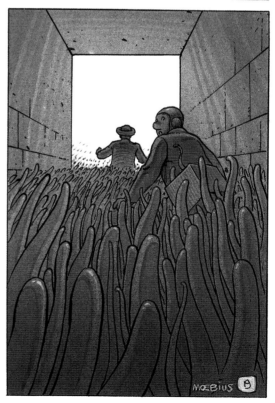

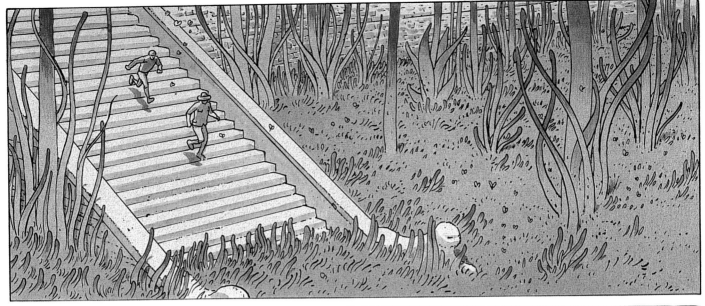

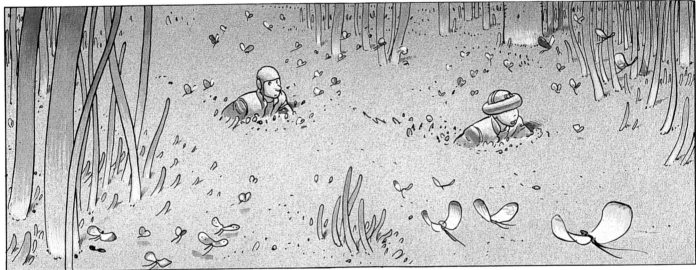

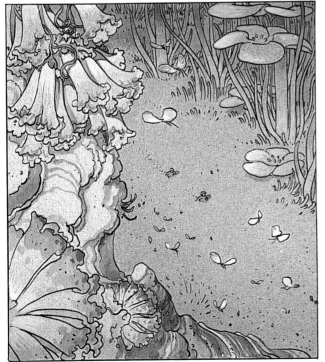

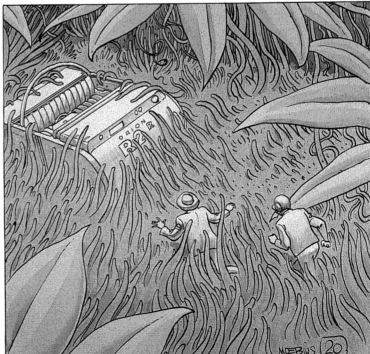

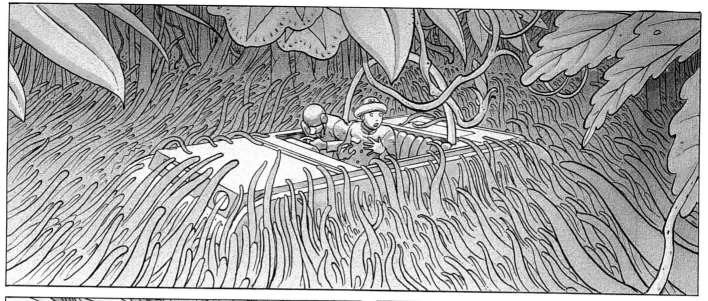

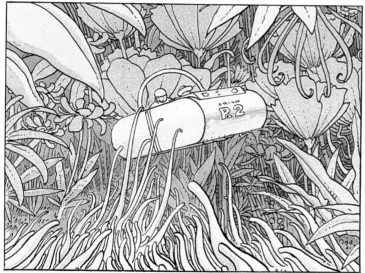

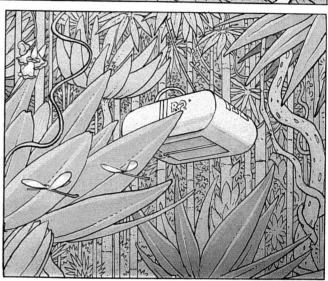

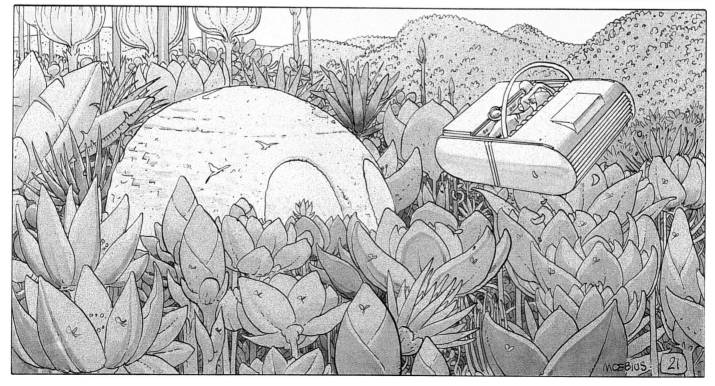

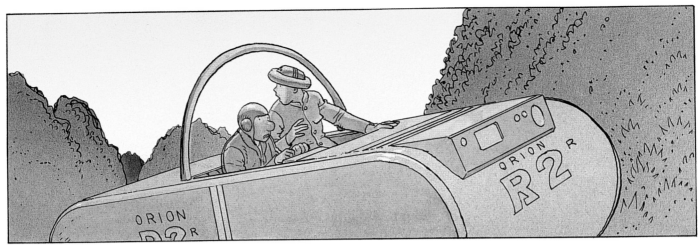

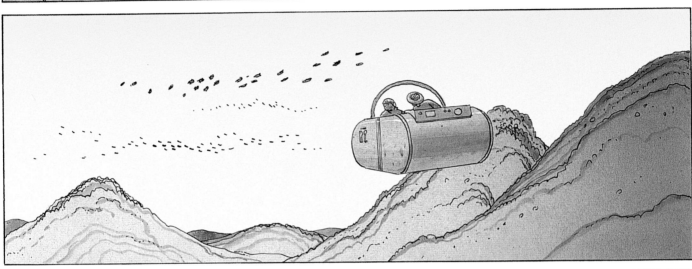

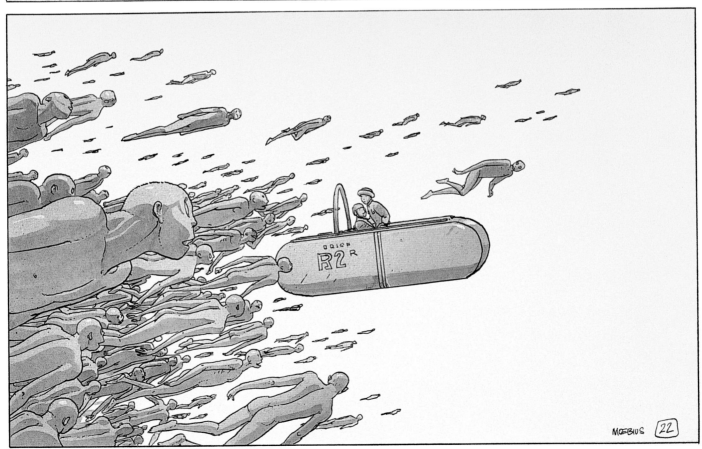

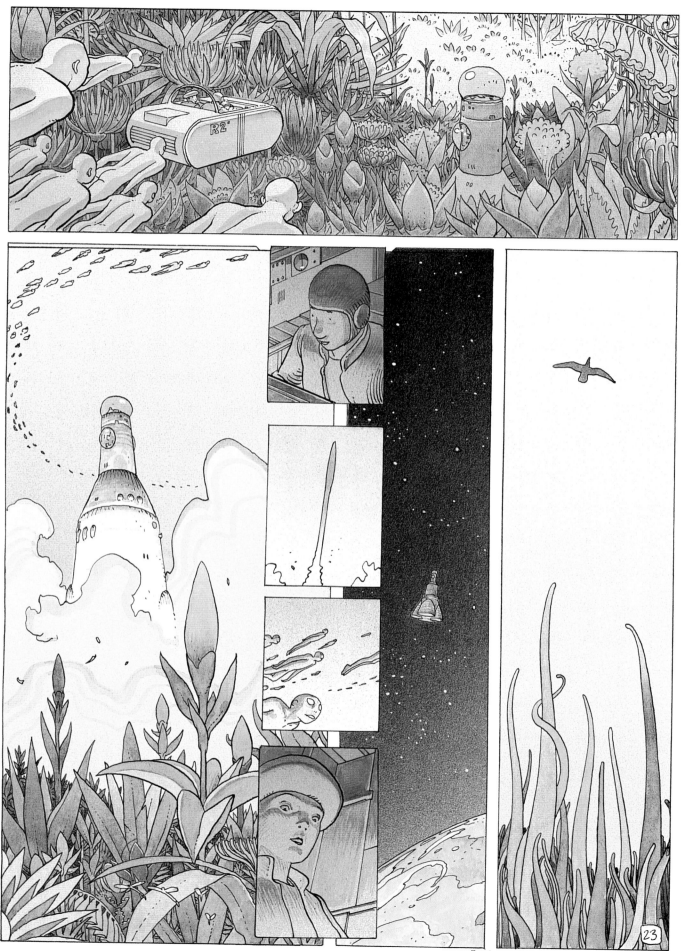

FIN. MŒBIUS 1990...

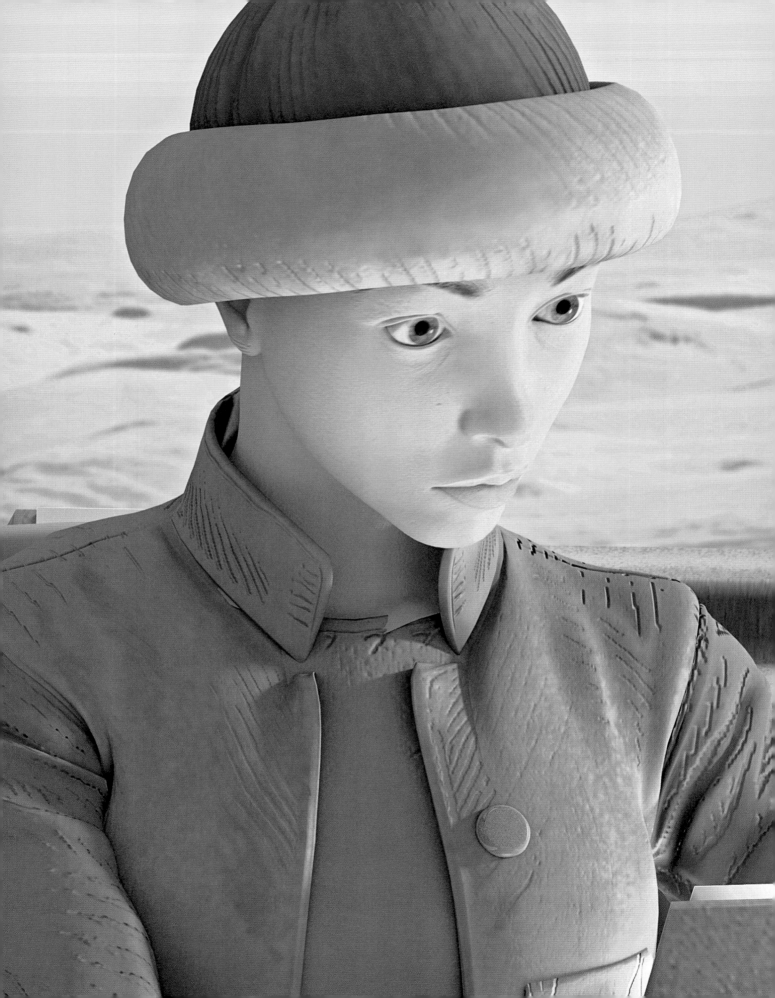

THE PLANET ONCE MORE: THE FILM

The movie version of "The Planet Once More" is a magnificent short film that arose from a meeting between Jean Giraud, Isabelle Giraud, and Pierre Buffin. A co-production with Buf-Compagnie, Angel Fine Productions, and Moebius Production, *La planète encore* premiered in Paris in 2011 in conjunction with Fondation Cartier's wide-ranging art exhibit "Moebius-Transe-Forme." The film is the result of the author's willingness to extend the boundaries of his art to the silver screen, through a three-dimensional representation of his universe.

The film was actually a trial run to demonstrate the potential of 3D work for the entire *Edena* series. With Jean Giraud's personal involvement in the venture, the goal was to stick to the original comics as closely as possible—to remain true to the line work, the color, and the story. The series presents an uncommonly rich universe, and every moment of the film is an argument to see more!

All images in this section are © Angel Fine / Moebius Production.

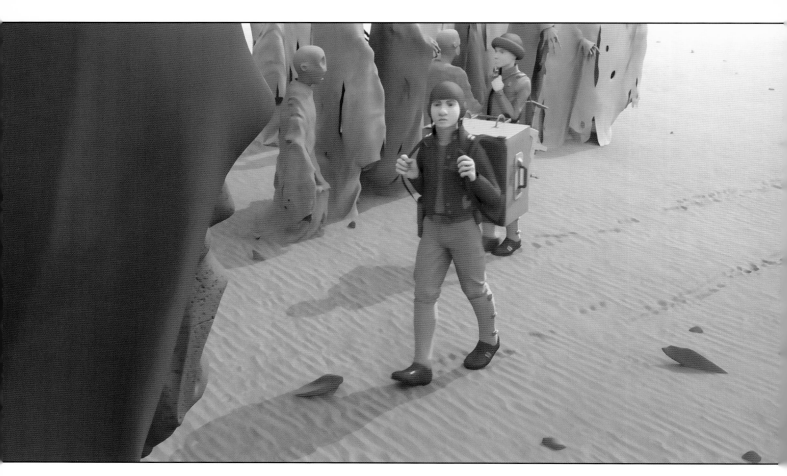

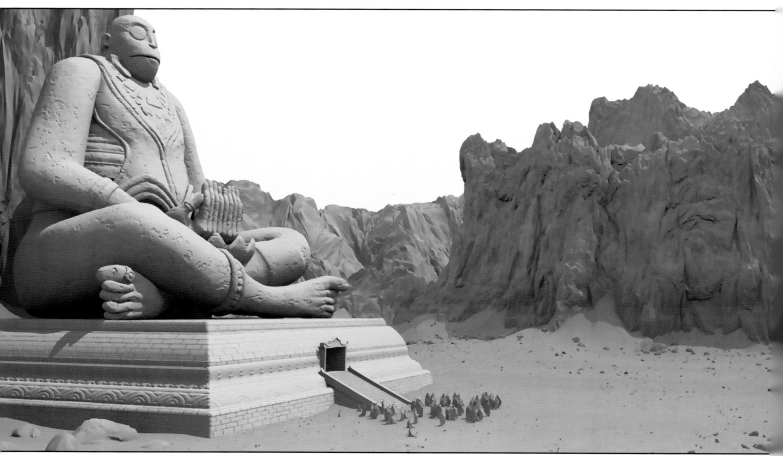

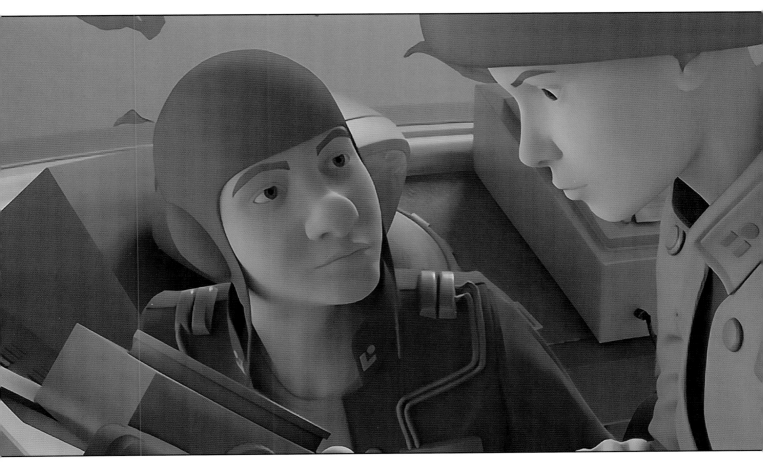

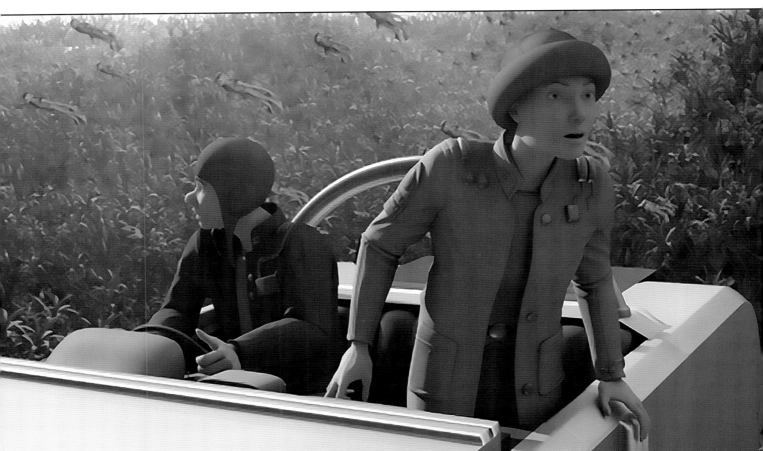

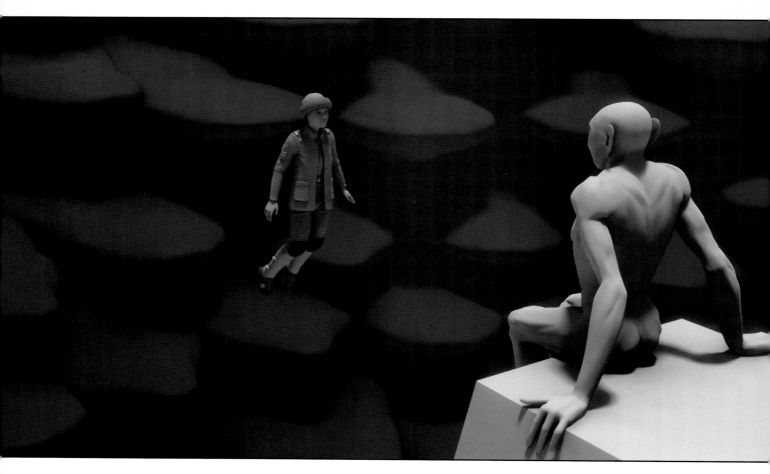

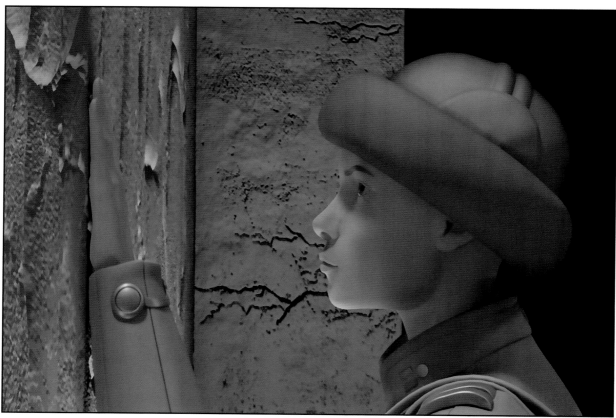

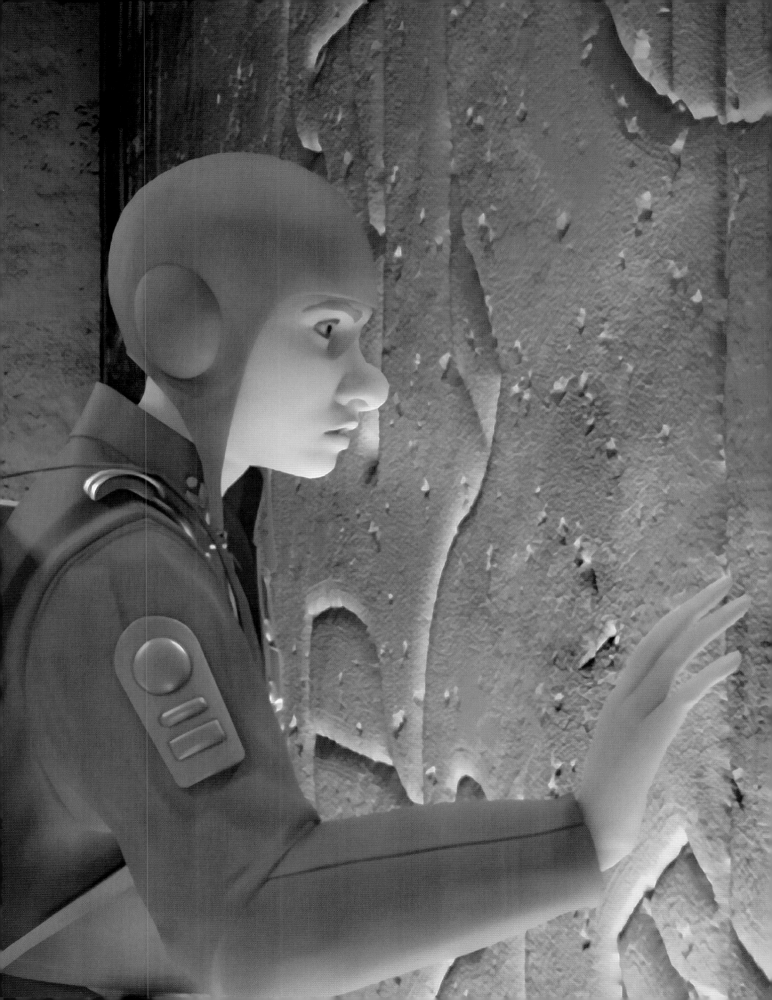

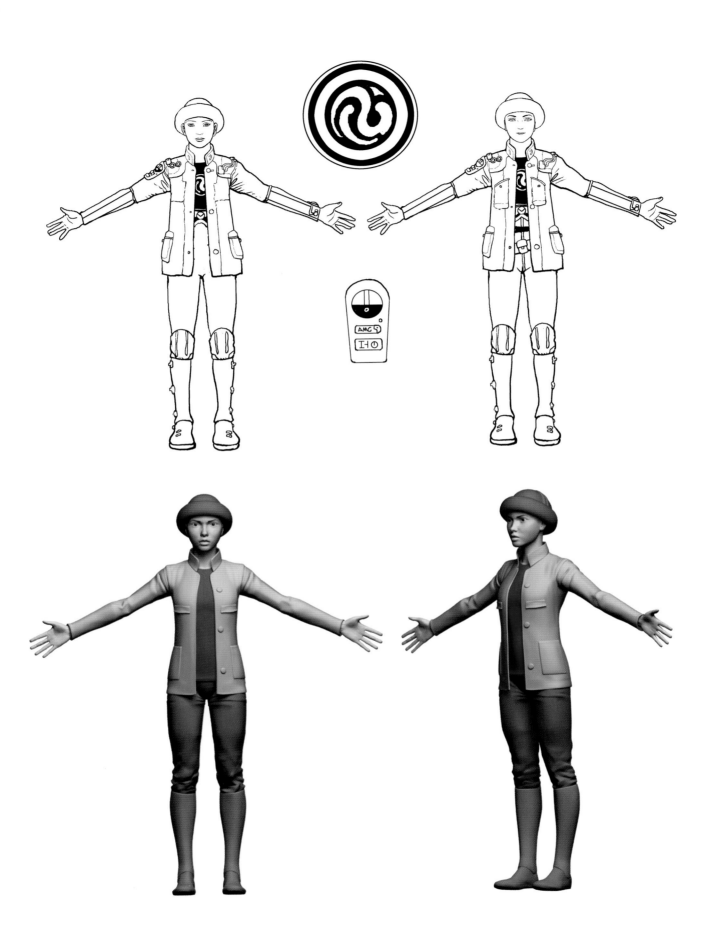

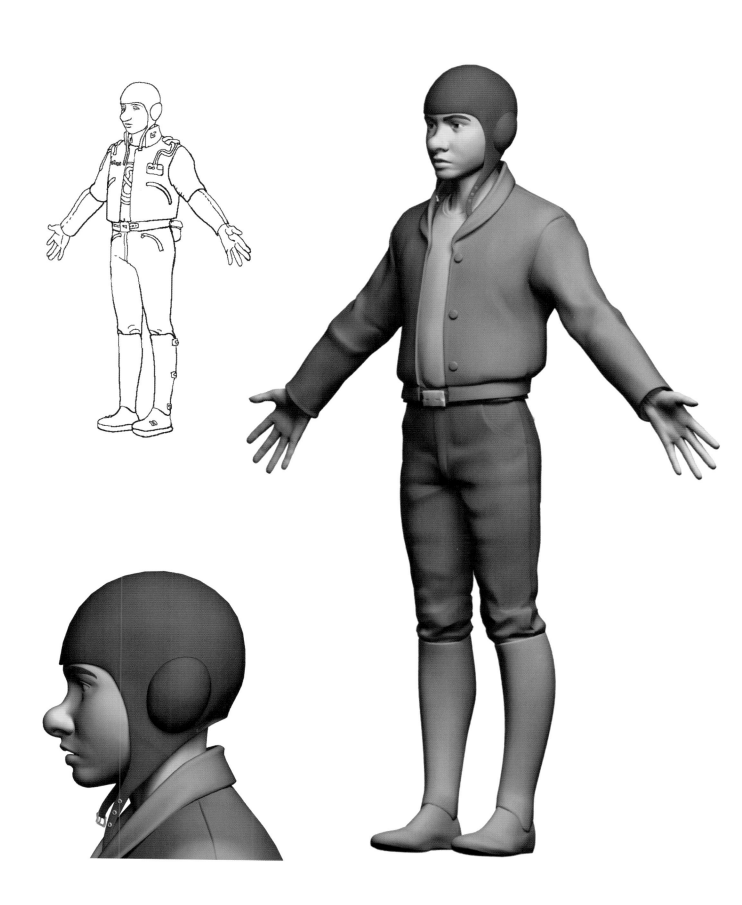

CHAPTER 3
THE QUEST FOR REBIRTH AND TRANSFORMATION

Jean Giraud (1989):

"It is at this point that readers discover the narrative's real hero: the artist. While following the story of Stel and Atan's respective changes, they're also reading my very own tale of adventure taking place in between the lines! I felt a tremendous ecstasy when I realized this transformation was occurring, both in my own self and on the page. I was in a veritable state of grace!"

Here in operation we see everyone's ability to cut across parallel universes in order to create their own world—not by virtue of mechanical prostheses, but by a quasi-magical power: the power of the dream.

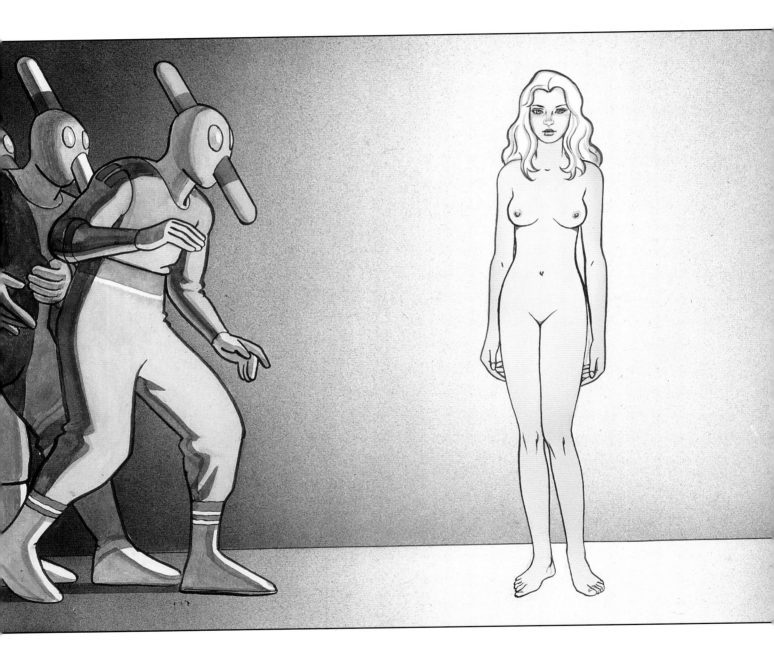

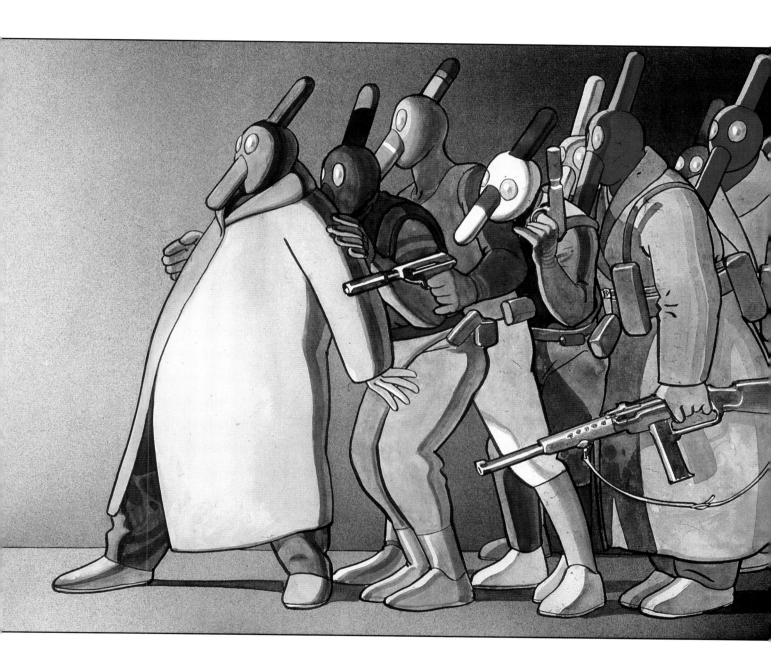

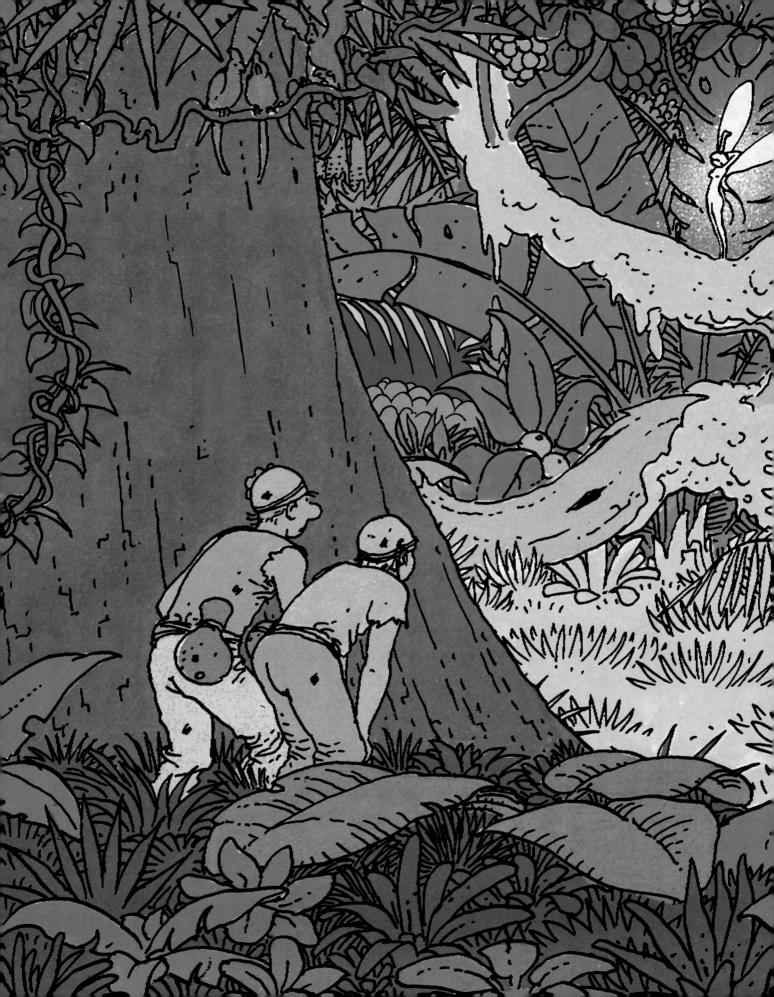

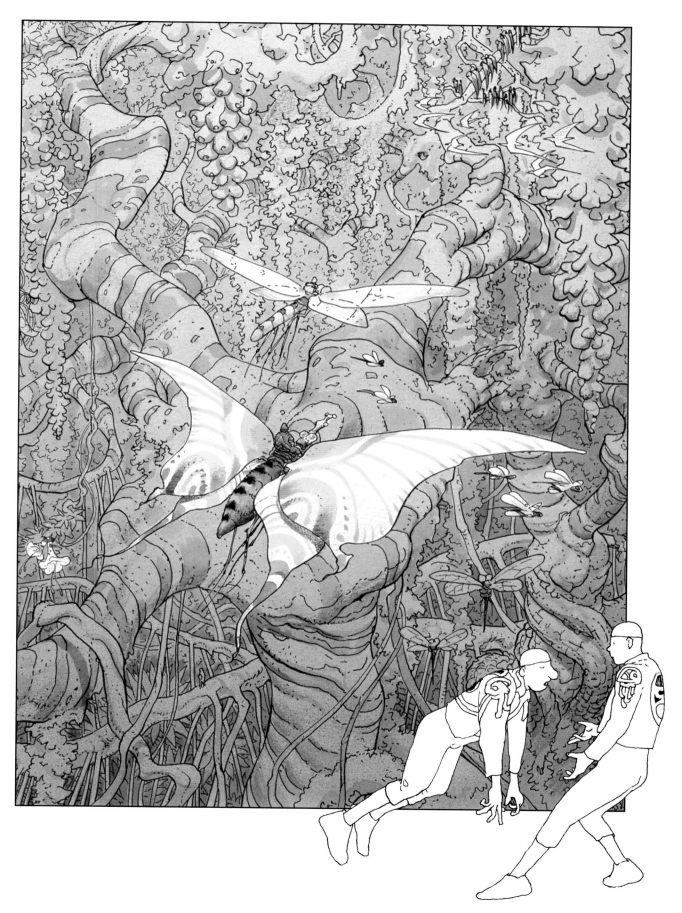

123

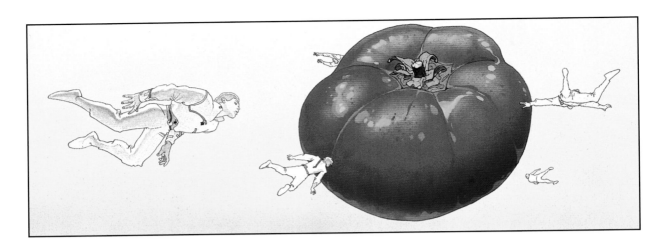

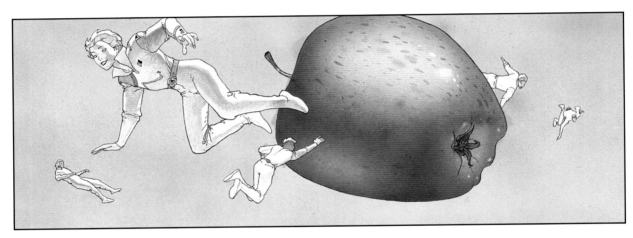

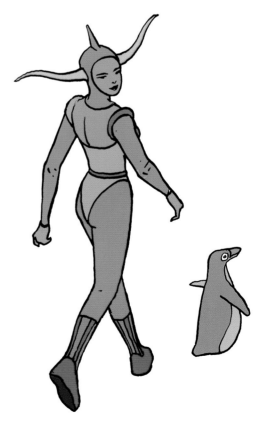

Jean Giraud (2010):
"I am a nexus of universes. I belong to a class of people—I'm not alone in this—whose hand and eye are antennae, sensitive to a certain type of reality."

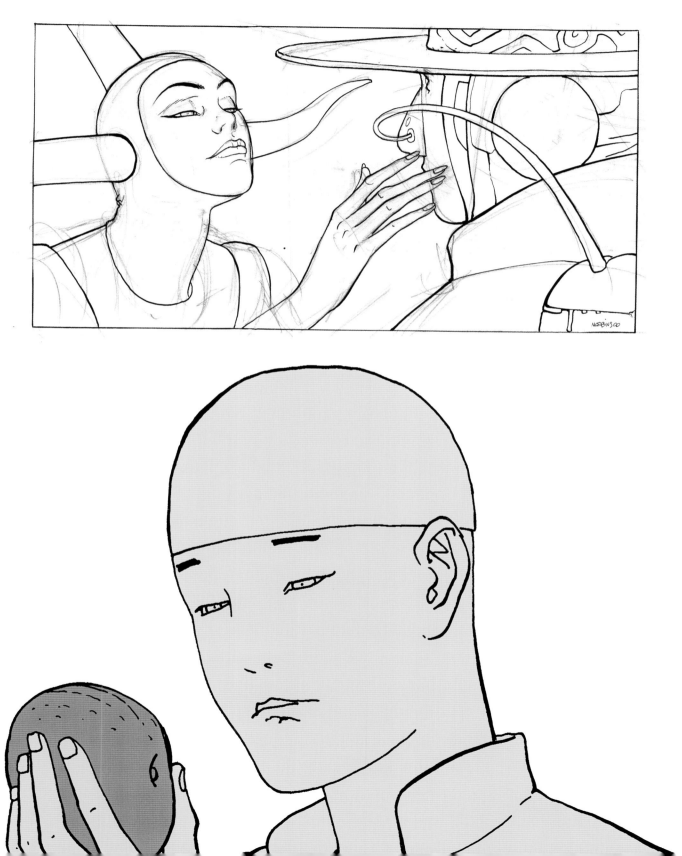

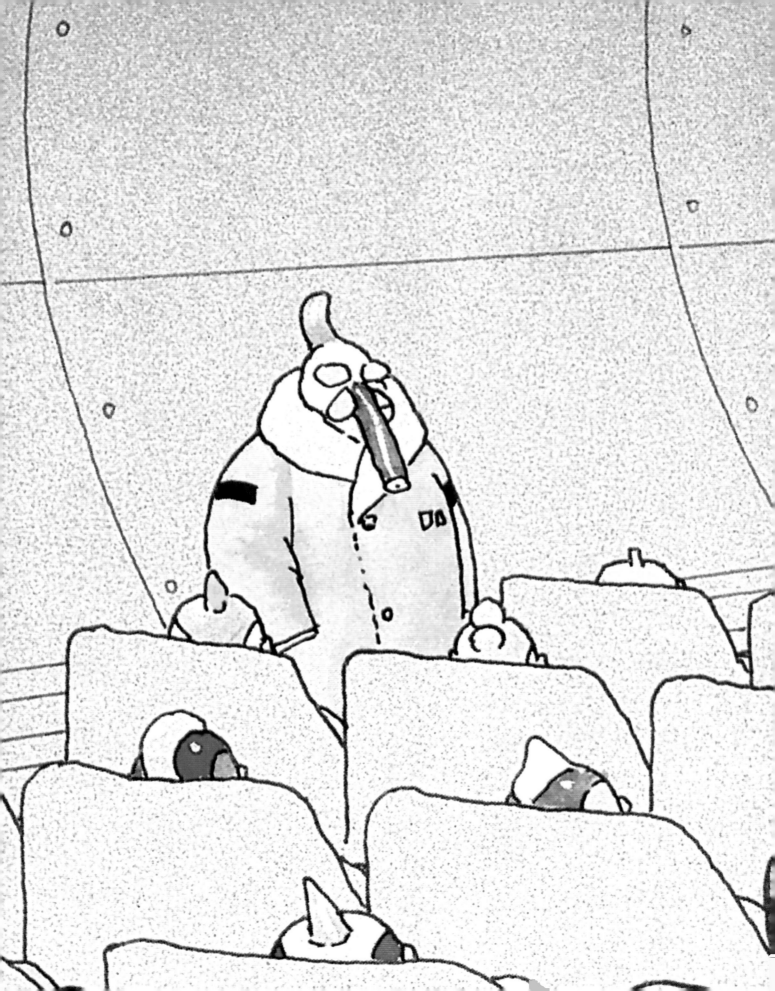

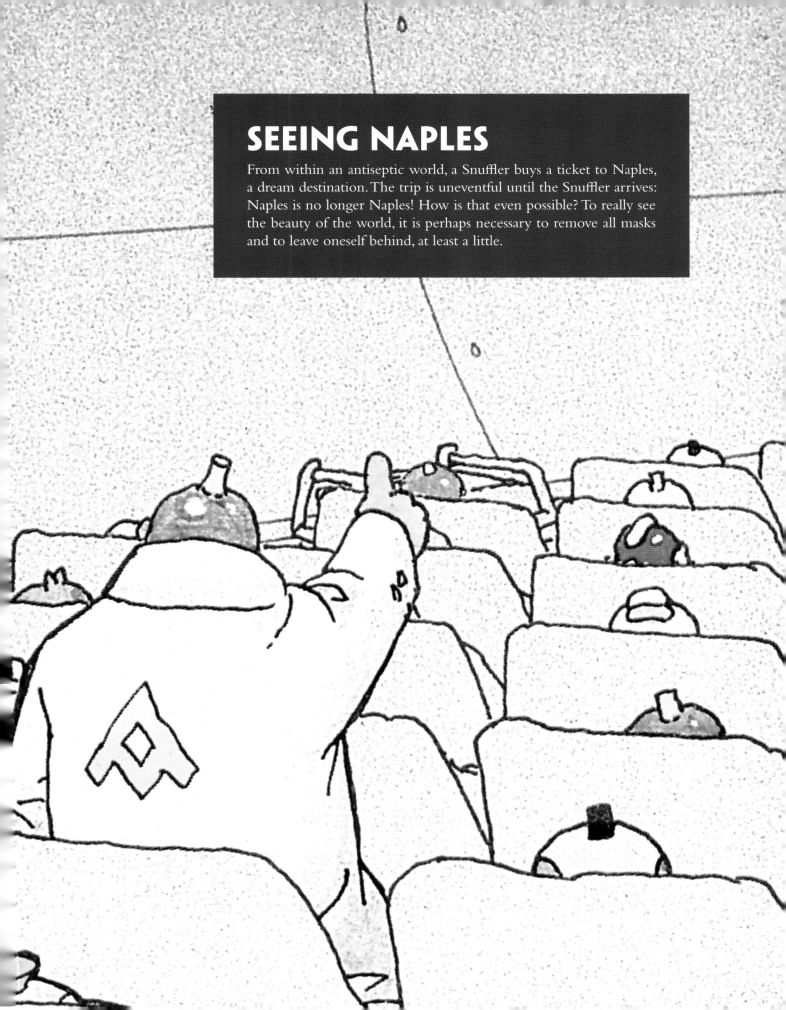

SEEING NAPLES

From within an antiseptic world, a Snuffler buys a ticket to Naples, a dream destination. The trip is uneventful until the Snuffler arrives: Naples is no longer Naples! How is that even possible? To really see the beauty of the world, it is perhaps necessary to remove all masks and to leave oneself behind, at least a little.

SEEING NAPLES

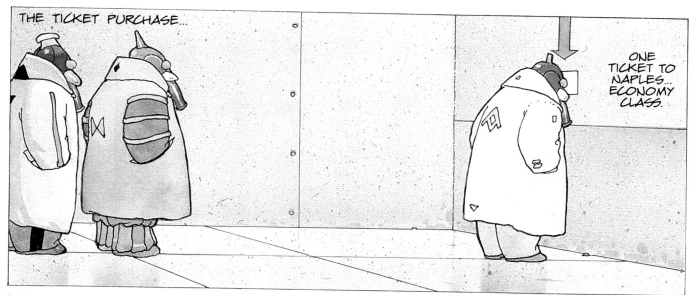

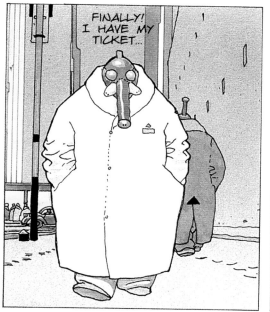

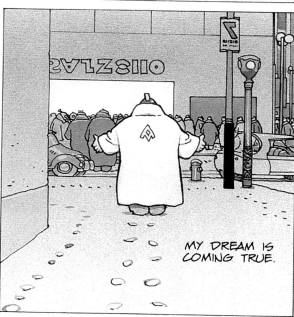

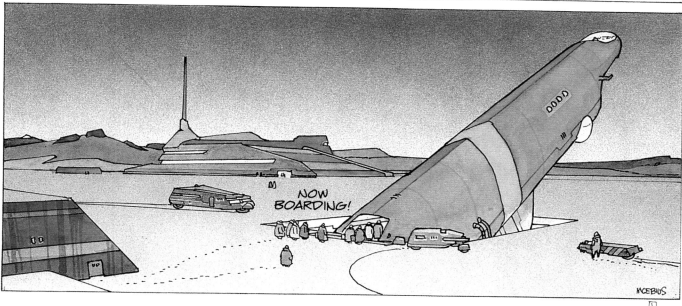

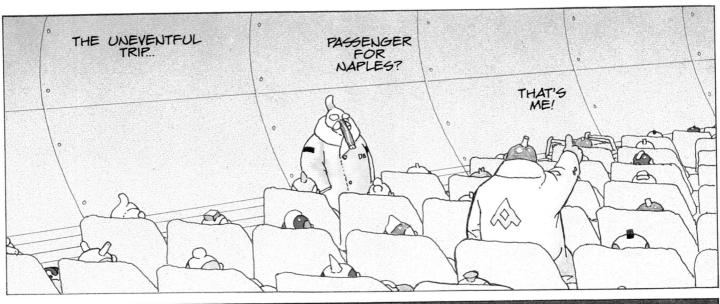

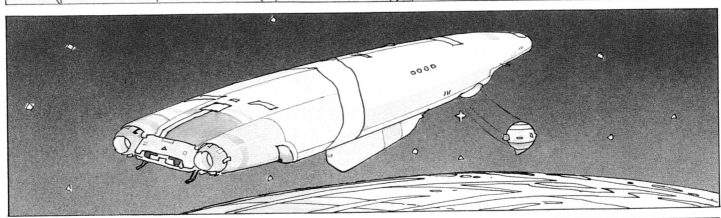

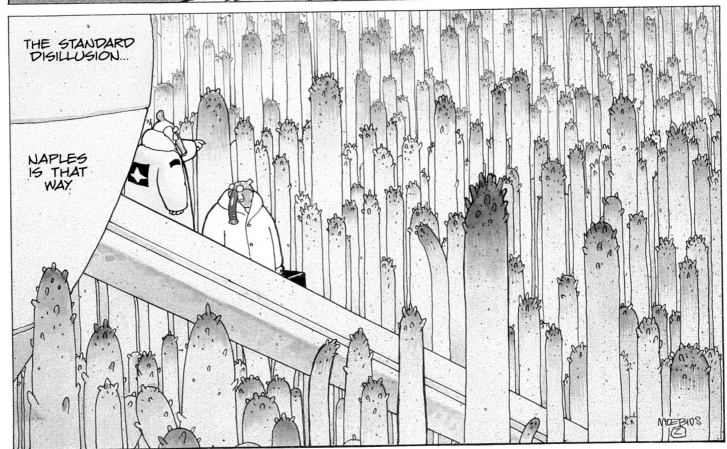

130

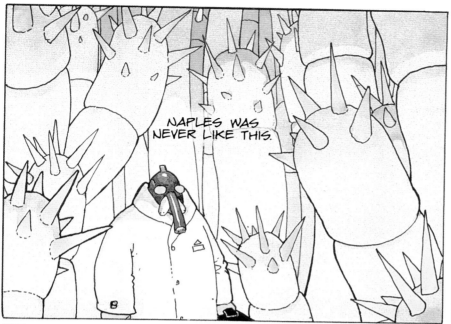

NAPLES WAS NEVER LIKE THIS.

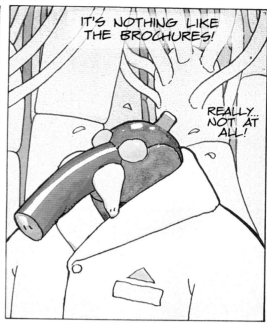

IT'S NOTHING LIKE THE BROCHURES!

REALLY... NOT AT ALL!

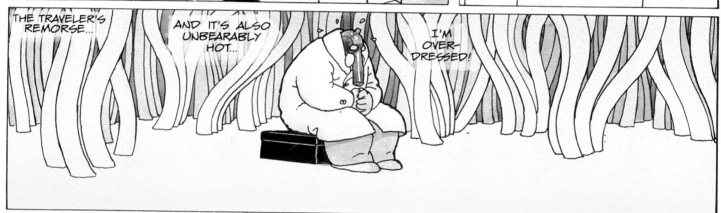

THE TRAVELER'S REMORSE...

AND IT'S ALSO UNBEARABLY HOT...

I'M OVER-DRESSED!

AHHH... THAT'S BETTER!

THE FACEMASK...

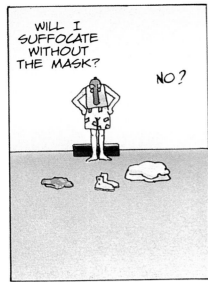

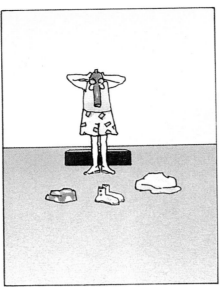

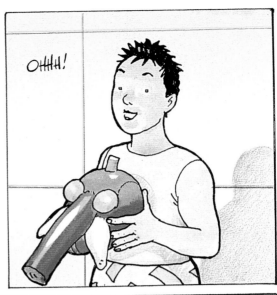

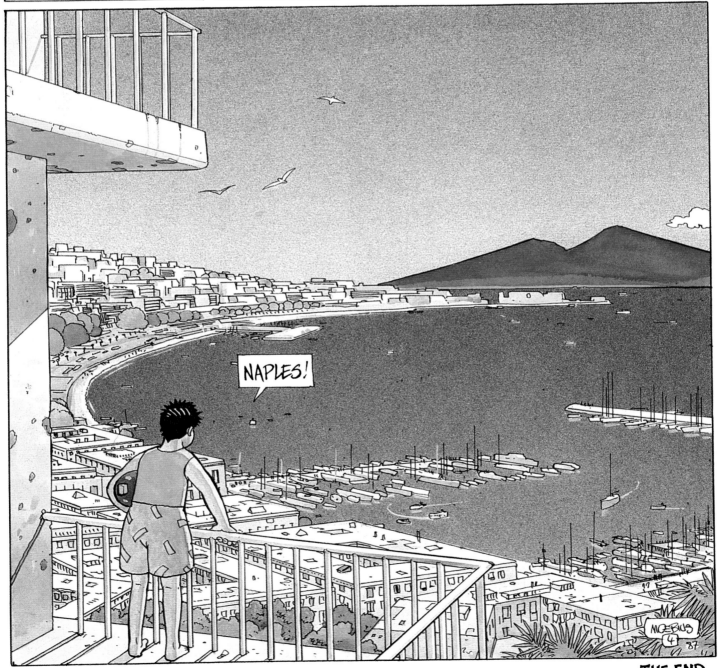

THE END

DYING TO SEE NAPLES

In the year 2000, on his second trip to Naples, Moebius would continue to be inspired by the city. With this story the artist's alter ego, Major Grubert, is brought into the world of Edena.

The all-powerful Vesuvius, a force of nature, allows him to be reborn and to rediscover the path of inspiration.

DYING TO SEE NAPLES

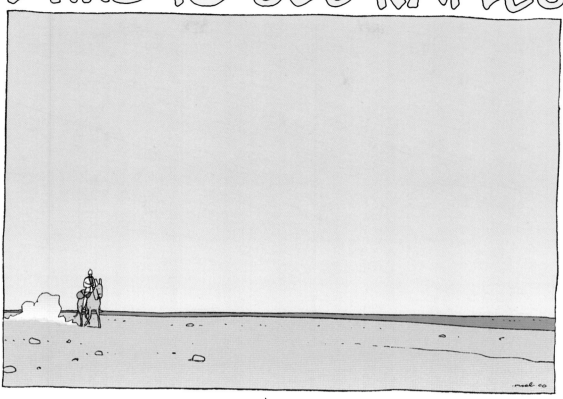

A

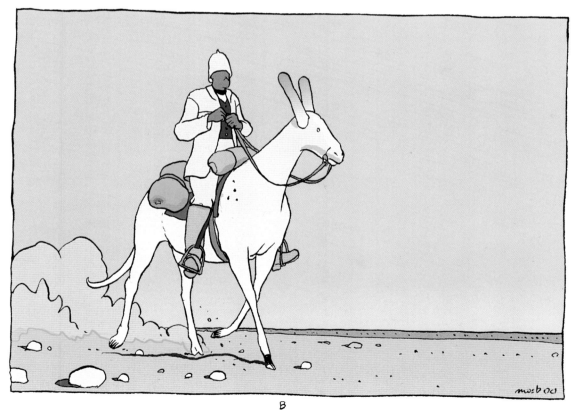

B

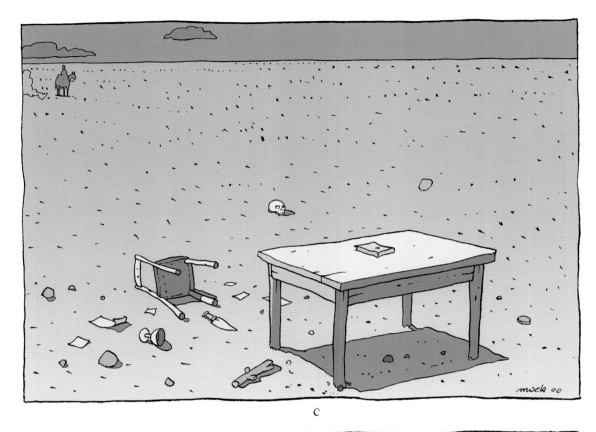

C

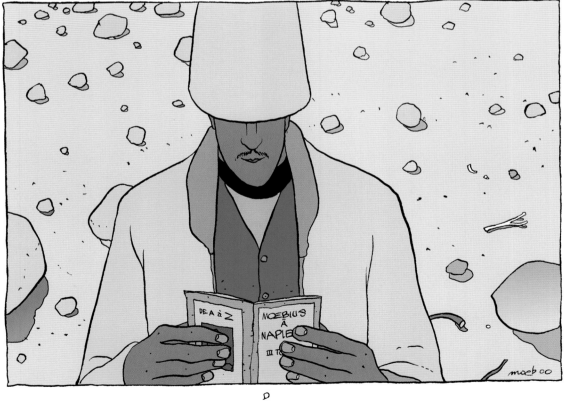

D

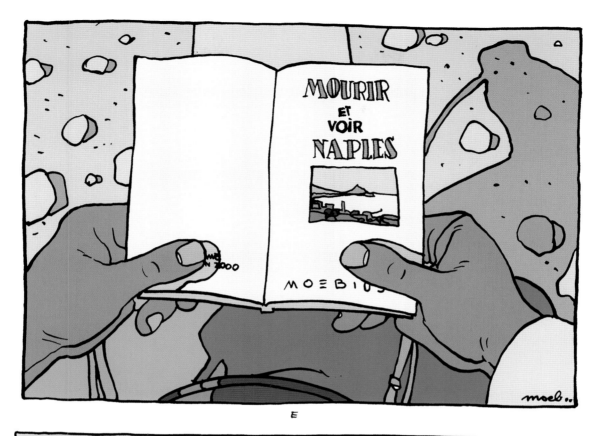

E

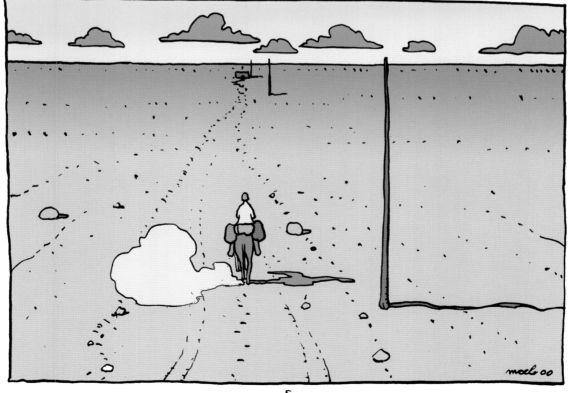

F

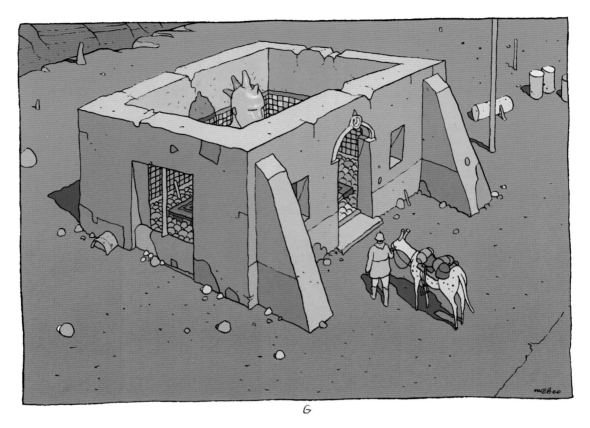

G

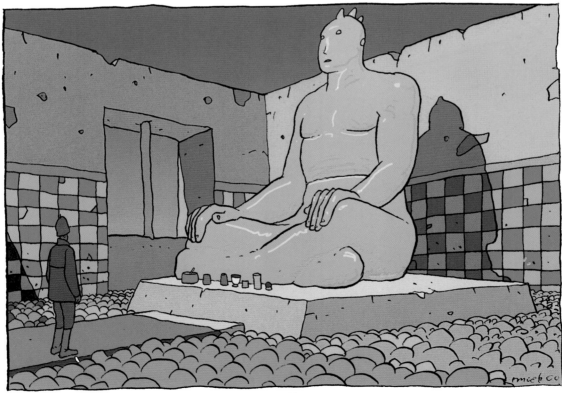

H

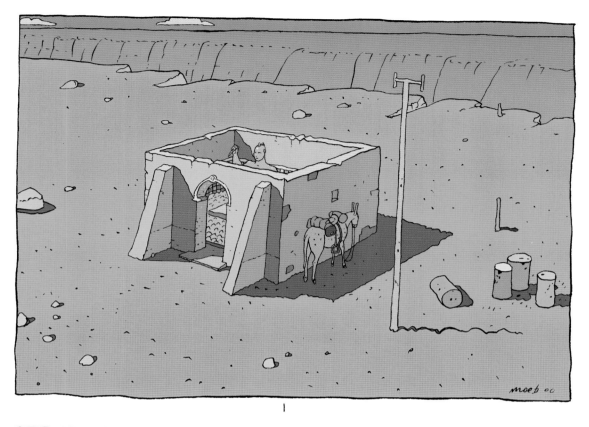

I

J

139

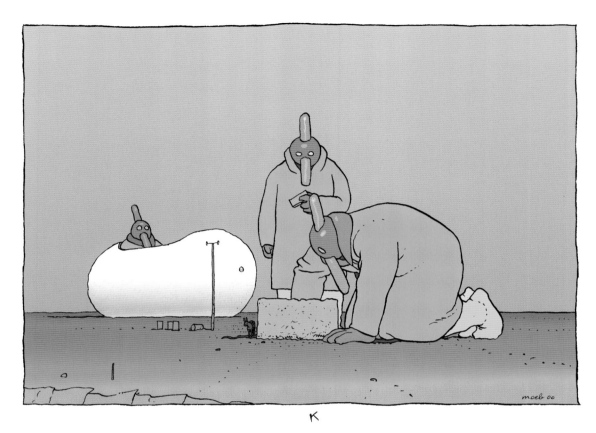

K

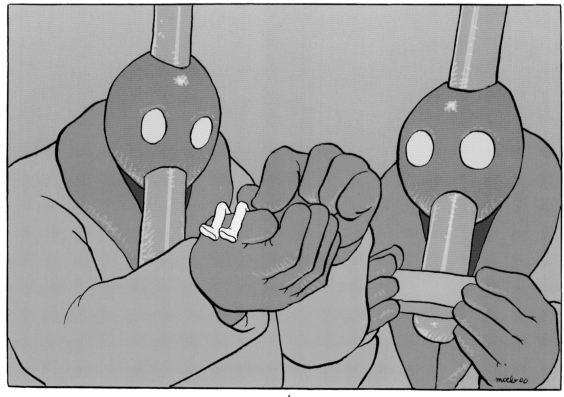

L

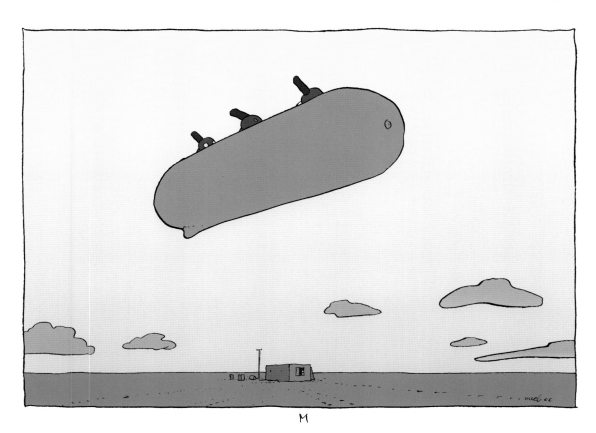

M

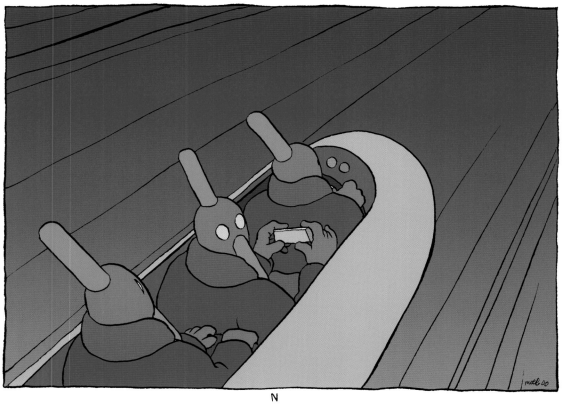

N

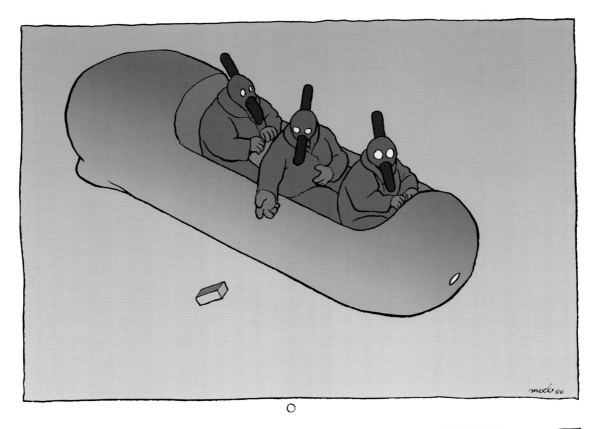

O

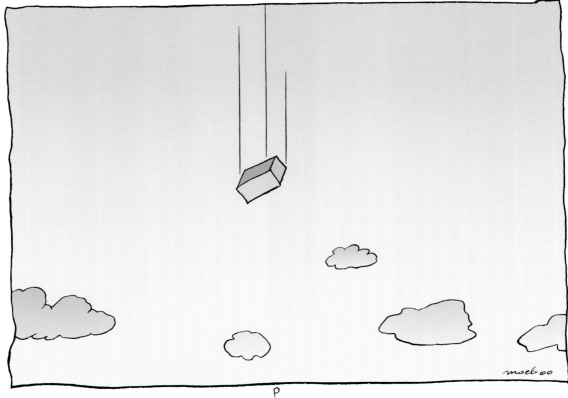

P

142

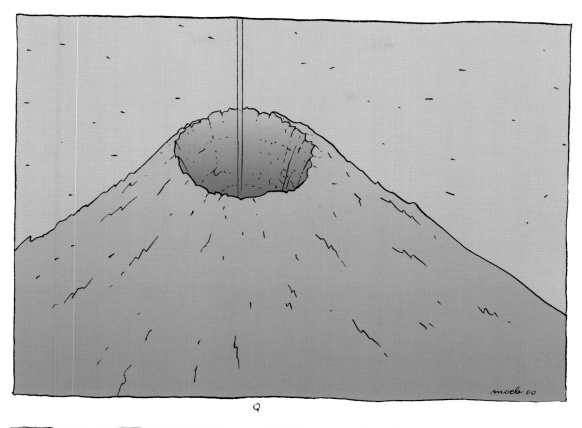

Q

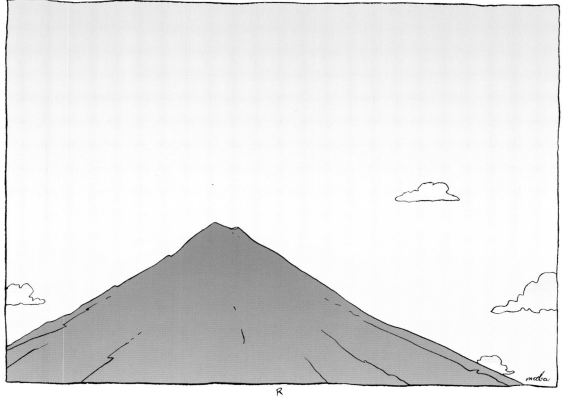

R

143

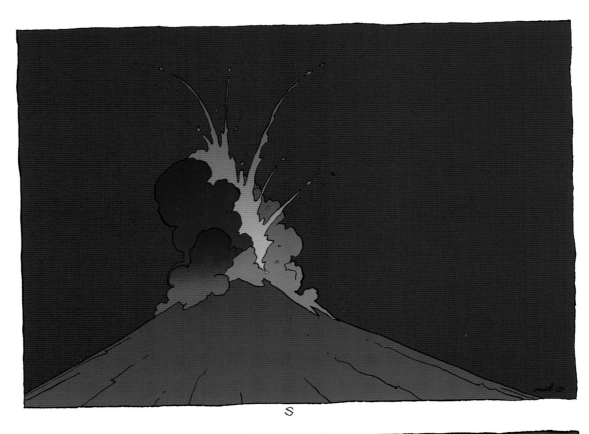

S

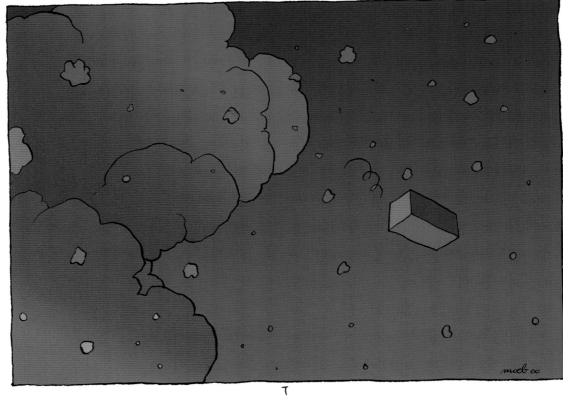

T

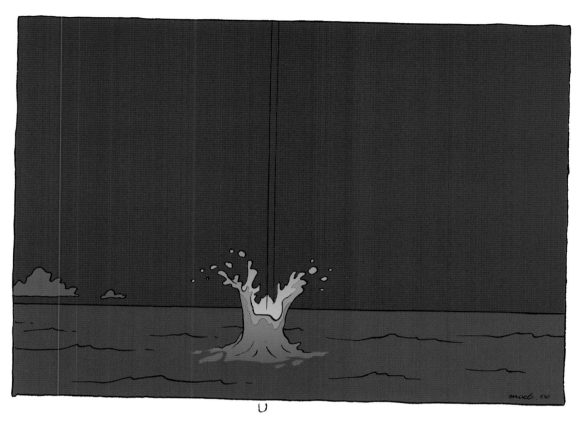

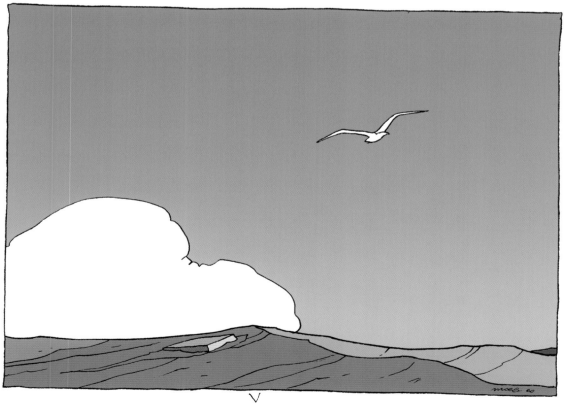

w

x

Y

Z

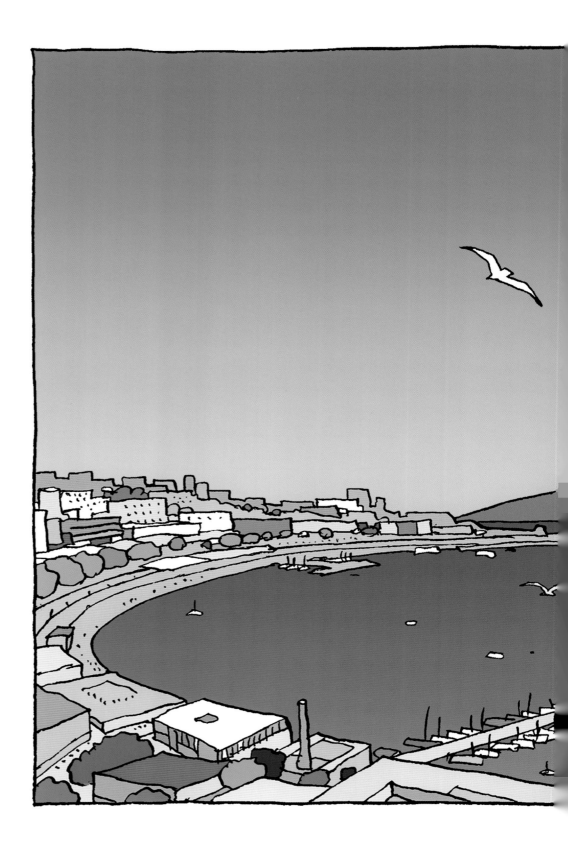

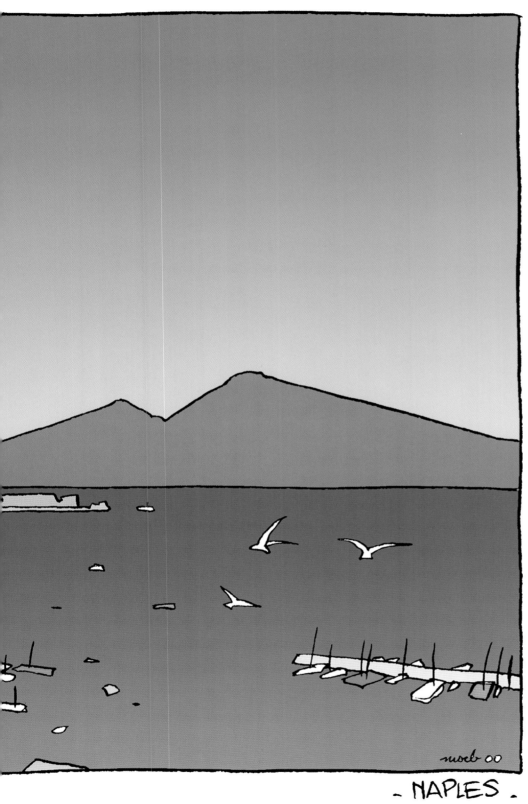

- NAPLES -

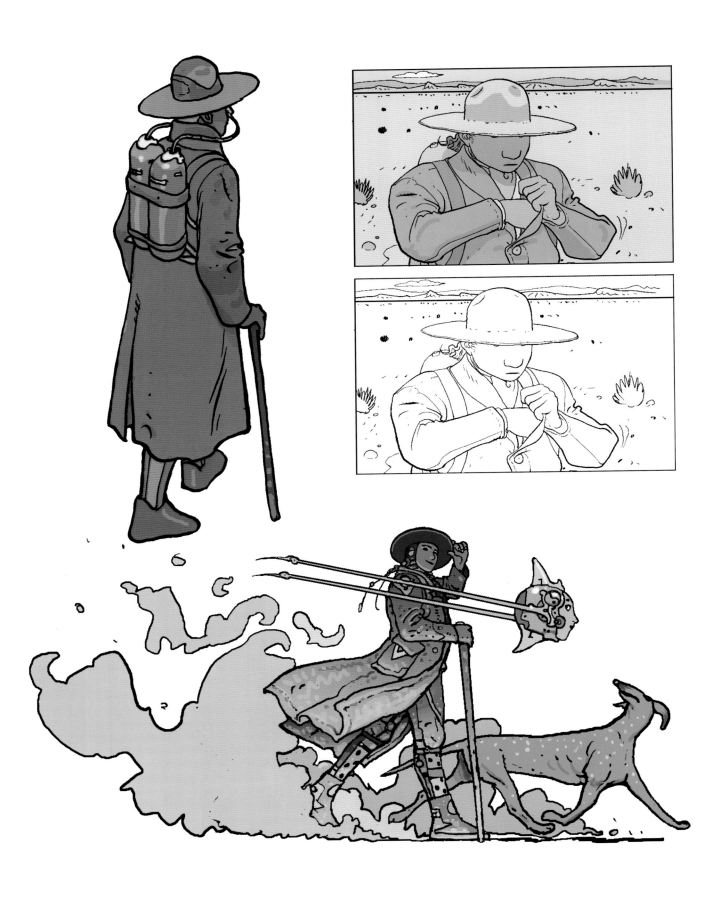

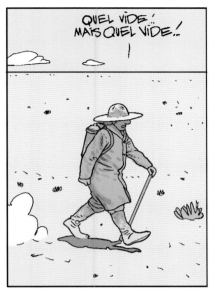

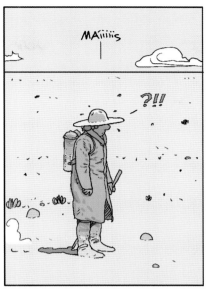

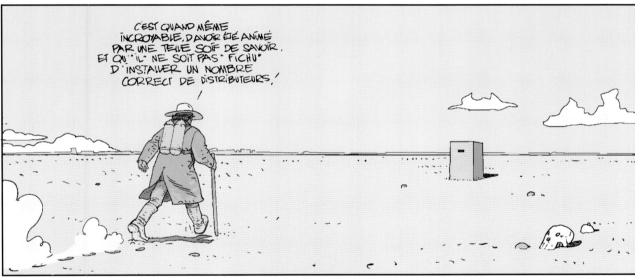

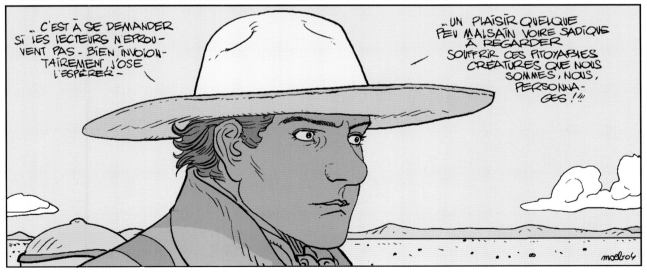

153

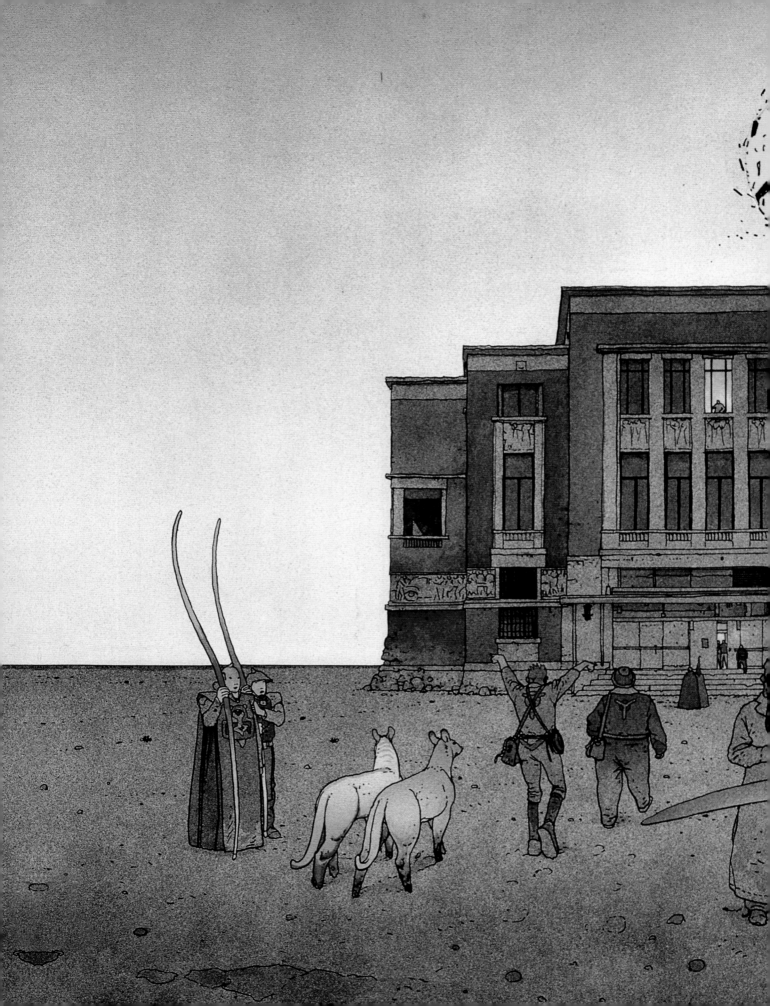

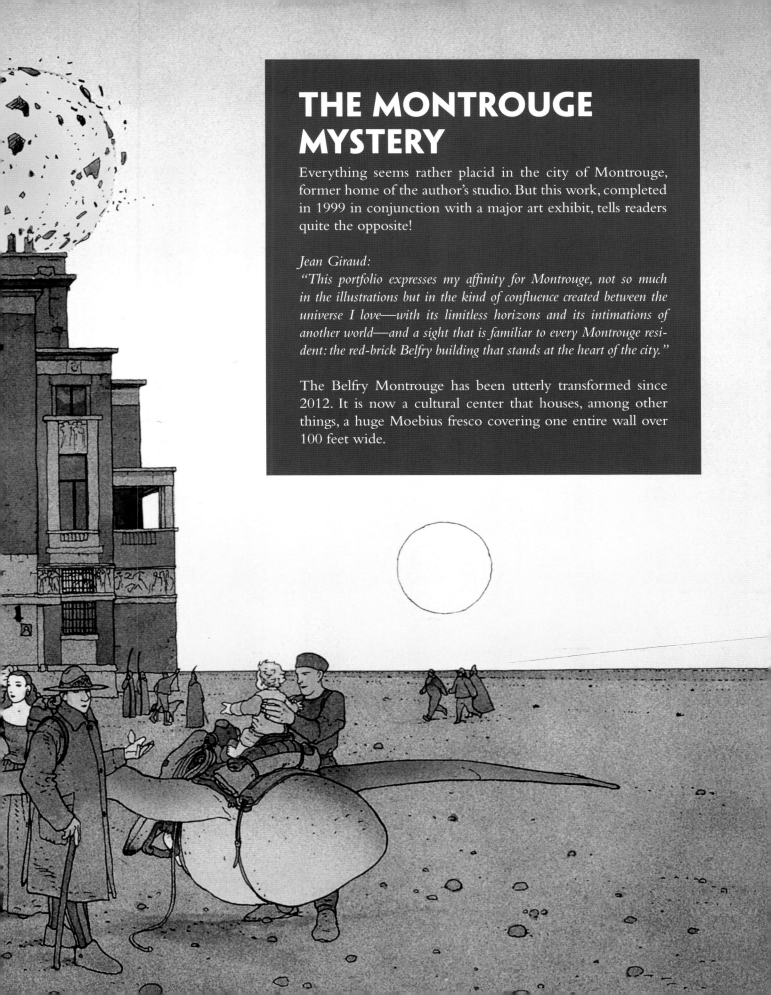

THE MONTROUGE MYSTERY

Everything seems rather placid in the city of Montrouge, former home of the author's studio. But this work, completed in 1999 in conjunction with a major art exhibit, tells readers quite the opposite!

Jean Giraud:
"This portfolio expresses my affinity for Montrouge, not so much in the illustrations but in the kind of confluence created between the universe I love—with its limitless horizons and its intimations of another world—and a sight that is familiar to every Montrouge resident: the red-brick Belfry building that stands at the heart of the city."

The Belfry Montrouge has been utterly transformed since 2012. It is now a cultural center that houses, among other things, a huge Moebius fresco covering one entire wall over 100 feet wide.

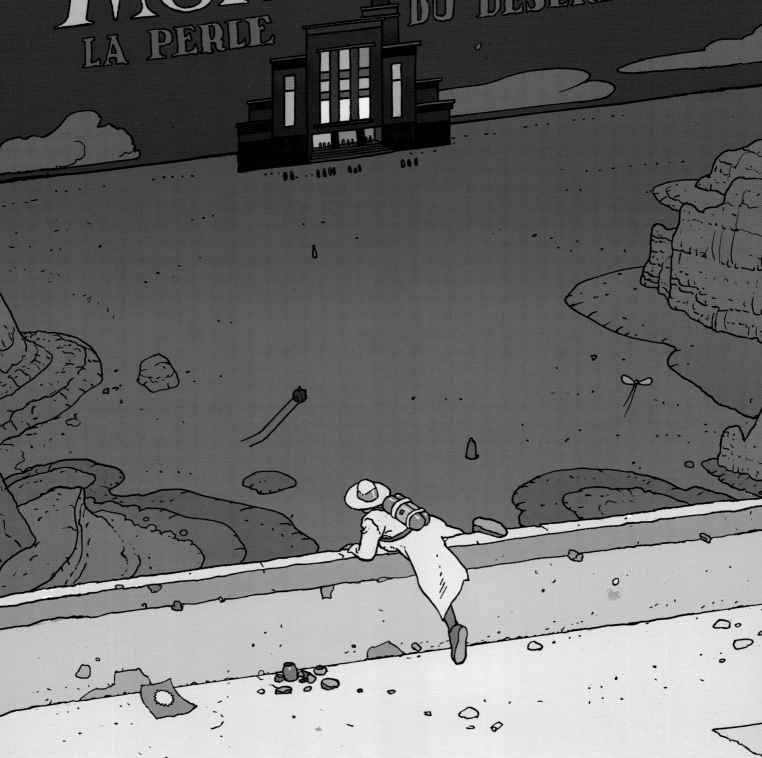

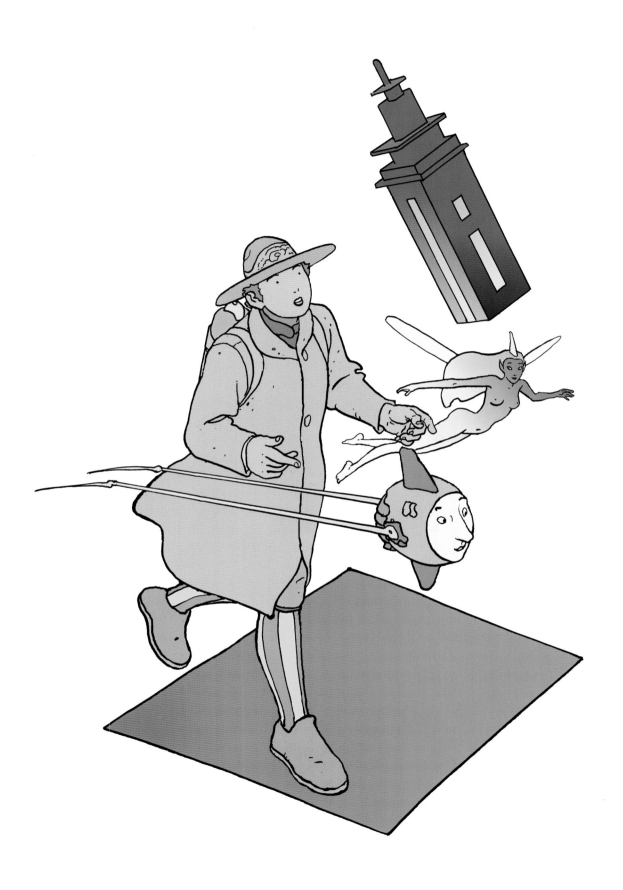

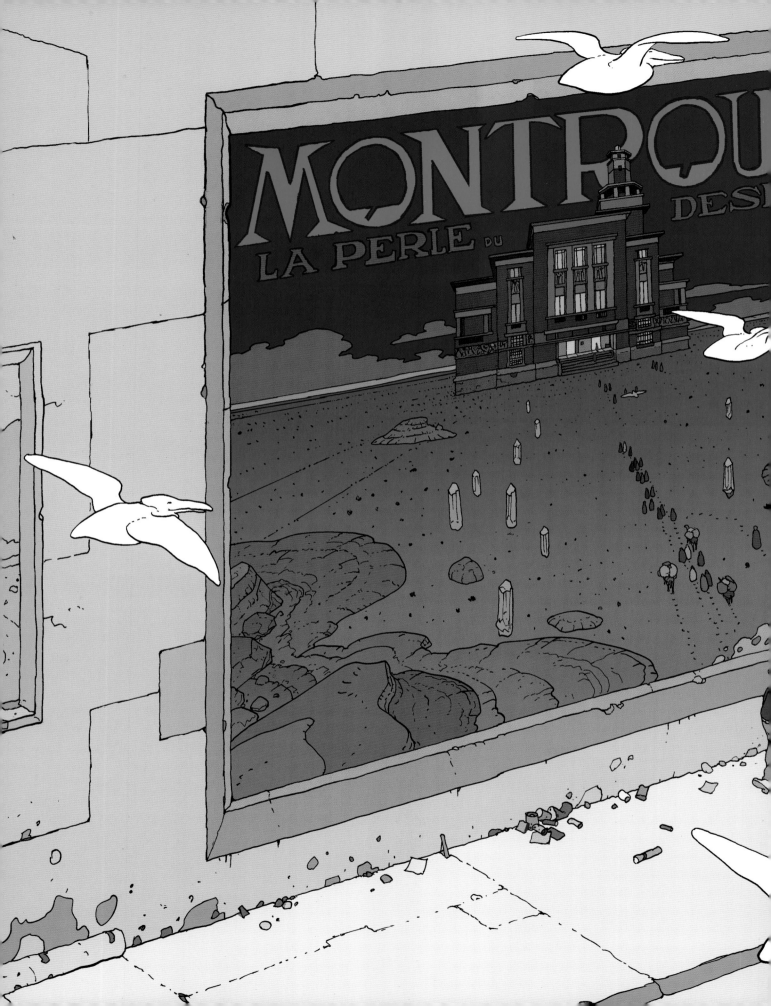

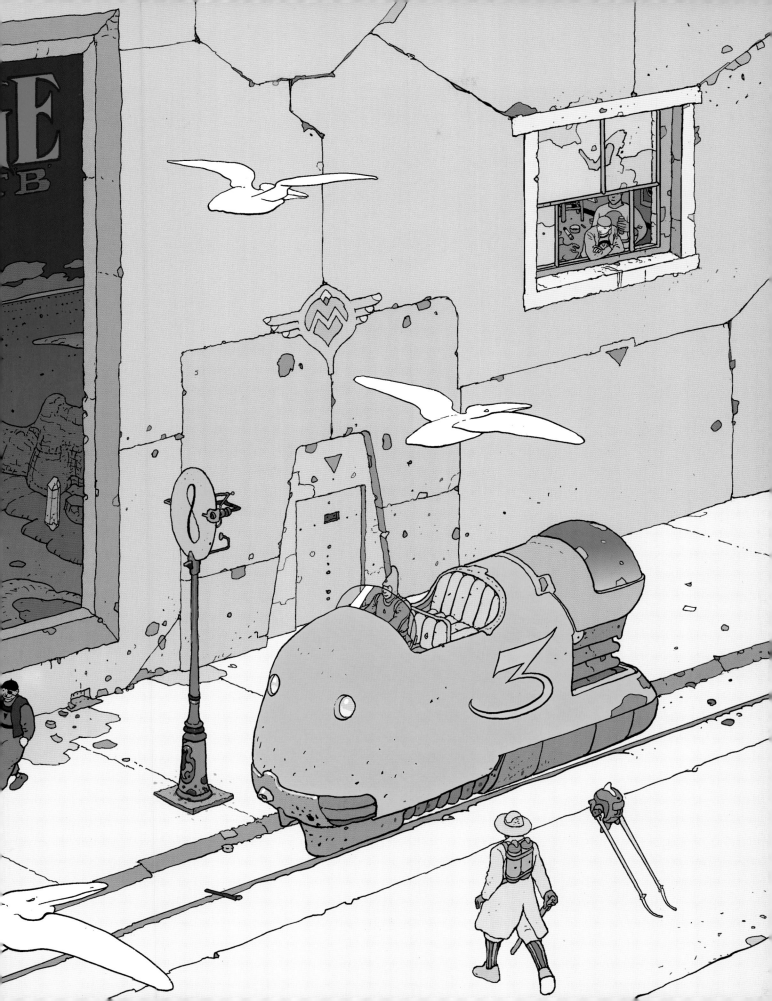

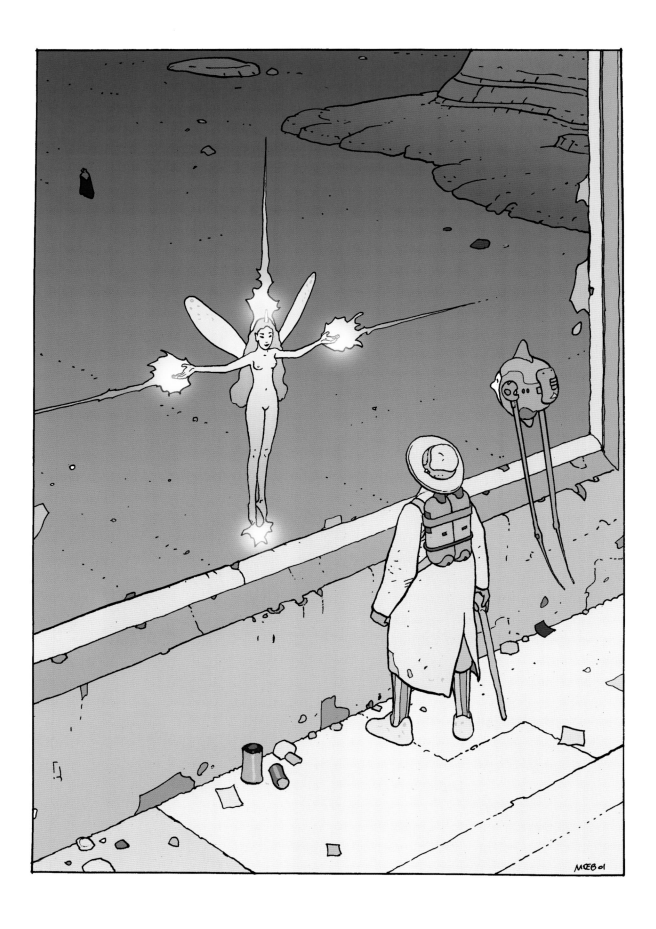

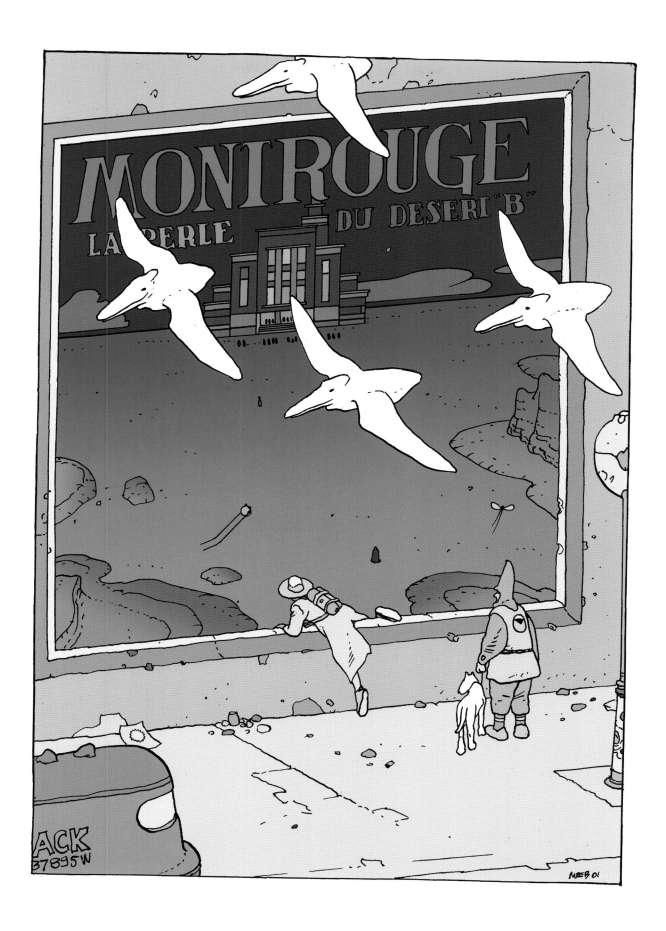

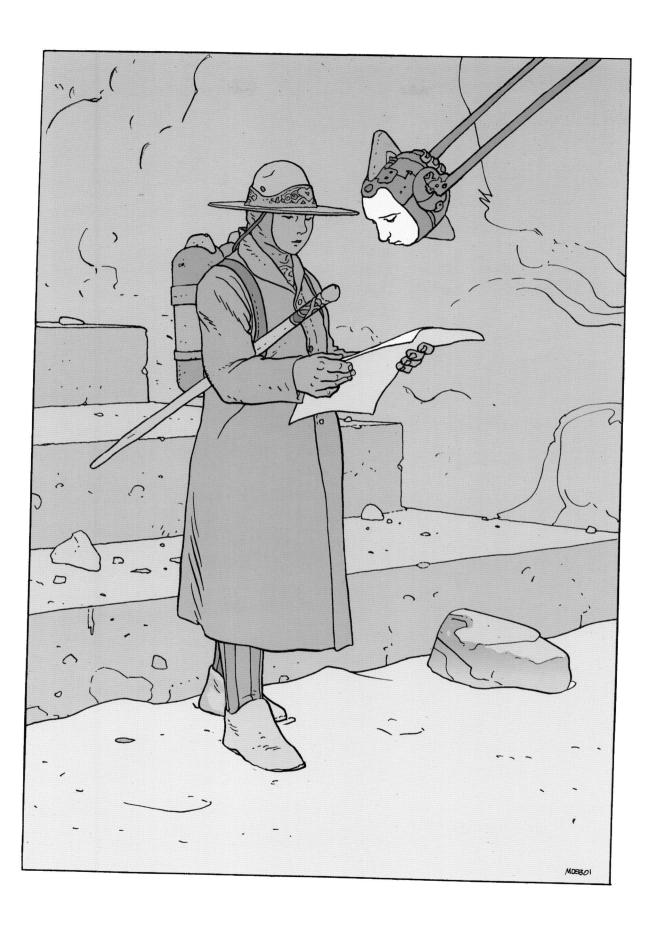

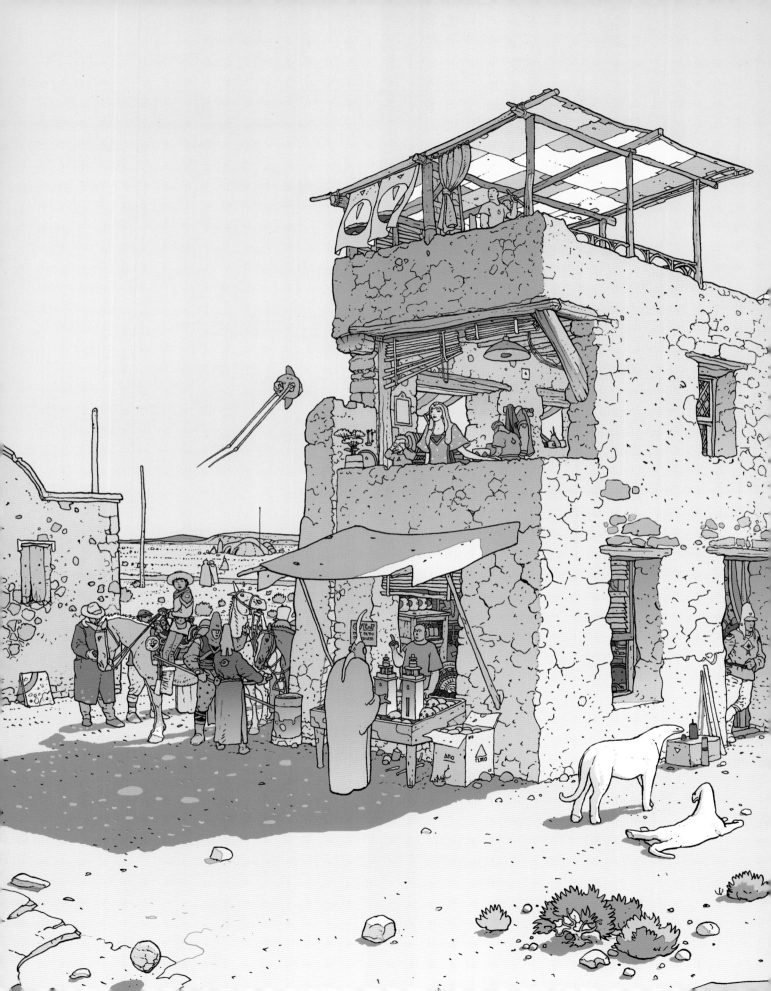

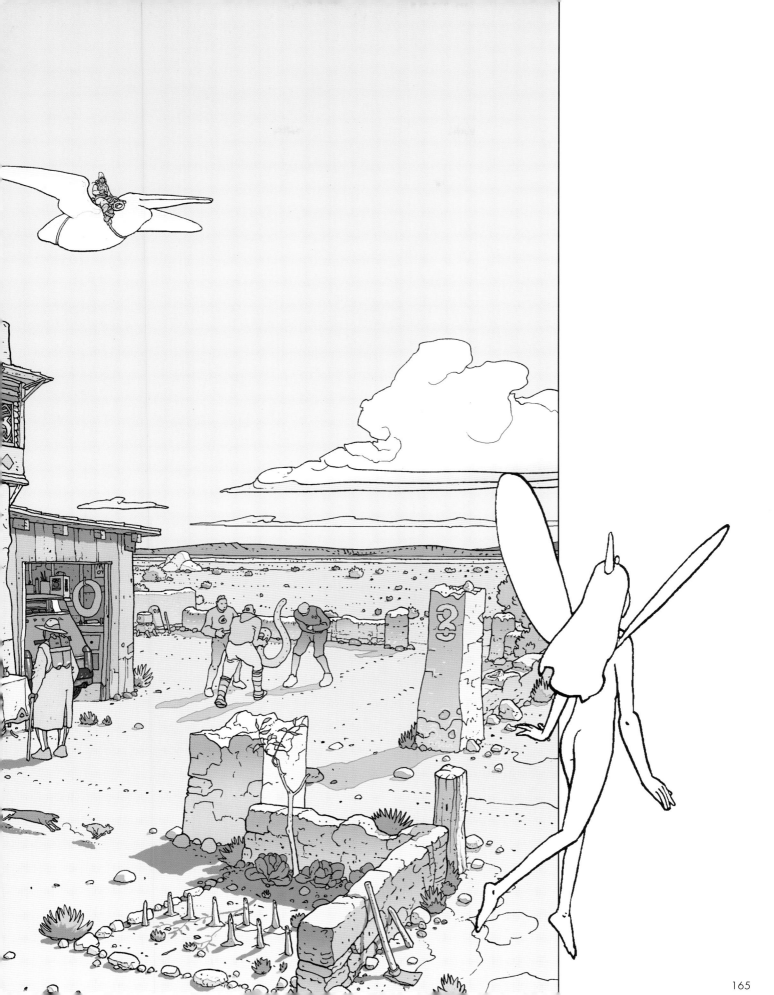

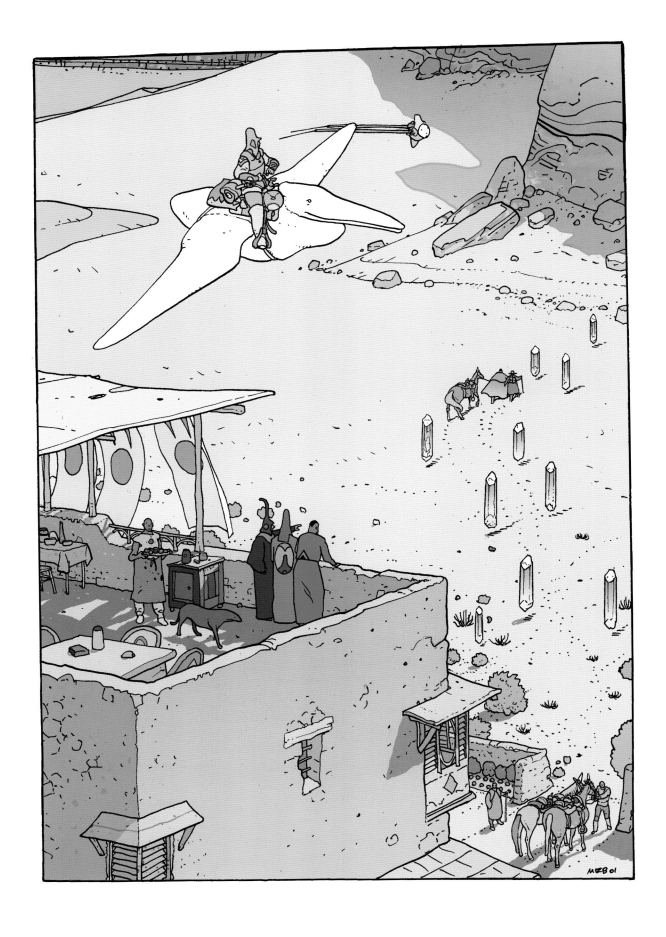

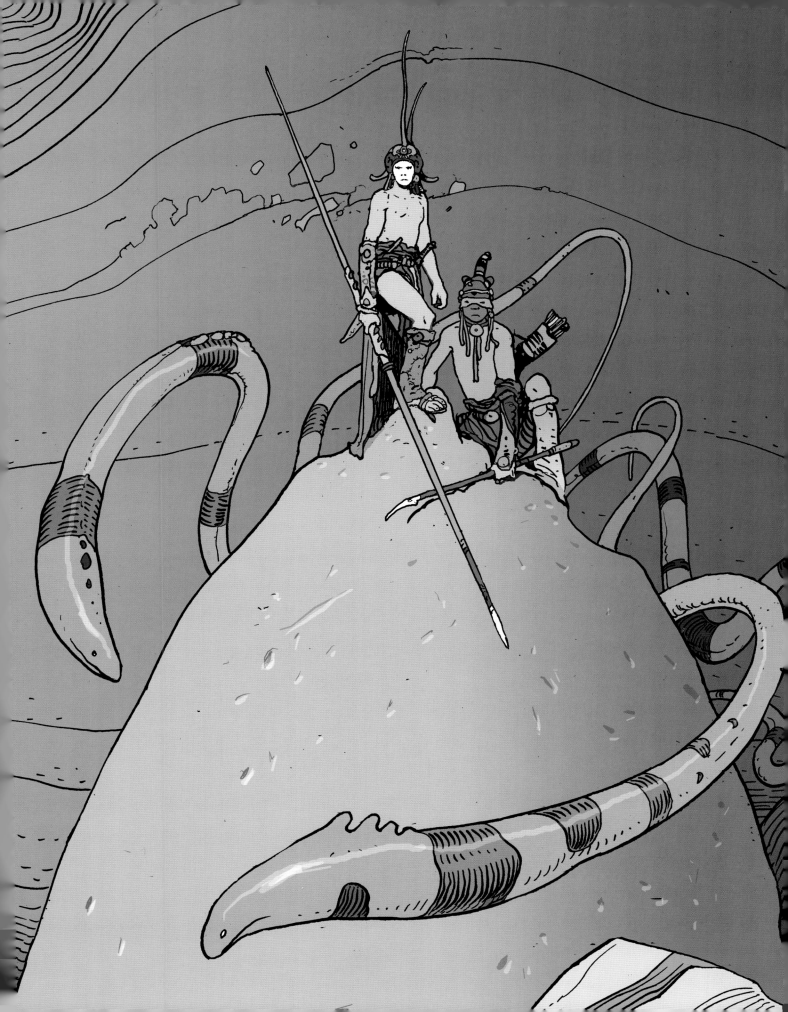

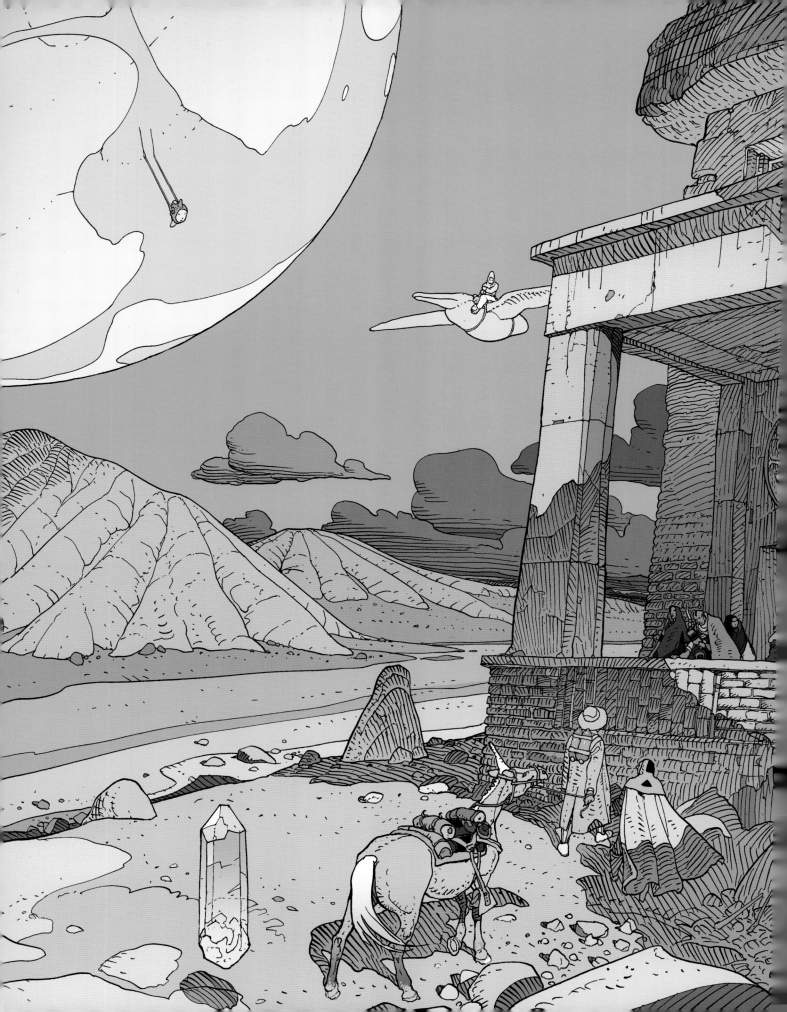

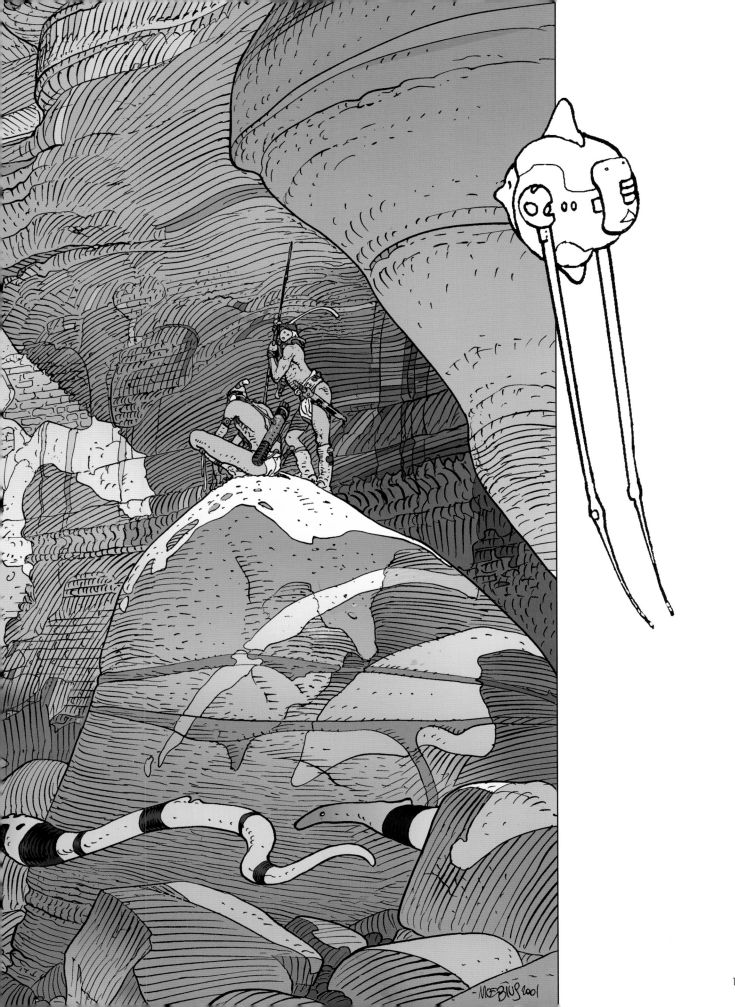

169

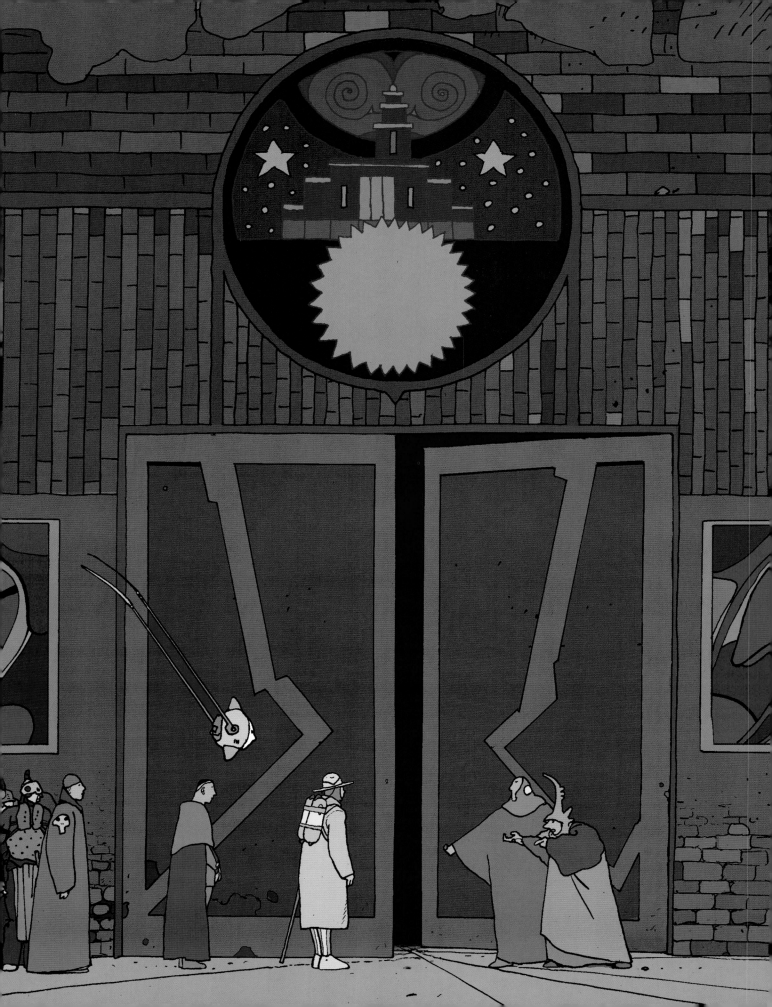

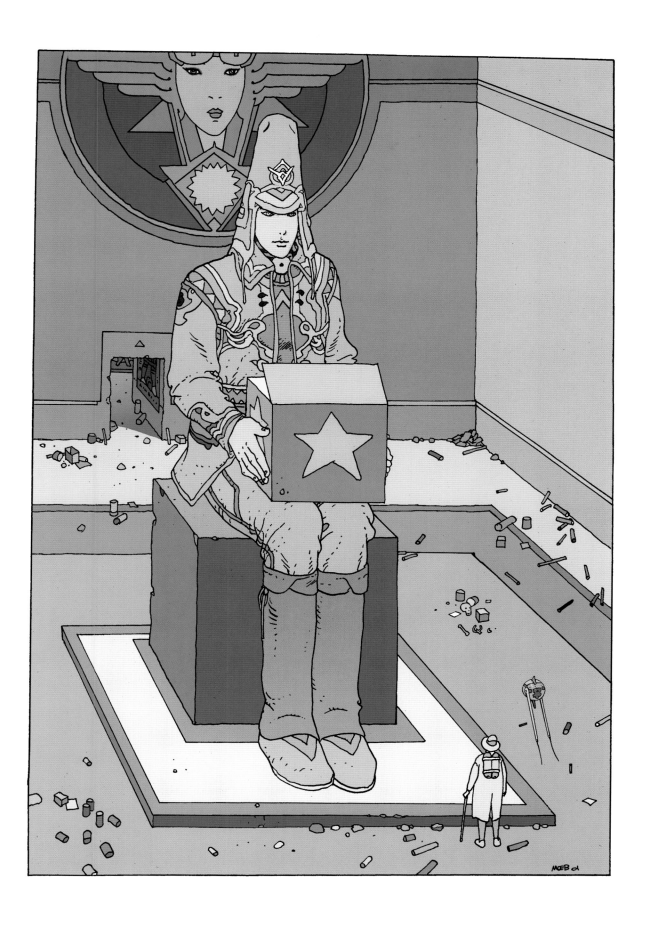

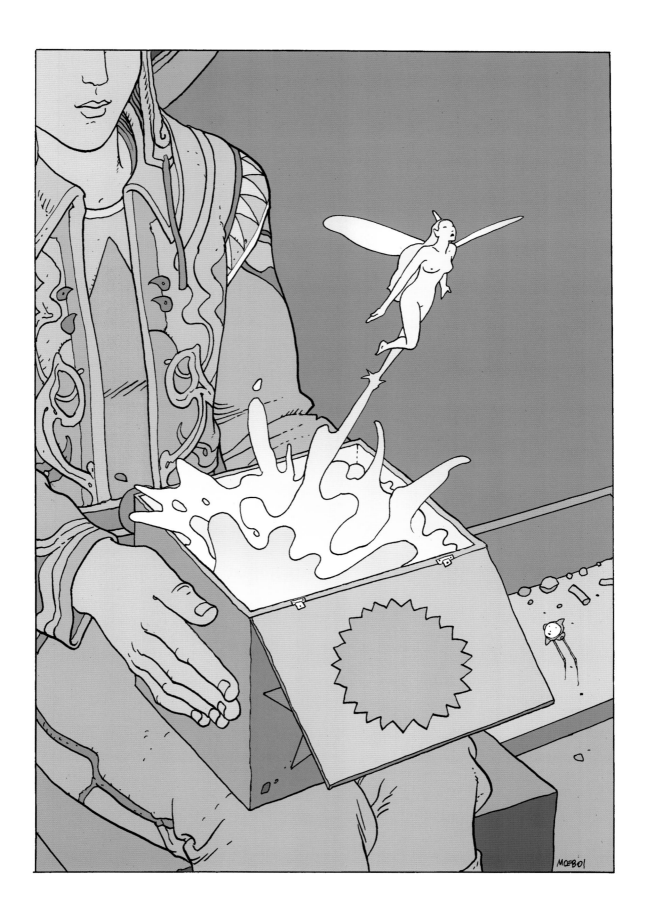

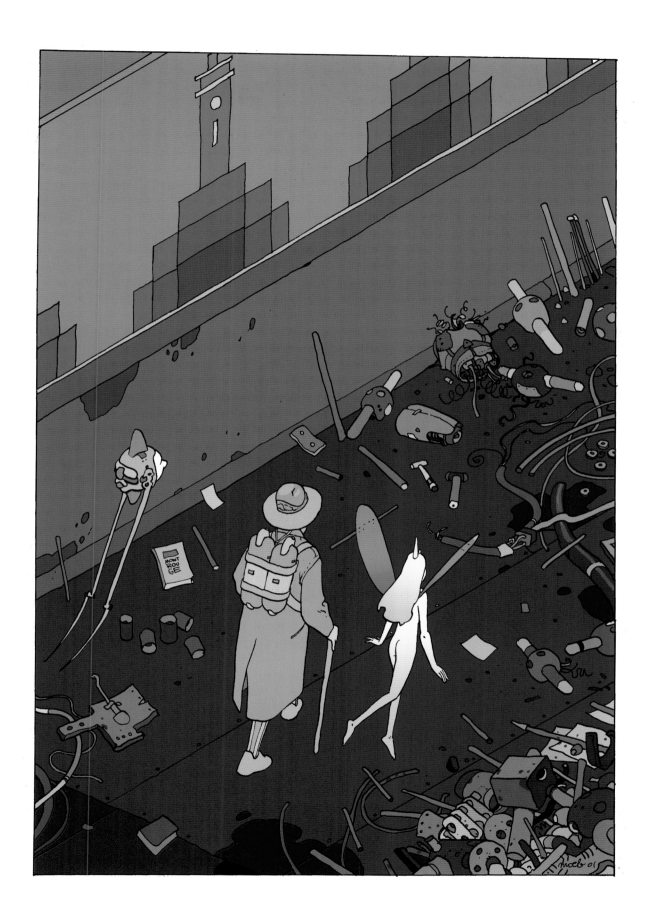

173

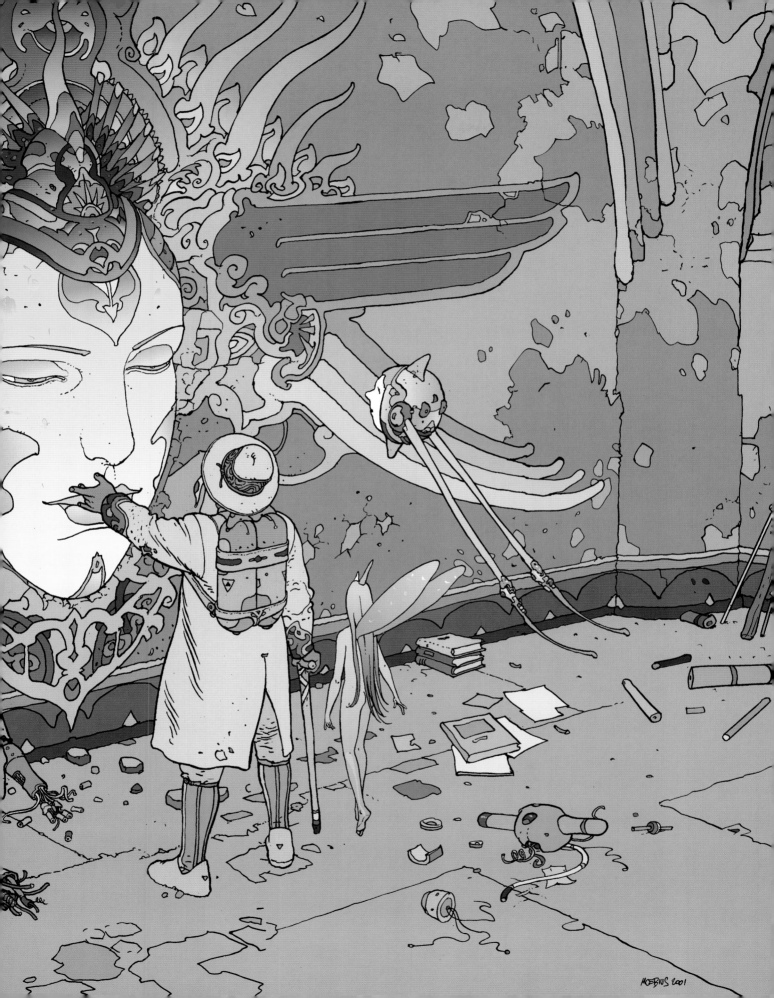

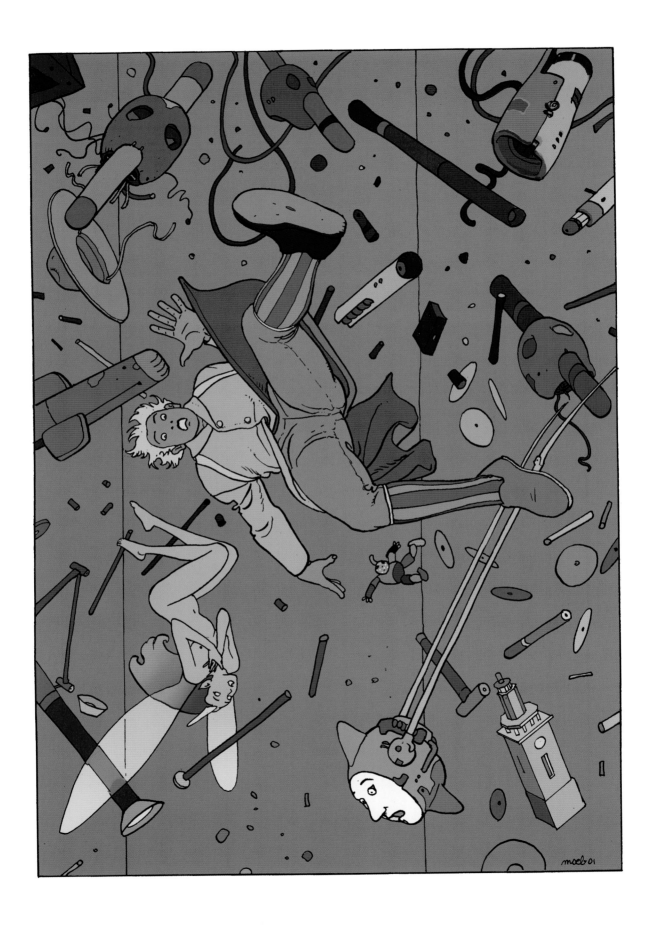

177

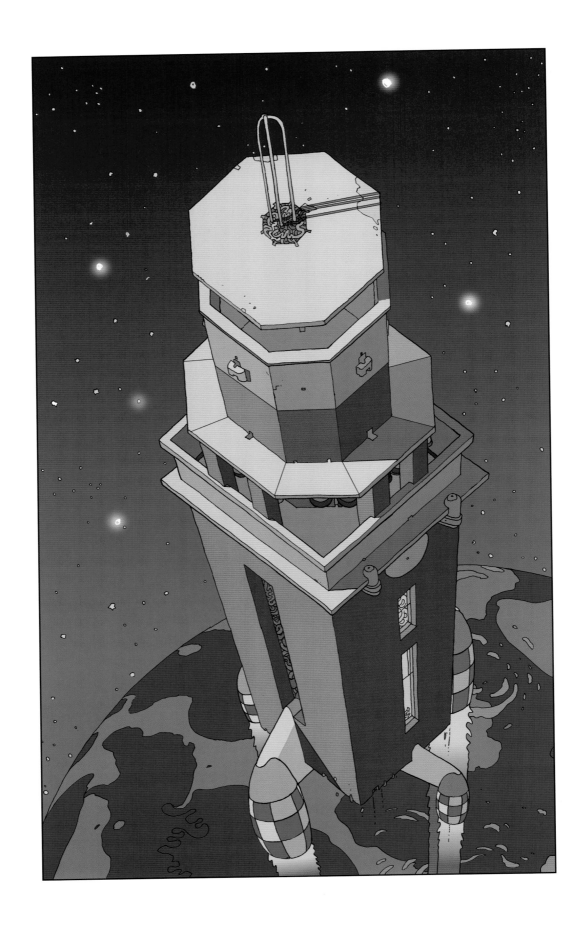

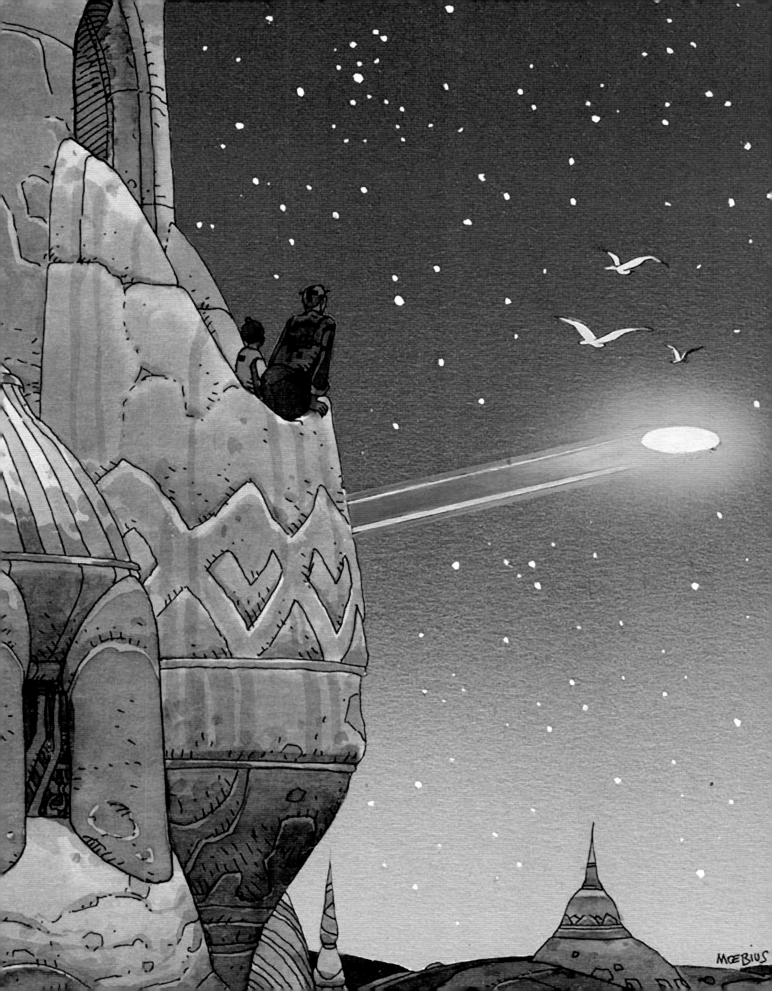

CHAPTER 4
THE JOURNEY

The Elemental to Stel, from "SRA":
"From now on, your name is 'Traveler.'"

Stel:
"The woman I'm looking for is my double . . . Her absence is what's made me the Traveler."

Whenever Moebius had a commission, one of his universes would often dictate an immediate response. Certainly, when it comes to marveling at the beauty of all existence or using every one of our senses to converge with the essence of other beings, or things, the world of Edena provides the perfect setting. This particular excursion calls, first of all, for having an extraordinary vehicle at hand; letting ourselves be carried away by our dreams to rise slightly above the world; then embarking on the adventure, open and ready for all discoveries, even those that may significantly change our direction along the way. The journey offers us the chance to awaken all our senses and, in the process, to find meaning in our lives.

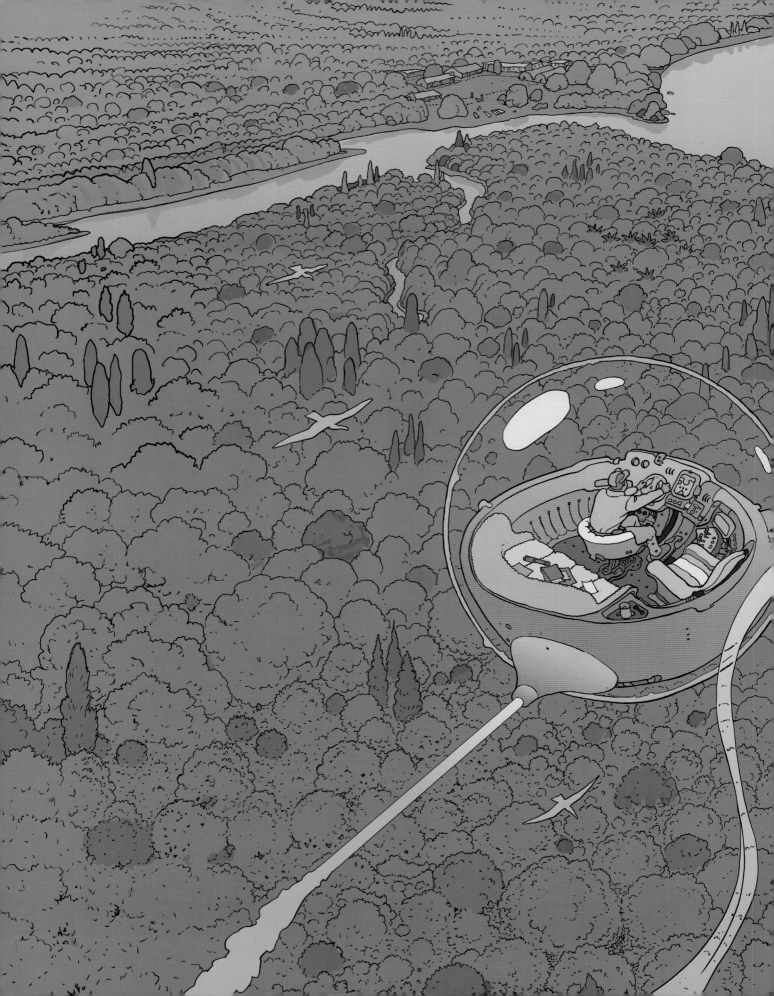

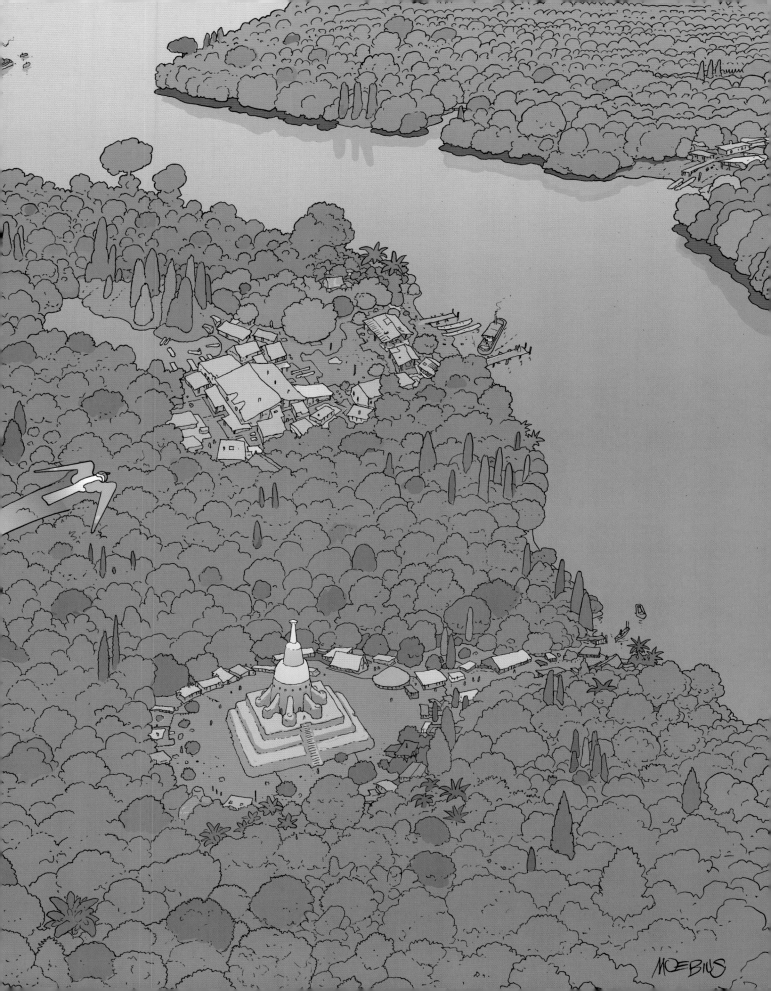

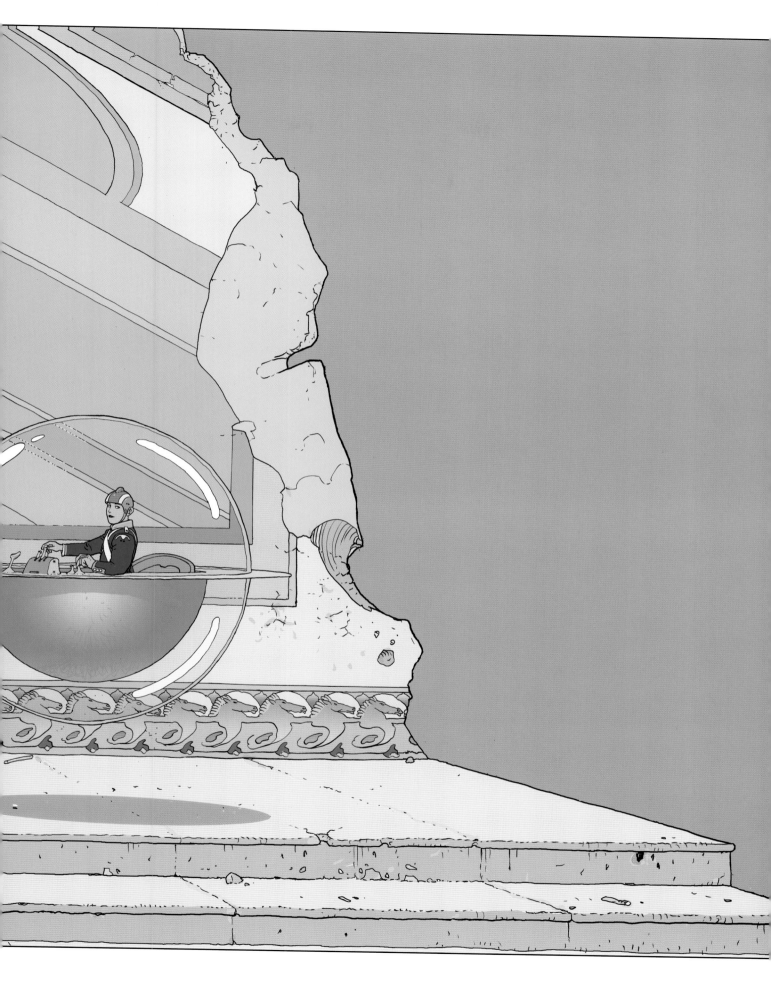

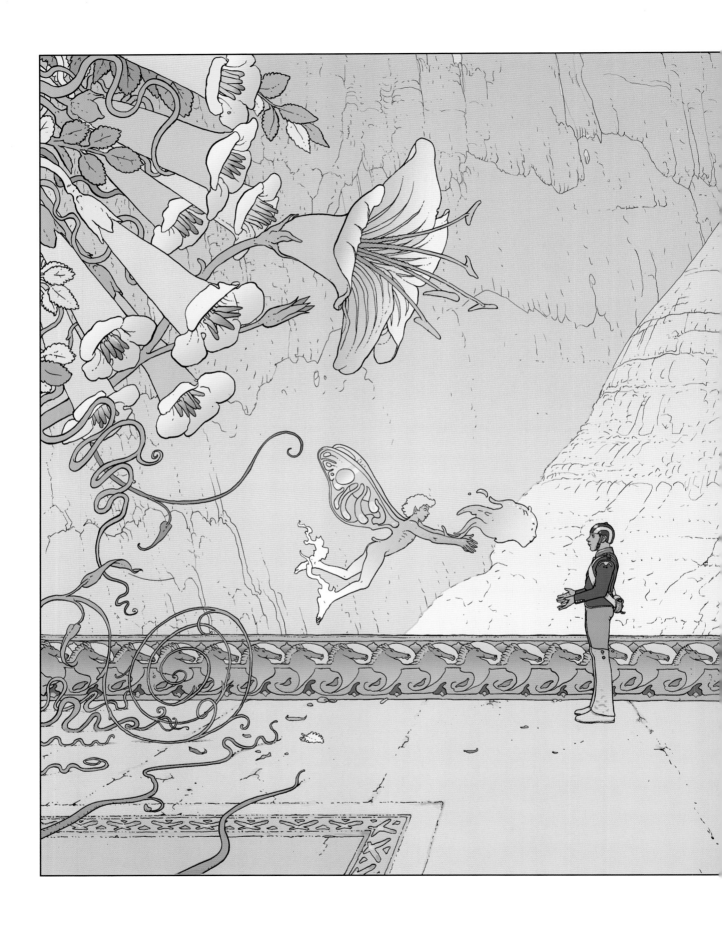

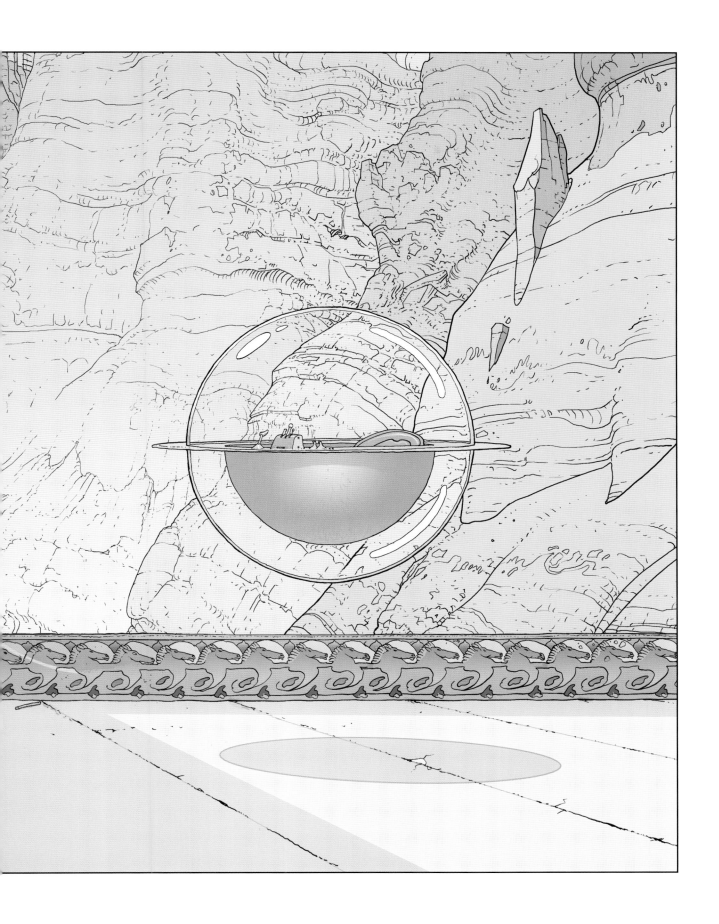

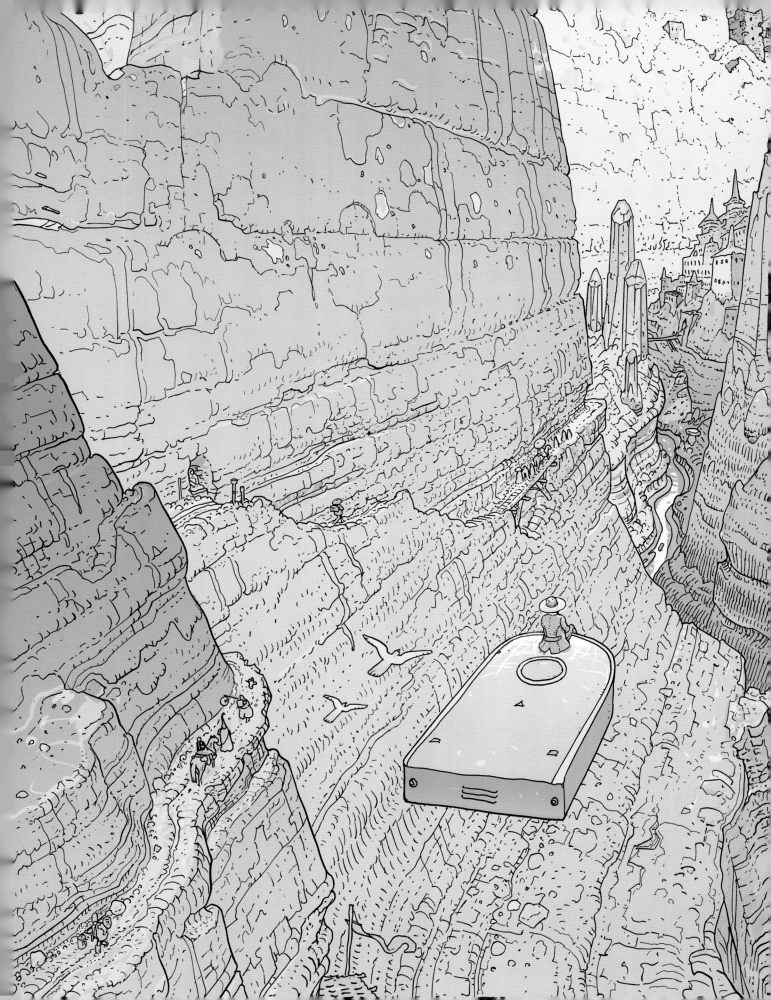

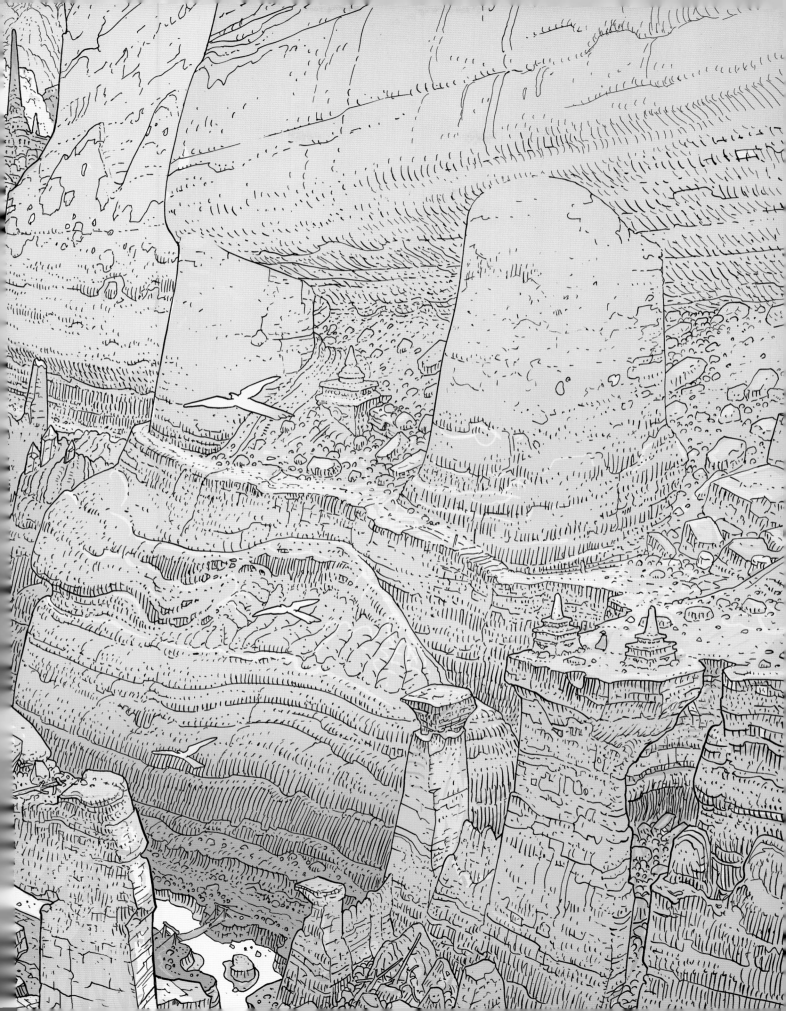

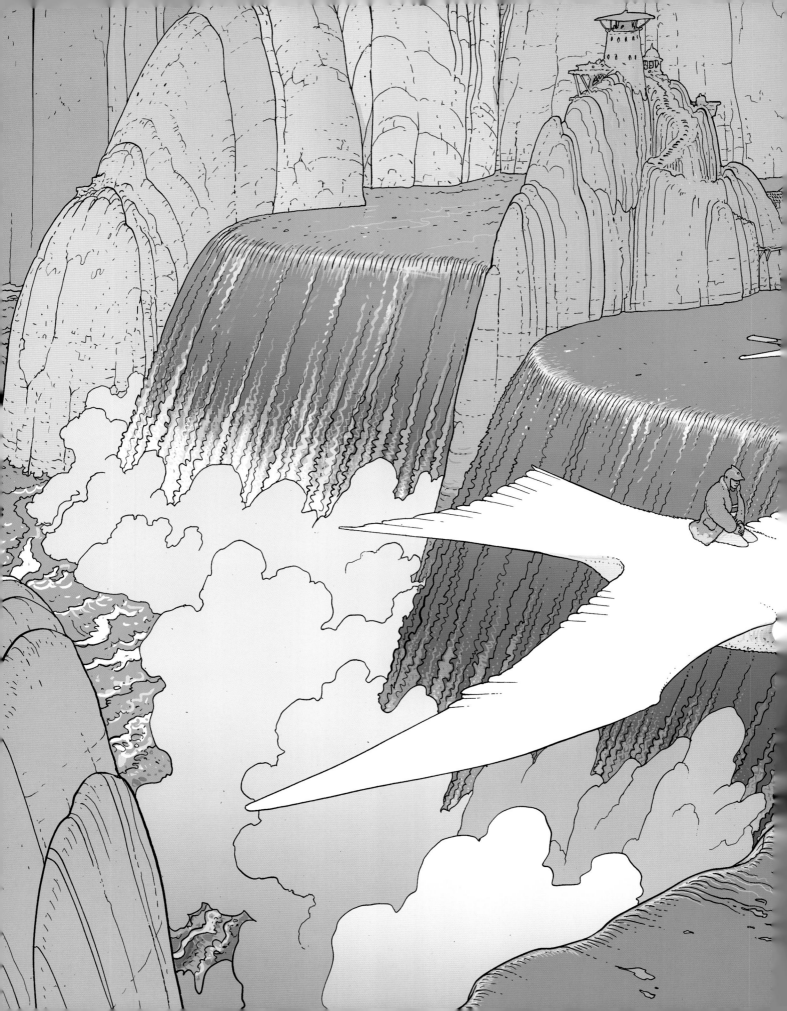

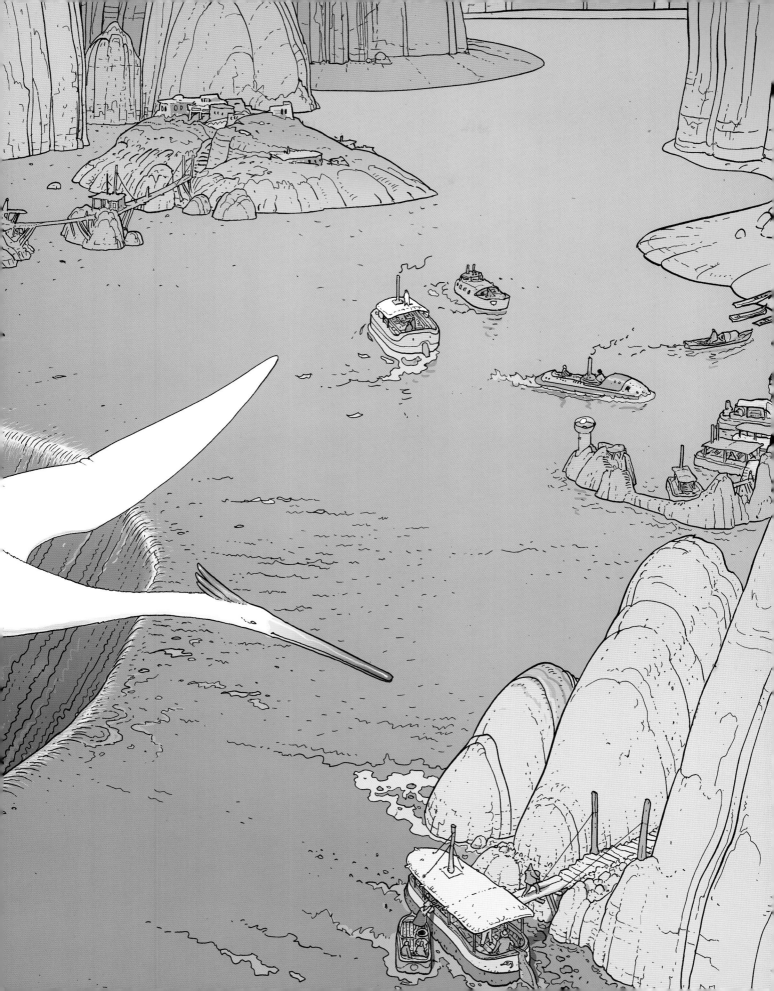

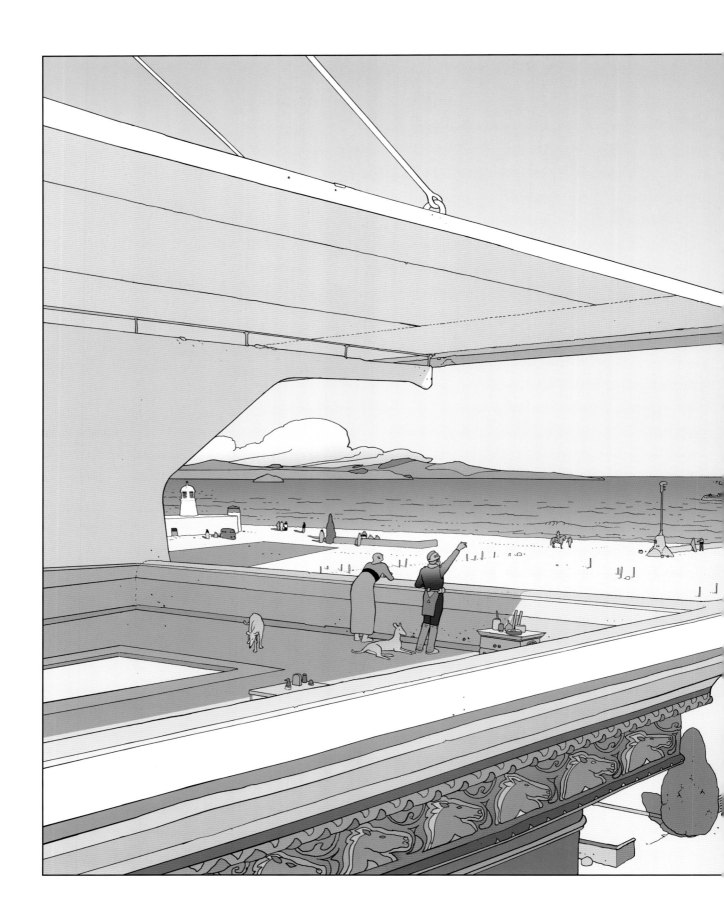

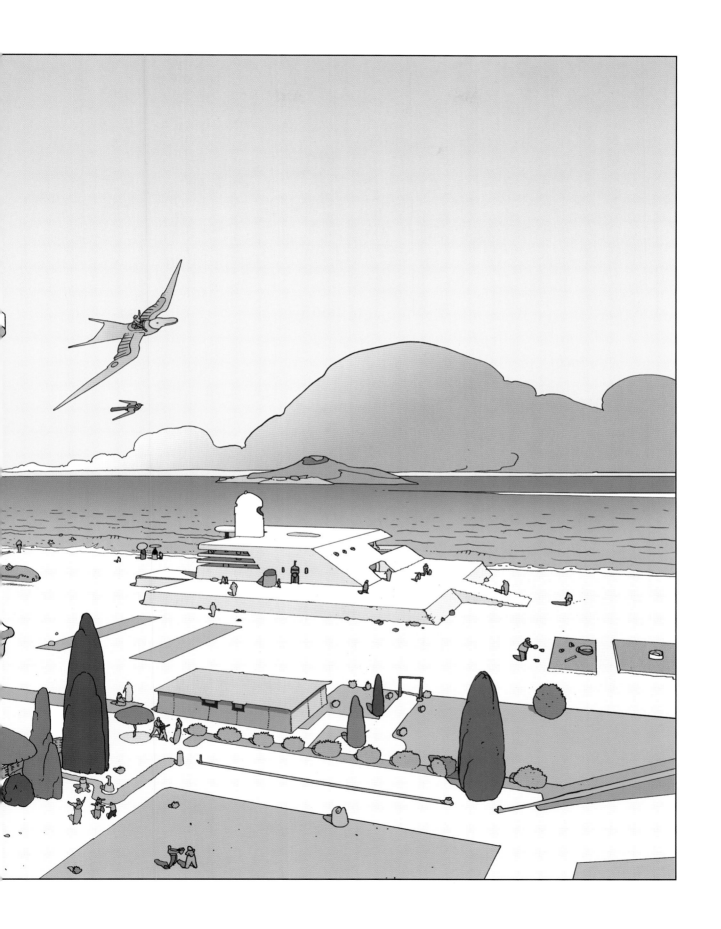

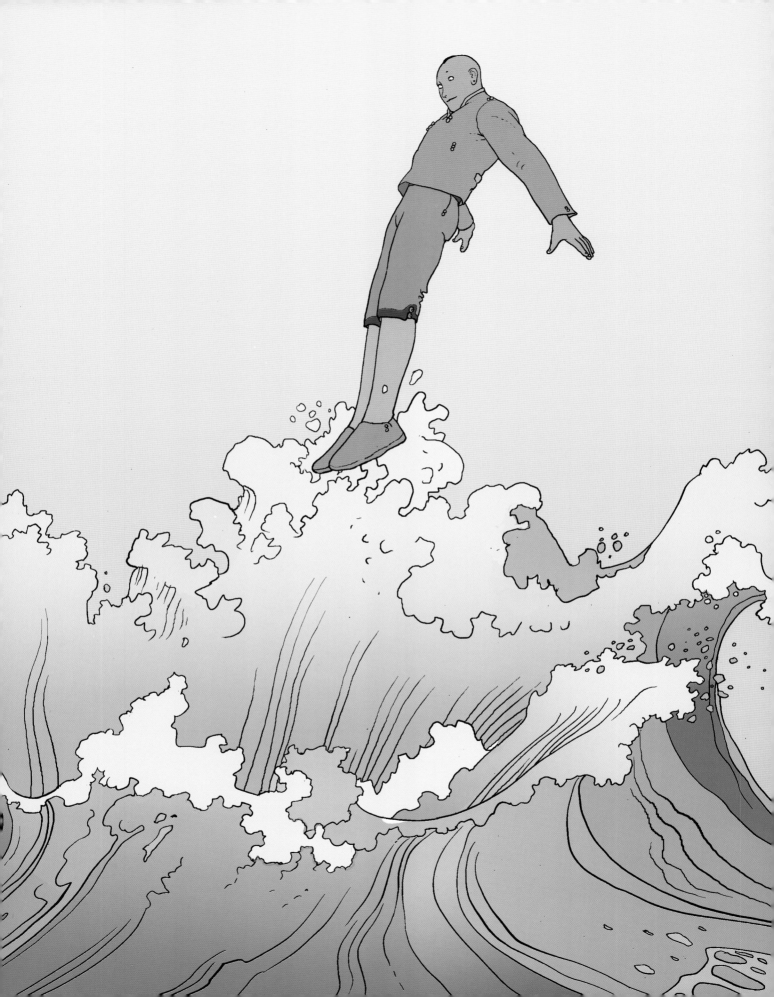

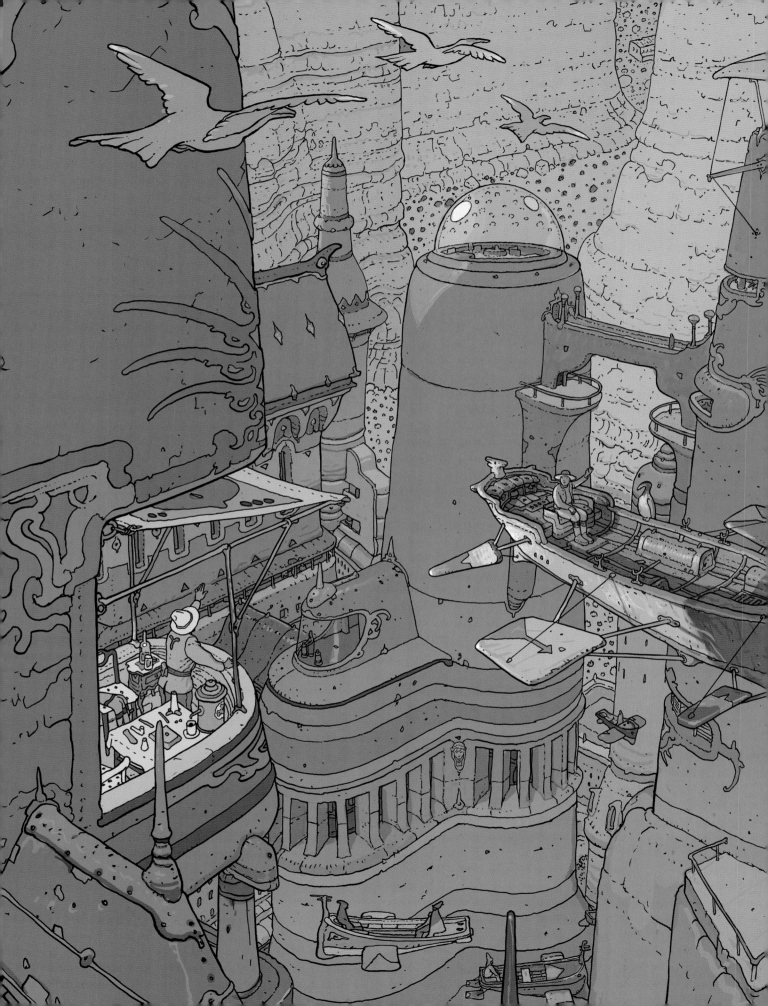

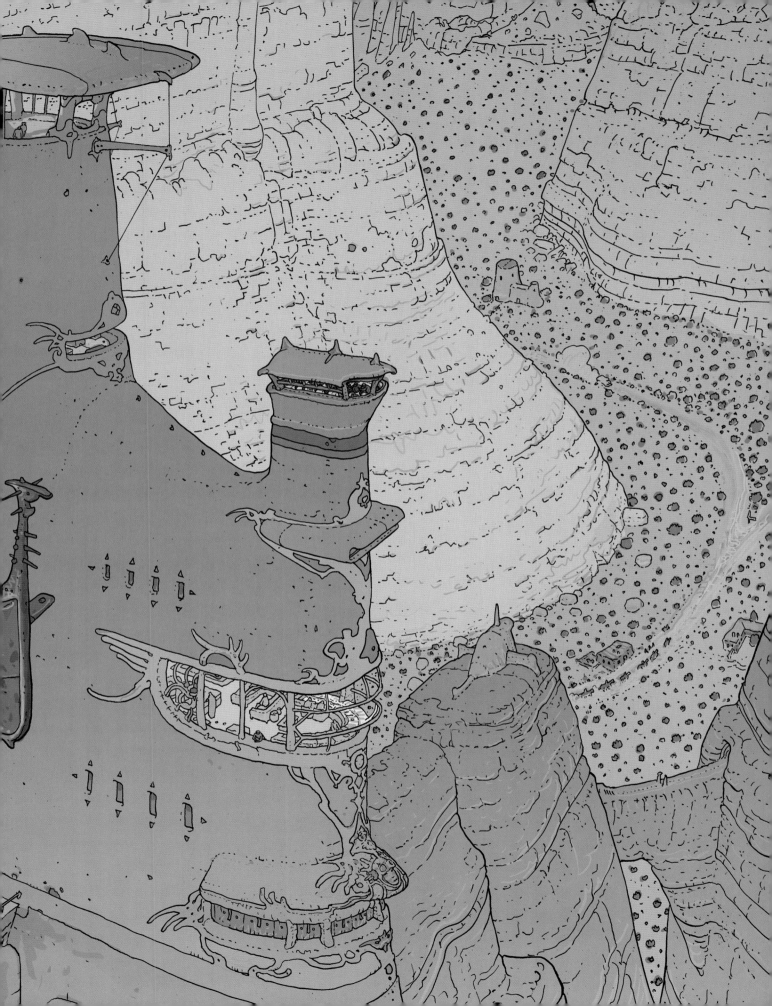

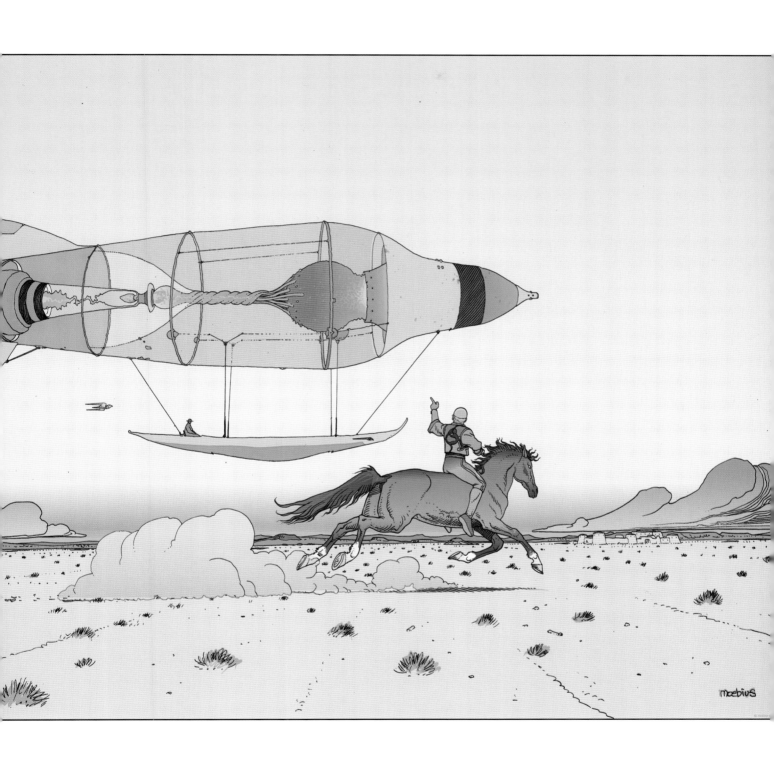

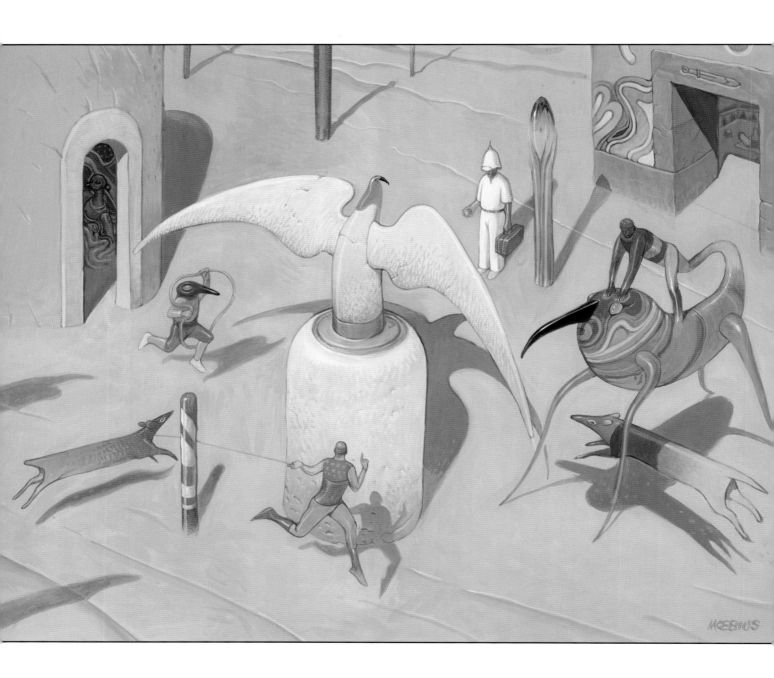

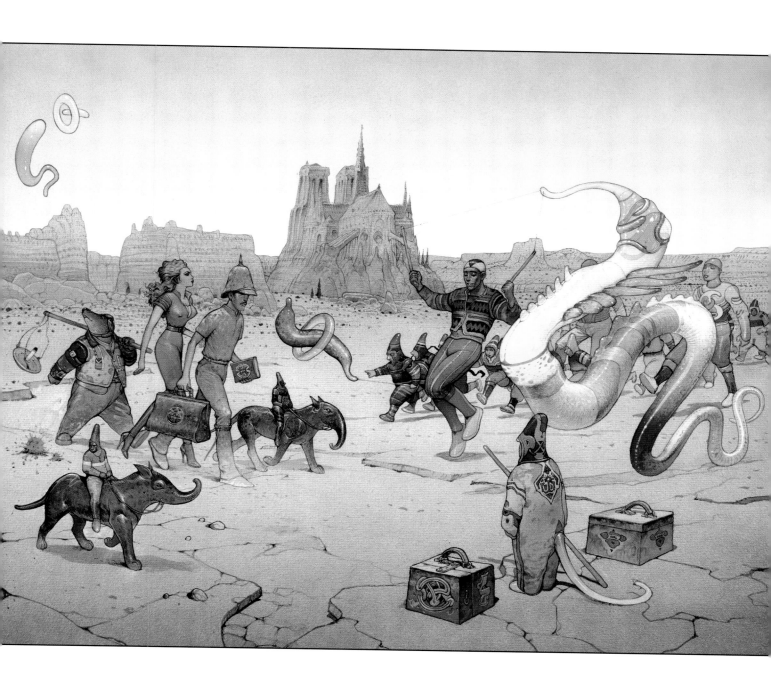

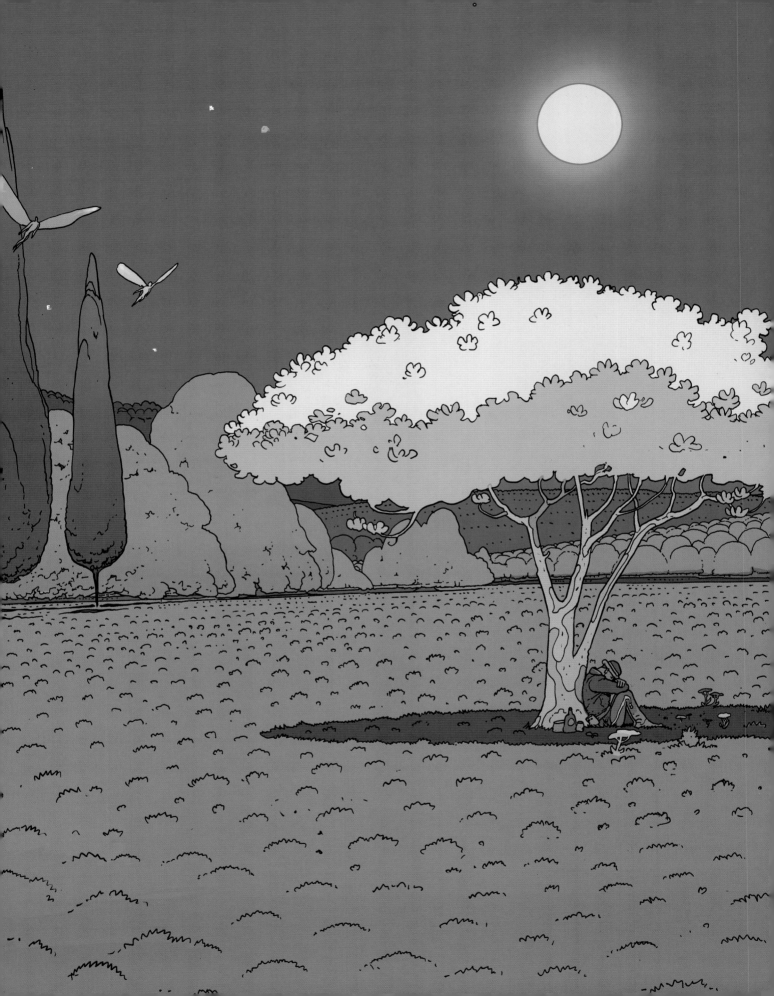

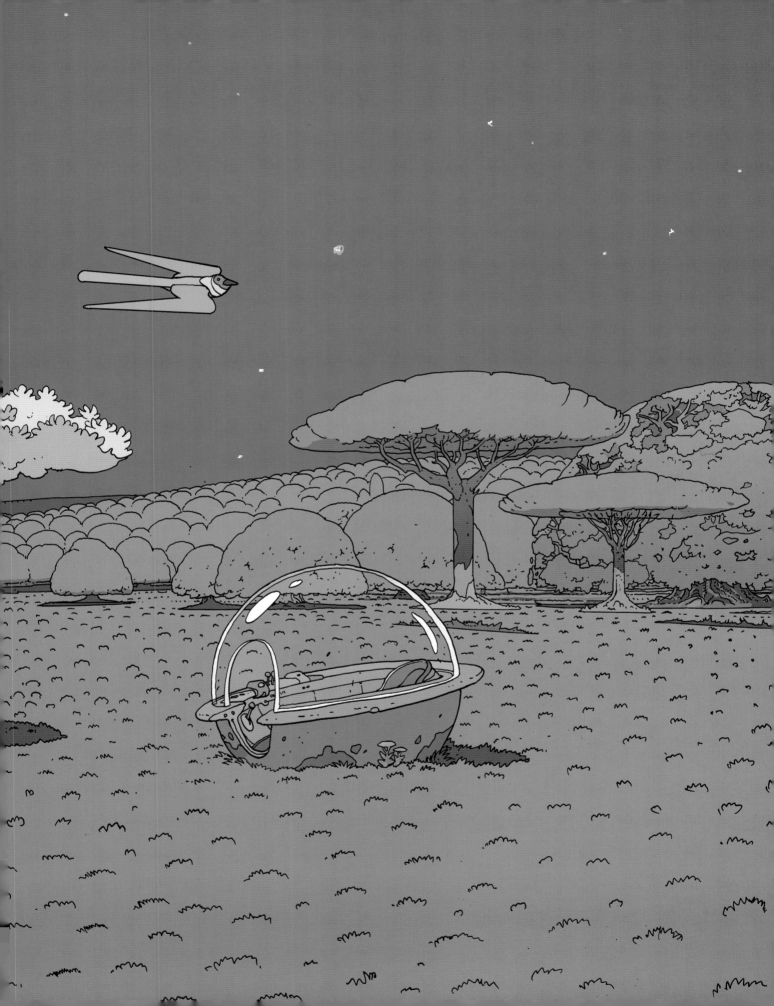

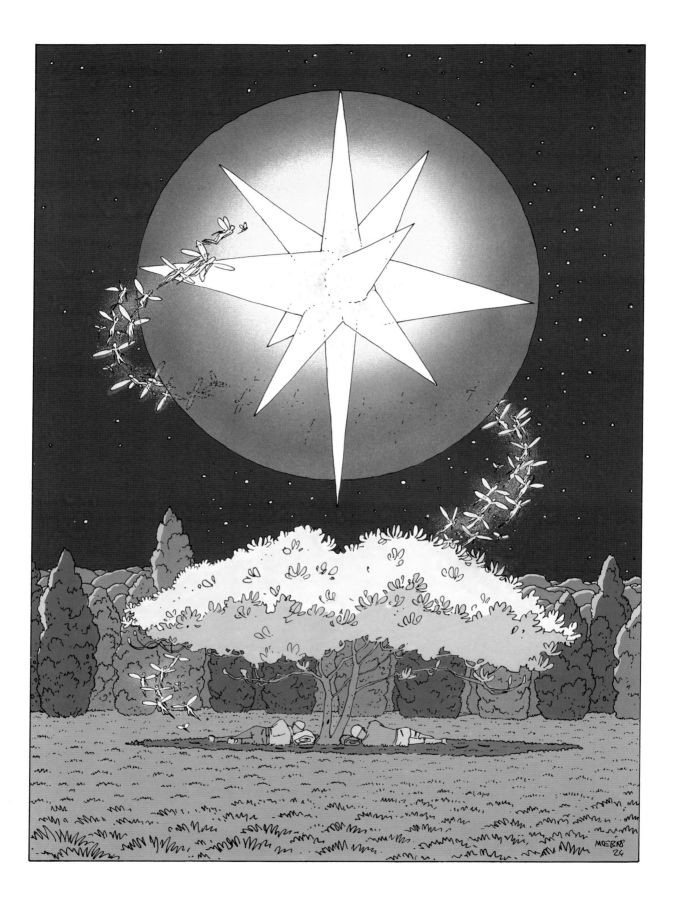

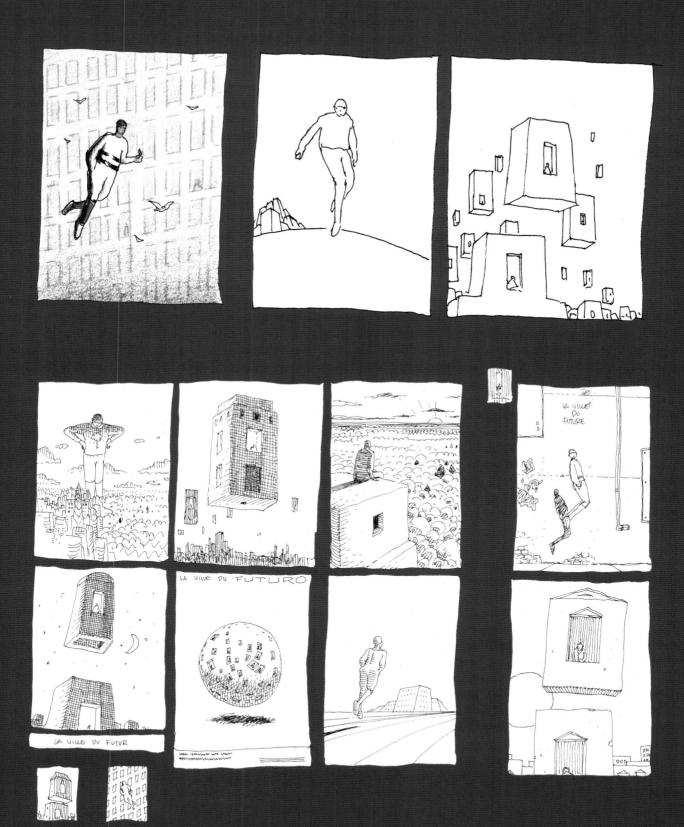

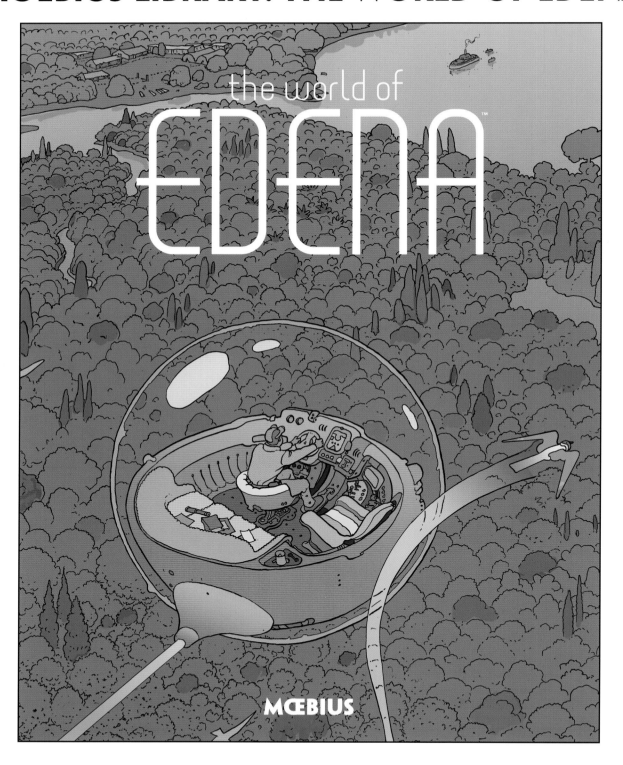

MOEBIUS LIBRARY: INSIDE MOEBIUS
PARTS 1 TO 3

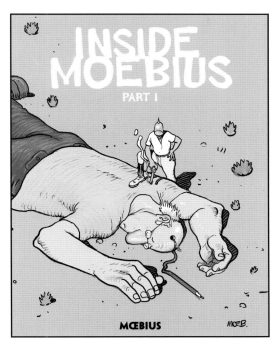

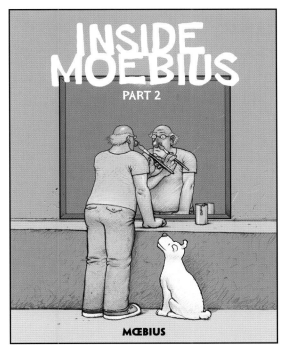

THREE VOLUMES IN 2018

SEE YOU SOON . . .

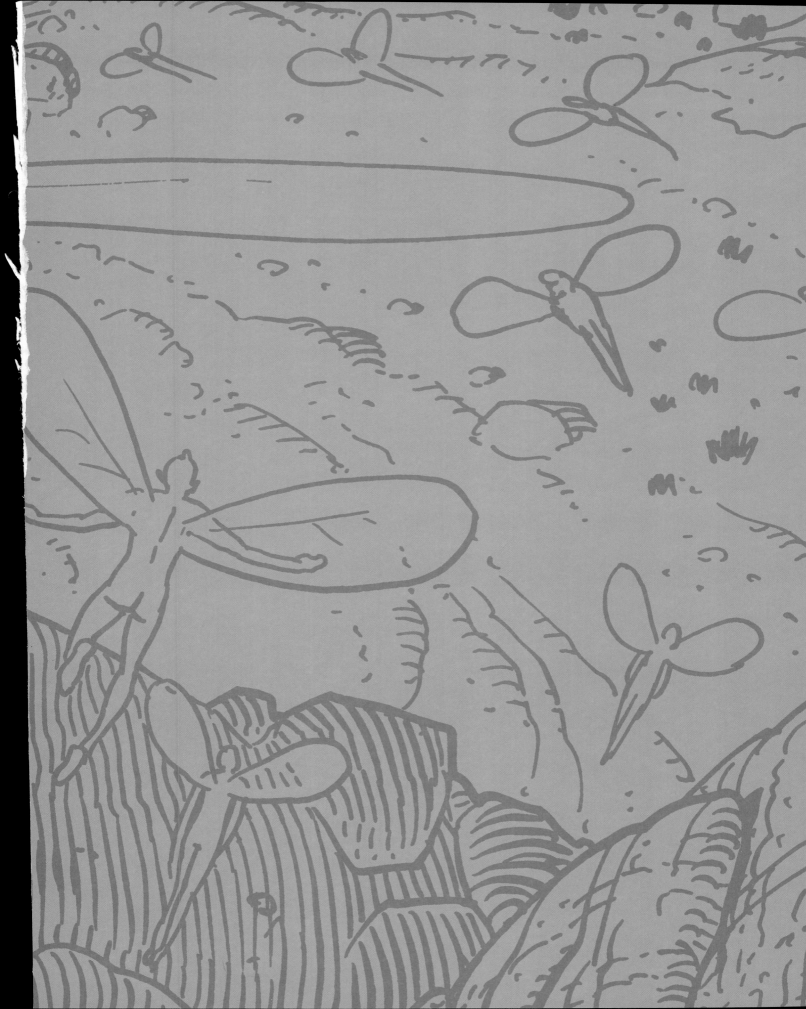